FINDING DAIRYLAND

FINDING DAIRYLAND

In Search of

WISCONSIN'S VANISHING HERITAGE

SCOTT WITTMAN

THE
History
PRESS

Published by The History Press
Charleston, SC
www.historypress.com

First published 2022

Manufactured in the United States

ISBN 9781467148894

Library of Congress Control Number: 2021952399

To a dairy farmer I was never able to meet but owe an unrepayable debt.
The guardian angel of my three sons:

Joseph P. Steffens
(1946–2004)

CONTENTS

Acknowledgements 9
Introduction 13

1. A Born Identity 17
2. Ghosts of the Northern Highlands 39
3. Echoes of the Driftless 67
4. Spirits of the Central Plains 95
5. Skeletons on the Eastern Ridge 119
6. Surveying the Landscape 141
7. The Reclaim 165

Bibliography 187
About the Author 191

ACKNOWLEDGEMENTS

The landscape of our state tells a story. The dairy industry in Wisconsin has had many chapters over the decades, the remnants of which can still be seen in countless places, often obscured by modern architectural add-ons, tear-downs or abandonments. As dairy, which remains a billion-dollar industry and a driving force of state economics, transitions to bigger operations and much larger processing facilities, the smaller family farms have often been left behind, causing farms to end after generations and businesses to go bankrupt, as our landscape shows the scars.

The causes and reasons for this are many, some which are touched on in the stories that follow, though that is not what this book is meant to be about. My interest lies much more with who they were, telling their personal accounts and honoring their contributions, which have been all too often forgotten or, in some cases, intentionally shunned. We are America's Dairyland for good reason. That is a moniker we embrace and an identity that defines us throughout the world. All of those who contributed to that legacy—and this book contains the accounts of a miniscule fraction of them—deserve to be remembered.

Those who tell their stories in these pages deserve our dignity and respect. Their experiences may differ from others, as simply running a small dairy farm in Wisconsin does not mean an automatic death sentence to an operation, but they are their experiences nonetheless. Telling their personal histories in these pages took courage. Nobody said they had to. I thank and admire them immensely.

The chronicles relayed in this project are but a handful of all that was researched and visited. Those chosen were included to tell as diverse a range of experiences as possible, while at the same time keeping a somewhat cohesive narrative. I hope I have achieved that.

Most, if not all, of the properties in this book are privately owned. Photos included, or not, were at my discretion with this in mind. All photos of properties were taken from public view or with permission.

AN UNDERTAKING SUCH AS this takes myriad people to collectively work toward a goal, and I was graced with the help and cooperation of many during this process.

First and foremost, my wife, Vicky and our three boys, Asa, Jett and Rhodes. Simply put, my everything.

Wisconsin is unmatched, in my opinion as a researcher, in the quality and excellence of our historical facilities, archives and resources. Much of the research for this project was done under the extraordinary circumstances of the Covid-19 pandemic, which limited hours and access and created a heavy reliance on the highly skilled and talented staffs of our historical societies and public libraries throughout our state. Through staff shortages, questions about safety and the general unknown of when "things would get back to normal," countless numbers of you still agreed to come in and meet with me when you were supposed to be off, digitized documents and located items I could not otherwise get to because of these unprecedented times, and you all hold my deepest appreciation and gratitude.

Thank you to those who took time out of your lives to spend a day, a few hours or a couple minutes with me, whether in person or in the hundreds of phone and email conversations I had for this project. Although only a handful will be seen in these pages in name and story, every minute spent contributed to this final piece. For your time and effort, I am forever indebted. You were open and honest about subjects it is often hard to be open and honest about. You answered my questions, some very hard, and shared intimate information about your lives, your families, your triumphs and your struggles. The topics we covered weren't always comfortable, though you felt this project was worth telling me about, and for that I cannot thank you enough. I hope you find the book a worthy culmination.

A special thanks to the following, in no particular order:

Lorraine Pilch, John Berg and the Price County Historical Society (John invited me into his home and really helped to open several lines of

communication for me in the Northwoods); Joseph Hermolin, Langlade County Historical Society; Maxine, Darlene and Larry at the Butternut Area Historical Society; Leah Penzkover, architecture and history inventory coordinator at the State Historic Preservation Office of the WHS; Kim Krueger, coordinator, North Wood County Historical Society; Bill and Carol Kranz; Nancy Kastenschmidt; Terry Kempen; Jim Hardzinski; Mark Kempen; Alan Larson; Marge Van Heuklon; Paul Kearns; Trevor Kearns; Bruce Koch; Jody Smith; Tracey Roberts, executive director, and staff at the Grant County Historical Society; Emory Lubke, Soo Line Historical Society; Pat McCormick; Don Rudolph; Linda Wait; Kathleen McGwin; Marquette County Historical Society; Vernon County Historical Society; Jackson County Historical Society; Lily Lindegren Nichols and Melanie Meyer at the Rusk County Historical Society; Katie Dippel Reilly, executive assistant, Sheboygan County Historical Research Center; Paul Lindegren; Ken McGwin; Beverly Brayton; Dennis Brayton; Sherburn Mabie; John Rodrigue; The History Press; and so many more.

INTRODUCTION

I f you could take a road trip through a timeline of the state of Wisconsin of just the last 150 years, you would witness one of the greatest shifts in localized socioeconomics, as evidenced simply by the physical landscape, in our nation's history.

Beginning in the late 1860s, you would be driving through heavily forested lands in the Northwoods—millions of acres of massive white pine forests, surrounded by the northern hardwoods of hemlock, sugar maple and yellow birch. In the southern portion of the state, oak savannas have already given way to settlement, and small wheat farms and mining communities have taken root.

Traveling further down the road and into the 1870s, the forests are interspersed with seas of gold, as wheat fields bending in the wind provide a pleasant environment. Small farming communities financed by the sale of the wheat snuggle up along both sides of the road, until you pull up to the 1880s and see the wheat fields are turning a thirsty brown and have stopped growing. Dead crops put the survival of the farms that tend them in danger. The sky is turning dark and ominous.

As you continue down the road of the 1880s, past the plowed-to-death former fields of wheat, you begin seeing droves of cattle. You also notice that the forests you had passed through for a few decades were gone. Only large stumps remain, and piles of scarred tree trunks and branches lie everywhere, causing you to swerve around them.

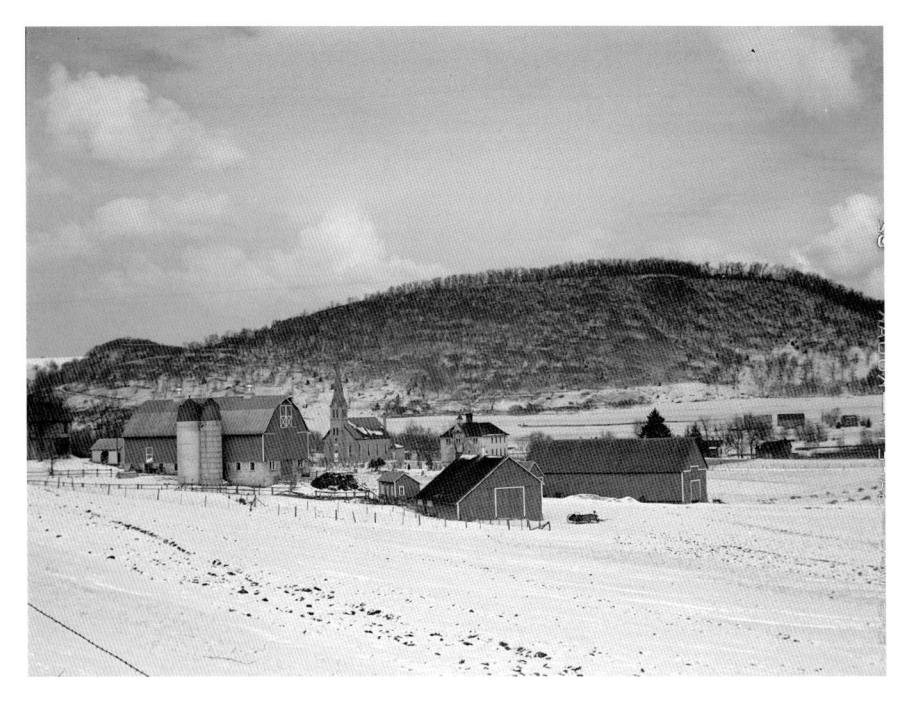

Typical Wisconsin dairy farm scene. Vernon County, 1941. *Library of Congress.*

You finally make your way to the 1890s and head into the turn of the twentieth century and find that this is a place you really like. Countless quaint little towns with red barns, silos and black-and-white cattle along the road make this a picturesque area for you to pull over and want to stay the night. In the morning, you stop and pick up fresh butter and cheese blocks of every brand and category, as well as miscellaneous items you need at several other shops and stores throughout the area. Soon after, you hit the road again.

You take this for a pretty long stretch, all the way to the 1940s, enjoying the scenery of the dairy farming communities, though you notice that the small little cheese stores and factories you stopped at earlier are a bit fewer and farther between. You spot larger factories, processing plants and warehouses along the rail lines in more populated areas, a change from down the road behind you a short distance, where you didn't see any of these.

By the time you get to the 1960s, the sun is beginning to set. You notice the farms that were so vibrant and plentiful the day prior now seem faded and empty. You pass so many where it seems that nobody is living in them anymore. The cows are gone. The barns are hollow. The farmhouse is deserted.

"What just happened?" you wonder aloud. "Did I miss something?"

Night falls. You decide to keep driving, having a bit of an uneasy feeling in an area you're not familiar with. Boarded-up storefronts and abandoned factories cramp your comfort level. You're confident that if you just drive through the night, in the dark, when the sun rises in the morning, everything will be back to how it was yesterday.

Morning finally breaks after a long, dark night. You are now driving through present day. You pass a beautiful scene of a family dairy farm with well-maintained buildings and a healthy herd seen in the pasture. It reminds you of driving through just a few decades ago. But for every one of these modern farms you see, a dozen more are wrecked, empty and neglected.

Cows begin to appear again, occasionally, as you proceed on. Hundreds of them, maybe thousands, but they all seem to be contained in gigantic, long barns that look to be almost a quarter mile in length and are no longer dispersed among the many smaller farmsteads that have been shuttered, many of which you've passed along the way, lying quiet along the countryside.

Dairy herd scene, central Wisconsin, circa 1940s. Photo by Andrew J. Mueller. *Courtesy of Marge Van Heuklon Private Collection.*

Your road trip ends, and you return home. The next day, you ask your friends and family members, whom you know regularly drive past those same empty farms and houses, about who they were and what happened to them. Perplexed, they pause to remember. "I don't really know," they say. "I guess I never thought much about it. They've just always been there."

And day again turns to night.

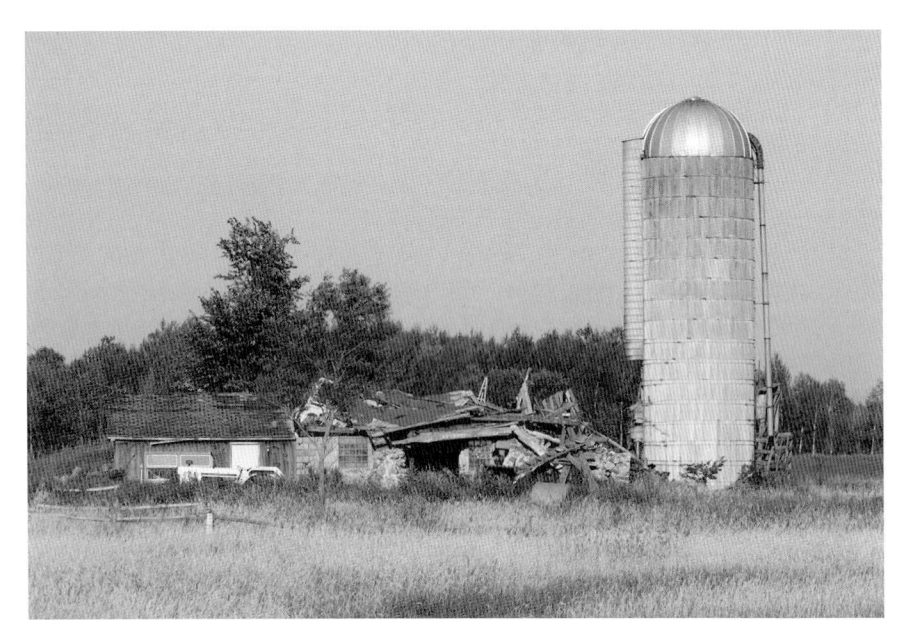

Remnants of a wrecked dairy farm, Taylor County. *Scott Wittman Visual, 2021.*

Chapter 1

A BORN IDENTITY

Glancing every so often back at the road on which I was traveling, heading northeast between the forests of the Kettle Moraine and Lake Michigan, my eyes were more transfixed on the multitude of artifacts I was driving past. My car, ten years old at the time, suddenly became the pinnacle of technology compared to the hollowed-out and rusted dead bodies of its long-ago brethren, now acting as oversized flowerpots for the underbrush and thicket growing through their fenders. The yards these skeletons were lying in, too, were left to the harsh elements of the Wisconsin climate for who knows how long, just as the many ruined houses, barns and various other barely standing buildings were, while still casting their shadows over them.

Descending toward the shoreline from the glacial landforms of the Kettle Moraine, the landscape opened as a cool lake breeze began blowing over the smaller rolling hills of Sheboygan County. I rode my brake slowly past old farmhouses built of cream city brick, a clay that turns a pale yellow when fired, providing a distinctly vintage look, and also providing the moniker for the city of Milwaukee, just a short drive south, as the "Cream City."

As I continued in the direction toward the rarely utilized county airport, an abandoned property adjacent, not dissimilar to the ones I had just driven by, held my attention a bit longer. The first structure to appear from the road was the barn. Traditional and purely utilitarian in architecture, it was peeking out from a copse of trees and shrubbery separating it from the two-lane county highway, which was patched with blacktop and tar. The peak of

Dairy herd scene near Weyauwega, Wisconsin, circa 1940s. Photo by Andrew J. Mueller. *Courtesy of Marge Van Heuklon Private Collection.*

the intact though decaying roof was still slightly higher than the tallest tree, as if reaching to maintain its superiority to the elements—a battle it will not win. Red paint was still clearly visible under the overhang where it had been shielded from decades of pelting rain, snow and sleet, though the rest had mutated into a muddy mix of maroons and sun-dyed browns, which, contrasted with the green shrubbery and blue sky, reminded me of a child's watercolor palette.

As I peered through entire segments of missing clapboard, exposing the overgrowth on the other side of the barn, I proceeded on past another grove of unkempt shrubbery. There, behind more wayward branches, the house came into view, broken and left to die, but still standing like a beaten boxer waiting for the match to be called. I pulled over before the left-turn-only road in front of me for a closer look, as other traffic was nonexistent. The house was a front and side–gabled, L-shaped structure, a popular architectural style from the mid- to late nineteenth century. At first glance, it appeared as if the house had been wood framed and sided, though closer examination

Abandoned 1899 dairy barn built by Ernst Heidenreiter, Sheboygan County. *Scott Wittman Visual, 2021.*

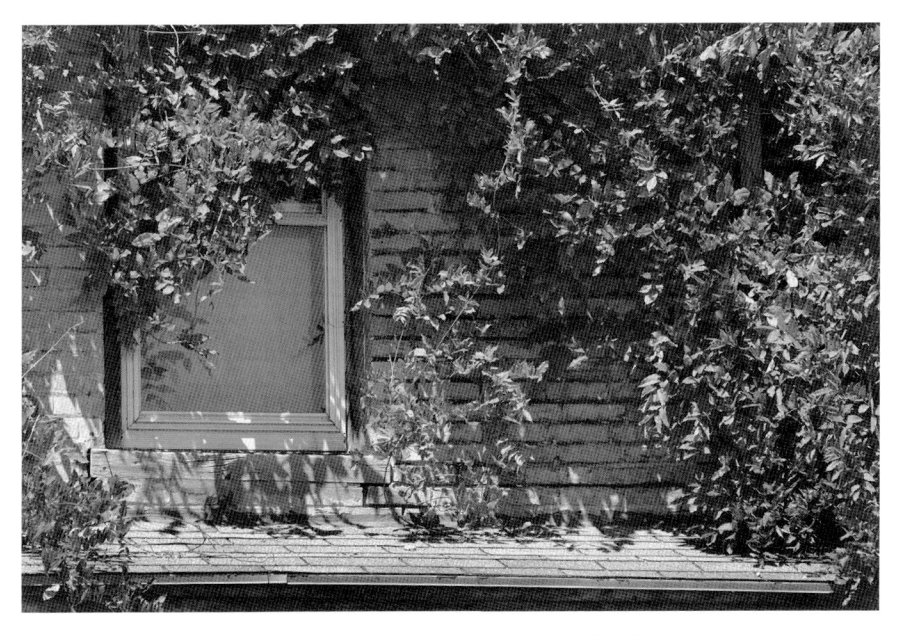

The original "cream city brick" still seen under the overgrowth. Heidenreiter/Prange farmhouse, Sheboygan County. *Scott Wittman Visual, 2021.*

exposed the familiar cream-colored yellow brick that had been sided over, likely when obvious later additions were made to the home.

I stepped out of my car and took a moment to recognize the feeling that I was standing at the crux of some sort of blip in the time-space continuum. To my right, across the street, I saw planes at an airport hangar, some clearly antiques themselves. Directly in front of me was a crumbled house on an empty farm built by the hands of someone who had likely never even seen an airplane, and now they are parked right outside his front door.

I studied the house from the road. I noticed the decorative trusses on the intersecting gables, accentuating the pitched roof. I noticed the elongated front porch, also with a pitched roof over the steps leading from the walk, inviting you to the front door. I noticed black graffiti on the original brick next to the living room bay window. I noticed reflections in the windows, the kind of abstract swirls that your mind tries to make sense of by creating faces peering out at you while looking at them in photographs. I noticed the wrecked milk house below the ramp to the bank barn I had seen earlier, with tracks, rutted over decades, still visible in the dirt leading to where the sliding barn doors used to be. I noticed a patchy area, discolored from the other grasses, with clumps of old hay scattered throughout, recognizing an old cow pasture.

I also noticed the stillness. If not for the wind or a distant car muffler, the silence would have spooked me. Such silence here tells a story. This house was built to remain here for generations. The additions to the home were made for expanding families. The brick arches over the second-story windows show attention to style and detail—and pride. The bones, the skeletal systems of a community of working family dairy farms, stay afloat on a sea of weeds and wild grass, but the families do not. The silence is the story.

It wasn't always so quiet.

The myriad leftover houses and farm communities throughout the state were once filled with the sounds of German, Swedish and Irish music; pounding hammers raising Belgian barns; and easterners looking for opportunities to start a new life as areas were being opened for settlement to the west. A population explosion occurred in Wisconsin in the 1840s, raising the number of people in the state to over 300,000 by 1850. By 1860, it was pushing 800,000. Polish, Swiss and Norwegian immigrants came by ship, railroad and horse and wagon to get a glimpse of this new America.

Photographs of immigrants from the period of the mid- to late nineteenth century oftentimes fail to convey an accurate message to the privileged eyes of the twenty-first-century viewer. We see hardened faces, wrought with despair, or even what sometimes seems like no emotion at all—just a stare back into the lens, as if their emotions had been neutered by disease, trauma, tempered expectations from repeated missed opportunities or, more likely, no opportunities at all.

They came to obtain for their children and grandchildren what was unachievable for them wherever they had come from: individual freedom to choose; to do as they wanted to do, even if that also meant the freedom to fail.

Carl Schurz, a prominent German American who first settled in Watertown, Wisconsin, before fighting in the Civil War and becoming a successful U.S. politician, wrote about the wave of immigrants coming in 1848:

> *They were mostly high-spirited young people, inspired by fresh ideals which they had failed to realize in the old world, but hoped to realize here; ready to enter upon any activity profitable but also to render life merry and beautiful; and withal, full of enthusiasm for the great American republic which was to be their home and the home of their children. Some had brought money with them; others had not. Some had been educated at German universities for learned professions, some were artists, some literary men, some merchants. Others had grown up in more humble walks of life, but, a very few drones excepted, all went to work with a cheerful purpose to make the best of everything.*

They worked in the lead mines of Grant and Crawford Counties, the lumber camps of the northern regions and the manufacturing plants and breweries of Milwaukee and Kenosha. They opened stores, built railroads and roads and worked in flour mills. They became teachers, pastors, blacksmiths and community leaders. They also created over 100,000 farms covering half of the entire state's available acreage and carved out an identity for the newly formed state.

This was unknown country to those who came. They would have been unaware of any differences in geography or soil composition between regions. They came based on hope and faith, and for those who came to the lower two-thirds of the state, they were happy to find that the resources were there for their prayers to be largely answered.

Albert Tuttle, a Connecticut pioneer looking for a land claim in what is now Portage County, wrote home to his wife and young son in the spring of 1847 after several months of being in the region: "The longer I live here the better I like the country. This is not out of the world, as many east suppose it to be. Whoever lives here ten or fifteen years will find this to be the very center of all creation."

Over one hundred years later, in the fall of 1960, John Steinbeck, while traveling through the state as he traversed across America for his book *Travels with Charley*, was equally pleasantly surprised:

> *It is possible, even probable, to be told a truth about a place, to accept it, to know and at the same time not to know anything about it. I had never been to Wisconsin but all my life I had heard about it, eaten its cheeses, some of them as good as any in the world. And I must have seen pictures. Everyone must have. Why then was I unprepared for the beauty of this region, for its variety of field and hill, forest, lake? I think now that I must have considered it one big level cow pasture because of the state's enormous yield of milk products. I never saw a country that changed so rapidly, and because I had not expected it, everything I saw brought a delight. I don't know how it is in other seasons. The summers may reek and rock with heat, the winters may groan with dismal cold. But when I saw it for the first and only time in early October, the air was rich with butter-colored sunlight, not fuzzy but crisp and clear so that every frost-gay tree was set off, the rising hills were not compounded, but alone and separate. There was a penetration of light into solid substance, so that I seemed to see into things, deep in, and I've seen that kind of light elsewhere only in Greece. I remember now that I had been told Wisconsin is a lovely state, but the telling had not prepared me. It was a magic day. The land dripped with richness, the fat cows and pigs gleaming against the green, and, in the smaller holdings, corn standing in little tents as corn should, and pumpkins all about.*

When Albert Tuttle was scouting land claims for his family to relocate to Wisconsin, wheat was the most important crop and by far the most prominent choice for the majority of the 100,000 farms started by the new arrivals. Wheat was cheap to plant and maintain, leading to a high profit margin, as Wisconsin became the second-leading producer of wheat in the nation by 1860. Several factors began to emerge, however, that would lead farmers to explore other options, not the least of which was the competition from states to its west, namely Minnesota, Iowa and, ultimately, the Dakotas. Ironically,

it was a flour miller and inventor living in Neenah, Wisconsin, a leading producer of wheat at the time, who ultimately put the nail in Wisconsin's wheat farming coffin.

John Stevens's inventions in grain production, specifically the roller mill, revolutionized the industry. He sold the rights to his patents, which led to an explosion of growth in the West, specifically in Minneapolis when they were purchased by two little-known companies of the day: General Mills and Pillsbury. This effectively ended Wisconsin's reign as a leading wheat producer, as did depleted soil and crop destruction from insects, leaving farmers searching for alternatives for income.

Wheat farmers on the East Coast, specifically New York state, had dealt with these same issues decades prior. Where Wisconsin had the devastation of wheat from the chinch bug, which would destroy the crop by feeding off its natural fluids and killing it by dehydration, New York had the Hessian fly and the wheat midge. Cause and effects from depleted soil and the railroads also had farmers in the East looking for other options, and their eyes gazed to the West. New Yorkers who migrated to Wisconsin in large numbers in the mid-nineteenth century had seen this story before, and one man set forth on a plan that would change the fortunes, history and heritage of Wisconsin forever.

Born into a farming family in the Oneida Valley of central New York in 1836, William Dempster Hoard saw the wheat crops of his father fail. He then witnessed as the crops of corn, barley and oats failed as well. Growing up, as he would later write, as a "passionate lover of hunting and fishing and still more of exploring the forests," the observant Hoard noticed as dairying slowly began to fill some of the monetary gaps caused by the lack of cash crops. Surrounding areas in New York, such as Herkimer and Madison Counties, became important regions in the production of milk and cheese. He saw cheese factories open and farmer cooperatives operate successfully.

At sixteen, Hoard quit school and began apprenticing on a 110-acre dairy farm with fifty cows, a large herd for the day. He learned not only the work ethic needed for the daily grind of the operation, but also how to utilize marketing and promotion, as the farm's products had expanded to markets outside its region. The farmer for whom he worked, Waterman Simonds, also required Hoard to take time during his work hours simply to read the pertinent industry literature of the time. This is when Hoard would learn

about the importance of science in farming, such as appliances of chemical analyses, socioeconomic impacts and the utilization of infrastructure in marketing. Hoard would also see his father implement some of these same progressive measures into his own farming operation while transitioning to dairy, later introducing the Devon breed of cattle to central New York. After falling in number to under three hundred in the world, this breed survives there today due to successful conservation efforts.

It was also during this time that Hoard became heavily influenced by the editor and publisher of the *New York Tribune*, Horace Greeley. It was in the *Tribune*, which was the highest-circulating newspaper in the country, that Greeley advocated for the settlement of the American West and popularized the premise, if not the slogan, "Go west, young man, and grow up with the country."

On October 1, 1857, twenty-year-old W.D. Hoard heeded Greeley's advice and did just that, taking a train first to Chicago, then to Milwaukee, and then on to Oak Grove, Wisconsin, where he moved in with a cousin, G.G. White. Within two and a half years, Hoard was married to who would become his lifelong partner, Agnes Elizabeth, and working on her parents' general farm in Lake Mills while also engaging in numerous odd jobs in various industries to make ends meet. Hoard, however, became frustrated by much of what he was noticing in his short time in Wisconsin to that point. He had seen this before. Wheat crops were failing. Cultivation of barley, hops and tobacco were not reaping enough rewards to make them viable alternatives, and to Hoard's dismay, dairy farming was virtually nonexistent, at least as a commercial endeavor. He was unable to utilize his expertise in dairying due to a lack of farmers "who had a herd of cows to exceed six," he later wrote, and if there happened to be a farmer who had ten or fifteen cows, they were counted "a local wonder."

It was also during this time that Hoard's political and activist vision was being formed as the country was heading into its great divide. On at least one occasion, Hoard traveled to Illinois to witness the man he was most compared to in his life, both in physical stature and demeanor, Abraham Lincoln, face off in one of a series of scheduled debates with his opponent for U.S. Senate, Stephen Douglas. Hoard also saw Lincoln speak at the Wisconsin State Fair in Milwaukee on September 30, 1859. Speaking before the Wisconsin State Agricultural Society, Lincoln touched on several aspects that undoubtedly a young W.D. Hoard heard loud and clear. Lincoln began by advocating for the sharing of agricultural knowledge:

But the chief use of agricultural fairs is to aid in improving the great calling of agriculture, in all its departments, and minute divisions—to make mutual exchange of agricultural discovery, information, and knowledge; so that, at the end, all may know everything, which may have been known to but one, or to but a few, at the beginning—to bring together especially all which is supposed to not be generally known, because of recent discovery, or invention.

And not only to bring together, and to impart all which has been accidentally discovered or invented upon ordinary motive; but, by exciting emulation, for premiums, and for the pride and honor of success—of triumph, in some sort—to stimulate that discovery and invention into extraordinary activity. In this, these Fairs are kindred to the patent clause in the Constitution of the United States; and to the department, and practical system, based upon that clause.

Later, Lincoln invokes another aspect of Hoard's past education at the Simondses' farm, how science and farming correlate:

In all this, book-learning is available. A capacity, and taste, for reading, gives access to whatever has already been discovered by others. It is the key, or one of the keys, to the already solved problems. And not only so. It gives a relish, and facility, for successfully pursuing the [yet] unsolved ones. The rudiments of science are available, and highly valuable. Some knowledge of Botany assists in dealing with the vegetable world—with all growing crops. Chemistry assists in the analysis of soils, selection, and application of manures, and in numerous other ways. The mechanical branches of Natural Philosophy are ready help in almost everything; but especially in reference to implements and machinery.

The thought recurs that education—cultivated thought—can best be combined with agricultural labor, or any labor, on the principle of thorough work—that careless, half performed, slovenly work, makes no place for such combination. And thorough work, again, renders sufficient, the smallest quantity of ground to each man. And this again, conforms to what must occur in a world less inclined to wars, and more devoted to the arts of peace, than heretofore. Population must increase rapidly—more rapidly than in former times—and ere long the most valuable of all arts, will be the art of deriving a comfortable subsistence from the smallest area of soil. No community whose every member possesses this art, can ever be the victim of oppression of any of its forms. Such community will be alike independent of crowned-kings, money-kings, and land-kings.

Hoard heard all of this, writing later, "Mr. Lincoln's speech made a very profound impression on me."

After two tours of duty in the Union army during the Civil War, in which breakbone fever (dengue fever) almost killed him, Hoard returned to his wife, and now three sons, in Lake Mills. The frustration returned as well, as the odd jobs continued, crops were hit or miss and he needed to find a new beginning.

He turned to his old inspiration, the editor of the *New York Tribune*, Horace Greeley, and started a newspaper. Having no experience at all in the field, Hoard was able to secure arrangements with a local publisher, and the first edition of the *Jefferson County Union* rolled off the presses on March 7, 1870. He quickly realized the weekly newspaper could be utilized as a tool to engage a rural audience about dairy farming, and as he would later write, "I commenced to preaching the gospel according to the cow."

William Dempster Hoard. *Library of Congress.*

Now a newspaper editor, Hoard went to talk with schools, cheese factories and dairy organizations to maintain dialogue. In just the seventh weekly edition of the *Union*, he published a column by local Lake Mills dairy farmer Stephen Favill, who was also a Herkimer County, New York native, who wrote, "If the farmers of this country would substitute the cow for the plow, in ten years the value of the land will be increased at least 25 percent."

Hoard published industry-related research papers on dairy, offered his own insights, solicited writings from local farmers and printed reports from dairy organizations. He was instrumental in the forming of multiple grassroots dairy organizations, including the Jefferson County Dairyman's Association, the multistate Northwestern Dairyman's Association and the somewhat legendary Wisconsin Dairyman's Association, formed by what was known as the "Seven Wisemen of Wisconsin Dairying." The farm news became the most popular column of the paper, and advertisers wanted in. In due time, as the dairy industry grew, Hoard realized the column needed to be its own publication.

On January 23, 1885, the new publication, entitled *Hoard's Dairyman*, was placed as an inside supplement to the *Jefferson County Union*. It soon became its own standalone magazine and grew to be the largest circulated dairy publication in the world.

But Hoard was still not satisfied. Wisconsin's butter and cheese makers were selling their product at the lowest rate in the nation, and quite literally, buyers got what they paid for, as Wisconsin butter sold in the East was referred to as "western grease." He noticed a work ethic among many farmers he felt unacceptable, and he was not afraid to point this out in his magazine; he was sometimes criticized for his steely opinions on this matter. He traveled the state promoting cheese and butter production and aided in the organization of cheese factories and local co-ops.

Aided by promotion in the magazine, the Wisconsin Dairyman's Association (of which Hoard was a co-founder, secretary and later president) increased its influence throughout the state. Its meetings and yearly conventions grew rapidly. Hoard's biographer, Loren H. Osman, writes:

> *Their prospectus was a broad one: development of good dairy herds; stressing the beneficial relationship the cow bears to the soil; showing how to build a permanent system of agriculture, improving the quality of dairy products; making Wisconsin known as a manufacturer of good dairy products; developing a transportation system that would open a worldwide market to the dairy farmers of the state....*
>
> *...The association, with a strong roster of speakers and opportunities for open discussion at its meetings, became one of the most effective adult education projects in the state's history.*

In less than a generation, by 1910, Wisconsin was the top cheese-producing state in the nation.

By 1888, Hoard had returned to his love of politics and the influence of his hero, Abraham Lincoln, and was elected the sixteenth governor of Wisconsin. He continued to write for the magazine while leading the state he helped transform into "America's Dairyland."

THE ABANDONED DAIRY FARM I was currently exploring from the road was clearly from the time of Hoard's rise. The yellow "cream city brick" of the home was utilized heavily between the middle and late nineteenth century. The architecture of the barn and other outbuildings mirrored so many others of that period as well. I wondered if I was looking at Hoard's influence right in front of me. Was this a wheat farmer at one time who transitioned to dairy farming? Did Hoard himself inspire them? Were they influenced by a meeting they attended of the Wisconsin Dairyman's

Association? The answers are almost certainly—directly or indirectly—in the affirmative.

William Dempster Hoard has been lionized as a savior in Wisconsin, is still known as the "Father of Wisconsin Dairying" and was named "Wisconsin's Most Distinguished Citizen" at the San Francisco World's Fair in 1915.

But there was another dairy pioneer from Wisconsin, around the same time as Hoard's most influential years, whose contributions have been somewhat suppressed over the decades, even though she was much more famous than Hoard ever was.

That's right. *She.*

Living about as far from the lifestyle of a rural Wisconsin dairy farmer as possible, a wealthy Milwaukee socialite returned to her roots and likely did more for the promotion of Wisconsin dairy than anybody else in history.

Growing up on her parents' Sunny Peak Farm in Elm Grove in Waukesha County, Adda Johnston was born in 1852. Although her later reminiscences spoke fondly of her childhood at the farm, she decided rural life was not for her and spent her young adult life in Milwaukee, eventually marrying David Howie, a wealthy coal salesman, and becoming prominent citizens in the community.

Living in an almost five-thousand-square-foot Queen Anne mansion, the now Adda Howie spent her days in Milwaukee's high society writing poems and publishing children's books while her husband, eleven years her senior, was an agent for the Northwest Fuel Company.

She eventually inherited her parents' farm, now abandoned and in declining condition due to decades of occupation by tenant farmers after her parents had moved away. After the farm had not been lived in for quite some time, Adda and her son, who was attending the state agricultural school at UW-Madison, agreed to spend a week at the farm to decide its fate. If it was to be rented again, it needed to be repaired and restored to a presentable appearance.

Upon arrival, Adda Howie found the property to be in a dilapidated state. The soil was depleted and infertile. The barn and outbuildings were run-down and neglected. The house, in her memories a place of vibrance and joy, was covered in the darkened grime of years of dereliction.

But Adda was undeterred. Although she was used to having a team of house help at her Wells Street home in Milwaukee, she took it upon herself to clean her childhood home using her own hands, blood, sweat and tears. When the week was up, Adda Howie had found her new tenant—herself. The Howies would leave their Milwaukee mansion and move to Sunny Peak Farm.

Adda was adamant that this was to be no hobby farm for wealthy retirees but a model farm, one that could be patterned after by ordinary dairy farmers, instituting practices to better manage their farms and animals. It was to be paid for only by the profits turned by the farm, utilizing no family money whatsoever. She had seen many examples of what she believed were farmers prioritizing profits while their animals and crops endured filthy conditions, possibly affecting the food sources for consumers who were none the wiser. She began studying cattle breeds and herd management, devising what was at the time unconventional methods for maximizing product.

She invested in the Jersey cattle breed and advocated for sanitizing practices not much heard of on American farms at the time, including whitewashing the walls of the barn and all outbuildings along with weekly scrubbings. All windows would be regularly cleaned and curtained with denim hangings to keep flies out, and any milkers would be required to wash their hands before milking each individual cow. The care of the cows themselves was paramount to Mrs. Howie. She saw to it that they were brushed and petted regularly and kept in a comfortable, stress-free environment. Her cows were not tied to posts but kept in spacious stalls with plenty of room to stand and lie down, and she became quite well known for playing music for her cows, putting them in a calming mood, which she believed increased milk production.

As news of her methods began to spread, national and international publications began to take notice and visit Sunny Peak Farm for a closer look. Initial skepticism from some aside, Adda's Jersey breed continued to grow and thrive. Her cows claimed a multitude of championship ribbons and prizes at state, national and international fairs and exhibitions, and before long, Adda was in high demand.

Adda's talents in dairying could maybe only be rivaled by her talents as a public speaker. She toured the nation giving public talks for agricultural interests and became an international celebrity. In 1914, an Arizona newspaper referred to her as "one of the most famous women in the United States…about whom more has been written and printed in this and foreign countries than about any other woman now living."

She toured Europe several times, speaking in cities like Paris and London, where the king of England, Edward VII, invited her to tour his dairy barns. Her cows were also selling for exorbitant amounts of money for the day, including to the government of Japan, who sent a delegation to Sunny Peak to purchase directly from her.

By the time of her death in Milwaukee in 1936, Adda Howie was the first female member of the Wisconsin State Board of Agriculture, the first

Adda Howie serenading her cows at Sunny Peak Farm, 1909. *Courtesy of Wisconsin Historical Society.*

woman to receive honorary recognition by the University of Wisconsin and the first woman to have her portrait hung in the UW agricultural college gallery, along with countless other firsts.

ASSISTED BY PROMOTION FROM the University of Wisconsin's College of Agriculture, the first collegiate dairy school in the world, along with the trusted words of D.W. Hoard and Adda Howie, farmers began to embrace both scientific measures in dairying as well as practices in animal care and sanitation. In just a few short decades, dairy farming was intertwined with the culture of the Badger State.

By World War I, Wisconsin led the nation in dairy production, which would continue throughout the twentieth century. Cows became synonymous with the state, both in the milking type as well as in artificial roadside attractions.

Dairy-related roadside attractions: "Chatty Belle" in Neillsville (*top*) and "Antoinette" in Plymouth (*bottom*). *Scott Wittman Visual, 2021.*

Bovine statues adorned the roofs of buildings and became photo ops at highway rest stops. Artisan cheesemakers from the state won top prizes the world over, "America's Dairyland" was inscribed onto the license plate of every automobile and a new Alice in Dairyland was selected every year to be the ambassador of all things Wisconsin agriculture.

By the mid-1930s, 35 percent of all Wisconsin residents lived on the almost 200,000 dairy farms that covered the state.

By 2021, barely six thousand remained.

Oh, their hollowed-out shells are still here. The wrecked houses and falling-down barns. The caved-in chicken coops and broken, exposed foundations. The roadside remnants of those who delivered a young state purpose, identity and heritage. The boney leftovers are a tangible illustration of the dramatic rise and the long, slow, agonizing decline of the family-run dairy farm in the "Dairy State."

As I stood on the grounds of the old dairy farm in Sheboygan County, I wondered what transpired here between its construction and today. The physical debris is telling only half the tale, so what about the people who lived on this farm? What about the people who built it, lived it and worked it? What was their story?

And how do we continue to tell it?

THE FARMSTEAD WAS FIRST settled no later than 1875 by Joachim Klocking, a German immigrant who arrived in the area around 1857, and his wife, Mary. By 1889, the Klockings had relocated roughly thirty miles north and sold the property to Ernst Heidenreiter, a second-generation American and native New Yorker and a prominent name in Sheboygan County history.

Here, Ernst and his wife, Elizabeth, operated their family farm, Cottonwood Stock and Dairy Farm, along with their children for over twenty-five years. Short Horn, Jersey and Holstein cattle were raised on the sixty-seven-acre property, on which the fine, yellowed-brick residence already stood by the time of their ownership.

A veteran of the Civil War, Ernst engaged in combat during several battles and his regiment assisted with the capture of Confederate president Jefferson Davis. He was well respected in the community, as he was named town supervisor of Sheboygan Falls, along with district clerk and director of the local school district.

On the morning of December 8, 1915, sixty-nine-year-old Ernst had just finished chores on the farm, which was his daily custom, when he collapsed

at the home and died of a heart attack. The family and community were stunned, as he had been in "excellent health" up to that point. Heart failure would unfortunately run in the family, as Ernst's son, Ernst Peter Heidenreiter, and a grandson, Ernst Neal Heidenreiter, a former sheriff of Sheboygan County in the 1970s, also both passed of heart attacks, at forty-four and sixty-three years of age, respectively.

By 1912, the property had been purchased by noted local farmer Carl Prange, though Heidenreiter continued to live on and work the land.

Prange was the son of one of the first pioneers of Sheboygan County, William and Eleanor Prange, natives of Germany, who immigrated to the United States in 1848. Purchasing 160 acres of farmland from the U.S. government in Sheboygan Falls, William Prange remained on his farm his entire life, raising seven children with his wife. His second-eldest son, Carl, also remained on the homestead with his family for the span of his life, following his father into farming, while also obtaining more acreage in the area, including the Heidenreiter farm.

Some of Carl's siblings, however, took different paths for their careers. Carl's younger brother Henry Carl Prange began working at a general store as a clerk in his youth. As his knowledge of retail grew, so did his ambition, and he attempted to purchase a share in his employer's store. Denied, he, along with his younger sister Eliza and their brother-in-law, opened their own store in Sheboygan Falls in 1887. And thus began the H.C. Prange Company.

Much of the Prange extended family worked in the family store in various capacities throughout its first decade, though Carl and his son Otto continued to farm the homestead, having little interest in the retail business. After Ernst Heidenreiter Sr.'s death in 1915, the property was handed down from Carl to Otto, who was the next to make the farmstead his home.

At its height, Prange's had twenty-five stores in several states with thousands of employees transacting over a quarter billion dollars in sales. There were also twenty Prange Way discount stores throughout the region, adding to the locally owned empire. All the while, Otto was perfectly content raising his family with his wife, Erna, on his own dairy farm for the next half century.

Otto's cousin H.C. Prange Jr. took over after his father's death in 1928 and oversaw Prange's rise throughout the majority of the twentieth century.

In a cruel twist of fate, while Henry Carl Prange's sister and company co-founder, Eliza, was placing flowers at his grave shortly after his death, her car, parked on an incline, rolled backward, veered off the road and

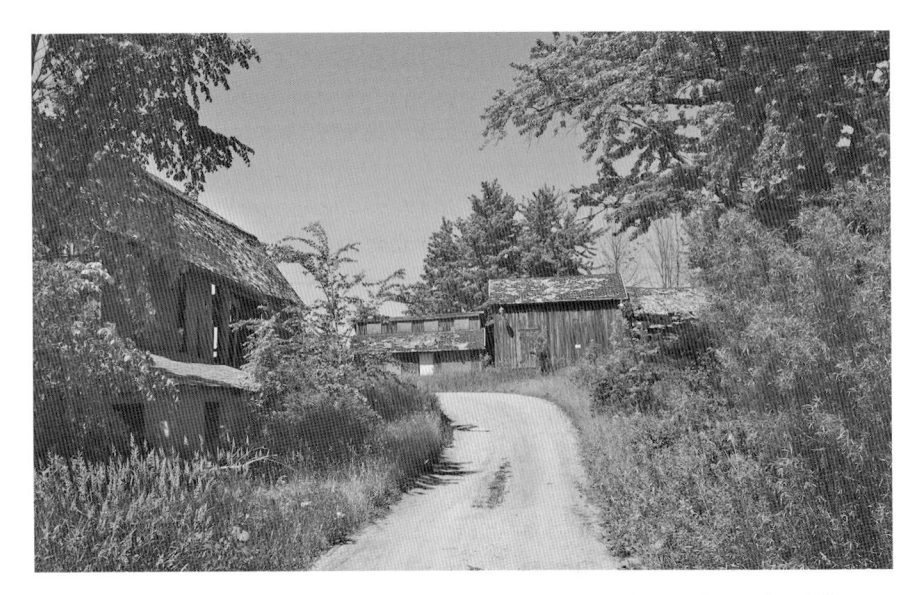

A trail leading to abandoned outbuildings on the Heidenreiter/Prange Farm. *Scott Wittman Visual, 2021.*

struck her. Eliza Prange was pinned underneath and died from her injuries hours later.

In 1992, H.C. Prange Co. sold to its competitor, Younkers, for $67 million, or the equivalent of over $127 million in 2021.

After moving onto the property purchased by his father in 1916, Otto Prange raised his family in the brick house built by Joachim Klocking in 1877 and tended to his cattle in the barn built by Ernst Heidenreiter in 1899.

The farm was also quite well known in the area for hosting social gatherings, as told in the May 15, 1950 edition of the *Sheboygan Press*: "Tuesday afternoon, Mrs. Otto Prange entertained members of her birthday club at her home on Route 2, Sheboygan Falls. Sheepshead was played and later a potluck supper was served. The celebrant received a gift from the group."

It was also the scene of their daughter Vernette Prange's wedding to Leslie Nysse on April 22, 1944, when a dinner was held for fifty guests and a reception for eighty, as well as Otto and Erna's golden wedding observance on May 10, 1964.

Otto Prange passed away in the home at 85 years of age in 1972. His son Harley then operated the farmstead on which he was born and lived all 73 years of his life until his death in 1990. As Harley Prange was unmarried and childless, the 115 successive years of dairy farming on the homestead ended with him.

A public auction was held several weeks after Harley's death, dispersing generations of artifacts. From the posting in the September 19, 1990 *Sheboygan Press*:

> **Sale Schedule:** *We will start at 10:00 a.m. on all small items mixed w/antiques, then household. About noon shop tools. Next corn crib, silo, barn cleaner, old bulk tank w/compressor. Then on to machinery about 1:30 to 2:00 p.m.*
> **Auctioneer's Note:** *Due only to the death of Mr. Prange will we sell all these items. Be there at 10:00 a.m. to help clean out the sheds and attics. Many small items. Machinery is in useable condition. "Be on time."*

The long, slow descent into decay for the farmstead commenced. If able to look through the neglect and dilapidation, as if peering at it through the lens of a Georgia O'Keeffe painting, one can still feel the energy of those who lived and loved there, of those who were born and died there—the joy of weddings, jubilation of birthdays and anniversaries and sadness of loss and grief.

The property sat empty for several years and was then purchased and turned into a Halloween-themed haunted house, advertised in the *Sheboygan Press* in 2000: "Creep your way through an authentic turn-of-the-century farmhouse, two barns and a warehouse. Realistic special effects and state-of-the-art sound systems. Voted '1999 Scariest Haunted House' in the state by the *Milwaukee Journal Sentinel*."

THE UNGRATEFUL FATE SUFFERED by this farmstead is unfortunately not unique.

Attempts to locate the lands of Sunny Peak Farm today find it was eventually sold to the state Highway Commission and is now hiding under a Brookfield country club and recently built subdivision off Interstate 94. Adda Howie's name has certainly become less recognized today than in her time. As the dairy industry grew, the credit given, as in most industries, was predominantly male-orientated, while female contributions were given less attention or even denigrated over generations.

THE SUDDEN, UNEXPECTED ASCENT and then slow, excruciating death of the heritage of family dairy farming in Wisconsin is well illustrated by Sunny Peak and the Klocking/Heidenreiter/Prange residence. Maybe it was even predictable.

Perhaps Abraham Lincoln himself, when beginning his closing statements to his speech at the 1859 Wisconsin State Fair witnessed by W.D. Hoard, foreshadowed this very struggle:

> *I will detain you but a moment longer. Some of you will be successful, and such will need but little philosophy to take them home in cheerful spirits; others will be disappointed and will be in a less happy mood. To such, let it be said, "Lay it not too much to heart." Let them adopt the maxim, "Better luck next time"; and then, by renewed exertion, make that better luck for themselves.*
>
> *And by the successful, and the unsuccessful, let it be remembered, that while occasions like the present, bring their sober and durable benefits, the exultations and mortifications of them, are but temporary; that the victor shall soon be the vanquished, if he relax in his exertion; and that the vanquished this year, may be victor the next, in spite of all competition.*

AUCTION

Farm Machinery, Antiques and Some Household

Sat., Sept. 22 — 10:00 A.M.

Harley Prange Estate
R. 1, Sheboygan Falls, WI

R & W Lunch on grounds

Location: 7 miles west of Sheboygan on Co. Trk. O. First farm west of the airport. Or north of Plymouth on Hwy. 57 to Co. Trk. O, then east 5 miles on Co. Trk. O to farm (next to airport). Watch for auction arrows.

Machinery: 5 tractors. Int. 756 D (German) tractor w/ Koehn cab, 2800 hrs., new radial rubber, 3 pt., hyd., ex. cond. Int. 560 gas tractor, NF, fast hitch, new rubber, runs ex. Int. 300 gas tractor, NF, good rubber, works real good. Int. M tractor, NF, w/hyd. loader, 2 buckets and chains, needs tires and paint but runs real good. Co-op tractor, NF, good running condition (Nearly Vintage). New Idea #325, 2 row narrow corn picker, 12 roll bed in ex. cond. Kewaunee 15' hyd. wheel disc, big blades, heavy duty, ex. Int. 14' Vibra shank digger. Case 12' hyd. wheel disc. Int. #540 4 — 16" trip bottom semi mtd. plow. Int. #56 4 row narrow corn planter w/fert. and insect., real good. 18' hyd. lift springtooth on cart, good cond. Int. 7' 2 pt. mower. New Holland #23 forage blower, Cardinal 20' single chain elevator on transport, very nice. Little Giant 36' bale elevator w/spout and motor, real good. Int #540 pto manure spreader w/pan. MM 10' dd grain drill w/grass, clean. 4 gravity boxes w/ wagons, all very nice, 1 w/auger. 3 green trailer. Case 2 wheel pto grain cart. 4 sec. springtooth. 3 sec. land crusher. 4 bar steel wheel rake. Int. 2 pt. 3 — 14" mtd. plow. Int. #76 pto combine. Rex forage box and wagon. 12'x4" Mayrath auger w/ motor.

Special Items: 1984 Chev Celebrity car, runs good, looks good. 1971 Chev Custom 10 pickup truck, runs good, needs some repair on body.

14'x40' cement stave corn silo (to come down). 3 sec. Welsh corn crib. 5 1100 bu. round cribs, 2 just like new (to be moved). Overhead gas tank w/stand. Badger barn cleaner w/about 200' of chain, chain good, unit as is, clockwise. Old bulk tank.

Shop Tools: Complete shop. Grinders. Vises. Benches. All tools, etc. Wagon load of real good tools will be sold about noon. Many wrenches and hand tools. Lots of chicken equip.

Antiques: Old cooker kettle w/jacket. Old shovels, forks and hand tools. 1 row corn planters, Kerosene heater. Large old kitchen stove w/chrome & decorative front. Milk and cream cans. Drive belts. Few crocks. Platform scale. Horse harness parts. Old wood bedroom set. Very old metal chandeliers. Old large concrete flower pots. About 20 lightning rods (complete) still on buildings, sold as is. Many, many small items found on a farm of this age. Many boxes of toys and games collected in the attic. We didn't go thru all these boxes, there will be surprises for everyone.

Household: Co-op upright freezer. Hotpoint refrigerator. Whirlpool 4 burner electric stove. Some smaller household items. Very nice metal safe.

Sale Schedule: We will start at 10:00 a.m. on all small items mixed w/antiques, then household. About noon shop tools. Next corn cribs, silo, barn cleaner, old bulk tank w/compressor. Then on to machinery about 1:30 to 2:00 p.m.

Auctioneer's Note: Due only to the death of Mr. Prange will we sell all these items. Be there at 10:00 a.m. to help clean out the sheds and attics. Many small items. Machinery is in usable condition. "Be on time".

Terms: See cashier 48 hrs. BEFORE sale if credit is desired.

Harley Prange Estate, Owners

Mrs. Vernette Nysse, Personal Representative

O'Brien Bros., Auctioneers Jim — Pat — Bill

John Diedrich, State Bank of St. Cloud, Cashier

Phone 414-999-3563

Leo Murphy and Dan O'Brien, Clerks

PAT
Ph Eden
477 2871

O'BRIEN BROS.
AUCTIONEERS — EDEN, WI
In the Garden of Eden

JIM
Ph Eden
477 6327

Member of State and National Auctioneers Associations

Clip and Save

Box 153, EDEN, WISCONSIN 53019

Leo Murphy and Bill O'Brien, Clerks

September 1990 auction posting for Harley Prange farm. *From the Sheboygan Press.*

Chapter 2

GHOSTS OF THE NORTHERN HIGHLANDS

Northern Wisconsin in the twenty-first century is well known as an outdoor enthusiast's vacation destination. With hundreds of thousands of acres of pristine forests and well-maintained waterfront along the shores of seemingly endless rivers and lakes, the landscape can evoke the romanticism of simpler times, where one can unplug and reengage with all that nature has to offer. A popular resort area now, this land, which was once a mountain range rivaling the Rockies but eventually was leveled by the glaciers into virtual flatland, has endured more transformational changes—geographically, socially and economically—than any other area of the state.

As America began to build many of its great cities in the early nineteenth century and then reconstruct itself after the ravage of the Civil War, the virgin timber forests of northern Wisconsin were transformed into vital assets for its lumber. The appetite of logging companies was unsatisfied after the forests of the eastern and middle Mississippi Valley states were devoured, and the push farther west required another donor of resources for wood and building materials, turning the lumbermen's attention to the Great Lakes region and, specifically, northern Wisconsin. The vast majority of the original lumber kings of the Northwoods learned the trade in the forests of New York, Vermont or Massachusetts and were enticed to the region by newspaper advertisements inviting them to continue making their fortunes in the Wisconsin pineries after the forests in the East were used up.

Looking across a stump field left from logging in the "cutover" of northern Wisconsin, 1916. *Courtesy of UW Digital Collections, public domain.*

Aided by the glaciers pummeling the soil into sand over thousands of years, which was conducive for the spread of white pine, the crown jewel of the forests in the eyes of the lumbermen, the region entered into its first population boom in the mid-1860s. By the turn of the century, Wisconsin was the world leader in lumber production, with an annual harvest of over 3.5 billion board feet of lumber produced.

Sawmills, woodenware factories, company stores and boardinghouses were built up all throughout the Northwoods, and full communities were created as Wisconsin lumber was utilized all around the nation as its destiny manifested west. In lieu of an actual search for appropriate names for many of these burgeoning towns, they oftentimes simply took the names of the lumber barons who created them, such as Hayward, Bruce, Sherry and Weyerhaeuser, whose namesake, Friedrich Weyerhaeuser, was the "Timber King of the Northwest" and eighth-richest American of all time.

Over time, hundreds of these lumber towns sprang up throughout the Northwoods as logging became the largest economic driver of the state. Despite warnings to the contrary from conservationists at the time, it was said repeatedly by lumber companies and promotors that the white pine and later hardwood forests of Wisconsin were "inexhaustible." The *Wisconsin Lumberman*, an early newspaper of the pineries, claimed, "The vast Pine Regions of the Upper Wisconsin river and its tributaries afforded means of subsistence to thousands of people. The resources of these Pineries, although

drawn heavily upon for a series of years, are not exhausted, and are about inexhaustible. Indeed, they have not, as yet, been fairly developed."

Eagle River was touted as being "surrounded as it is by an almost inexhaustible amount of pine" by the *Montreal River Miner and Iron County Republican* of Hurley in 1887. An executive of what became the Chippewa Lumber and Boom Company in 1875 proclaimed, "Our company owns or controls an almost unlimited extent of pine lands all the way to Superior. To cut it all will be the work of hundreds of men for the next 100 years."

To cut the entire northern third of the state, it took them barely twenty-five.

The landscape they left behind, however, was something akin to a warzone and was compared to exactly that by those who had returned from scourged battlefields in Europe. "Slash," the cast-off and unwanted debris left after logging, covered the region. The tops of trees, mangled and intertwined branches, broken tree trunks and even felled trees that for some reason were never recovered buried the forest floor between millions of stumps still rooted into the ground. That bed of tinder only compounded the intensity of the myriad conflagrations in the Northwoods, often turning what used to be endless rows of 180-foot-tall white pines into seas of blaze orange. In fact, the *Wisconsin State Forester* noted in 1908 that less than 40 percent of the "once magnificent forests of northern Wisconsin were ever utilized," due to the rest being burned up in fires fed by slash before they were ever able to be harvested.

The March 1931 edition of the *Research Bulletin* published by the Agricultural Experiment Station of the University of Wisconsin–Madison, regarding forest protection, noted:

> *From the standpoint of damage, slash stands at the top of the list of fire hazards. The intense heat of slash fires will usually kill all remaining trees and young growth.*
>
> *Thus, not only is the forest severely damaged, but the dead and falling trees, and the grass and weeds which come in, create a further fire hazard so that not uncommonly such areas burn over repeatedly until the land is practically a barren waste. The first slash fire which changes the natural forest to a weed patch of brush, aspen and cherry, and paves the way for further fires is a real catastrophe. It may require generations to build up the soil and reestablish a forest of desirable species.*

Between 1870 and 1930, during the height of the logging era and well past, upward of 2,500 fires burned in the Northwoods, scorching a half million acres—every year. One of those, occurring on October 8, 1871, and

known today as the Great Peshtigo Fire, is still the worst wildfire, in terms of lives lost, in American history.

"Warzone" seems appropriate.

HAVING DRAINED THE LANDS of their usefulness, timber companies were now restless to unload their holdings rather than be saddled with tax bills on land they no longer could reap benefits from.

As the myth of the "inexhaustible" Wisconsin forests was fading and the yet unsatisfied appetite of lumbermen moved farther west and south, a new illusion was in the midst of creation. It was one that would have to shape the perception of northern Wisconsin not as a barren, abused or fire-ravaged region but one whose fertile soil was ripe for cultivation, providing ample crops, "rivers of milk and lakes of cream." It was a designed allurement that would be hard for anybody to pass up, especially if they didn't know any better. This recruitment endeavor would need an all-hands-on-deck effort to achieve, and lumber companies, railroad tycoons, land speculators, immigration agents, loan officers, social scientists and the College of Agriculture at the University of Wisconsin were all ready to do their part.

Hiding in museums and libraries throughout the state, the remnants of that effort can still be seen in the form of promotional brochures and booklets utilized to make the case that northern Wisconsin was on the cusp of becoming an agricultural utopia at the turn of the twentieth century. In these small pamphlets, or "handbooks," yellowed now and fragile to the touch, were the words and pictures that would convince both foreigners of faraway shores and first- and second-generation Americans that farming here was your best bet to grasp the American Dream.

They were produced and distributed by the newly formed Wisconsin State Board of Immigration, railroad companies and land speculators. They would show up at fairs and Farmer's Association meetings, brought by immigration agents and representatives from the College of Agriculture. They painted the notion that your best life was right in front of you; all you had to do was come to the vast former timberlands of northern Wisconsin.

The Wisconsin Central Railroad, which called the Northwoods "The Place for Dairying" in its promotional booklets, also apparently believed deep freezes and a short growing season were of no issue, as it boasted, "The timberland farmer has escaped prairie plagues, such as drought, grasshoppers and cyclones, and has lived in a climate which has no superior in the world for healthfulness." It printed letters said to be from satisfied local farmers

who spoke of the soil as "all that can be desired, "the best" and "about the best in the country." It gave specific attention to four counties—Price, Taylor, Ashland and Iron—as "better in quality of land and in resources than any other four counties in the state." They were, conveniently, the four counties the railroad ran through.

In 1895, the dean of the College of Agriculture, William A. Henry, by direction of the state legislature, produced and authored *Northern Wisconsin: Handbook for the Homeseeker* to help encourage settlement of the region. In the summer and fall of that year, various representatives from the College of Agriculture and a professional photographer from Madison, H.J. Perkins, visited every county in northern Wisconsin to observe "the character and adaptation of the soil to agriculture." While doing so, "the herds and flocks of domestic animals wherever found were studied to ascertain whether farm animals would so thrive in this region."

Perkins's photographs, often staged, displayed timberland homesteaders in places like Sherry, Butternut, Grantsburg and Augusta. In them, the farmers are posing with their "prize-winning" lot of vegetables outside their newly built log homes and in their fields with crops almost taller than their heads. In what has become one of the more well-known images from the book, a group of men are standing in the farm fields of Edward Dascam, near Antigo, waving their hats in the air while only the tops of their heads can be seen over the six-foot-tall oats. There were photos showing silos, beautifully crafted barns with shorthorn cattle and Jersey cattle herds. There were photos of massive potato patches, mountains of harvested hay and large, brick farmhouses, dwarfed only by the larger cattle barns in the distance.

"After careful study of all the conditions prevailing in northern Wisconsin," writes Henry, "the writer of this article is firmly impressed with the belief that this will someday become one of the great dairy regions of America." He goes on to state why:

> *First of all there is that prime requisite for fine butter and cheeses, namely in ample supply of pure cold water, everywhere accessible. Northern Wisconsin is unexcelled by any region in the great abundance of pure cold water in her thousands of lakes, her many rivers, brooks and springs; indeed the water supply will meet the requirements of the most exacting in its quantity, prevalence, purity and coolness.*
>
> *The second requisite is an abundance of wholesome stock foods, in good variety for summer and winter feeding. In summer time the dairy cattle of northern Wisconsin will find in its pastures the finest of grasses and*

clovers, for the cropping. Red and white clover flourish, and timothy and blue-grass pastures are as prevalent and productive as anywhere further south. The pasture season for cattle is not so long in the far north by about one month as in the extreme southern part of our state, but while they last, these pastures are not excelled by those in any other part of the country, as we have ascertained by careful, close study of the turf of this region.

As for rumors of the "alleged difficulty of dairying" in the north due to its cold winters and short growing season, Henry writes, "This objection is really not a serious one." Rather, he notes:

It is a well-known fact that people living in the northern part of the United States usually suffer less inconvenience and pain from cold than those living at the south, because the northern people expect cold weather and are prepared for it, while at the south the houses and clothing are arranged for warm weather conditions and not for the cold waves which occasionally come and bring intense suffering.

Fifty thousand copies of *Northern Wisconsin: Handbook for the Homeseeker* were distributed in English, German and Norwegian, along with tens of thousands more scaled-down brochures and "promotional cards," similar in size and appearance to postcards. One such promotional card included a photo of a homestead family, the Kohlmans, outside their house. The husband and wife are sitting comfortably in separate chairs, their child standing close by. The caption under the photo reads:

Home of Chas Kohlman. near Butternut, Ashland County, Wisconsin.— In looking at this picture one cannot help being impressed by a certain air of prosperity and contentment which it suggests. This family made its beginning upon their land several years ago having no money. The fertility of the soil and the good prices which prevailed made it possible for them to pay for their land and improvements thereon, and to accumulate some stock and other personal property. In the winter time Mr. Kohlman found it profitable to sell wood from his land to charcoal kilns at Butternut. He not only sees a profit in farming, but also makes a good thing from his timber.

The backside of the card then appealed to a person's desire for freedom and autonomy, to be outside the reins of landlords or creditors or kings of overreaching governments:

Count your pennies to be sure, but it is perhaps more to the point to place yourself in a position where you can count out to yourself and not to your landlord or some other creditor. A man of limited means cannot, in these times, farm high priced lands and make annual profits. Usually the balance is on the other side. The amount of one year's rent in the old established districts will buy a beautiful piece of farming land in Taylor, Price, or Ashland Counties, Wisconsin. These lands are timbered with the finest growth of hardwood and hemlock, all of which is salable. The soil is of the best in Wisconsin. Good neighbors, good schools and church privilege.

Newspaper ads ran throughout the country in German-language periodicals. Land agents who could speak Slovak, Hungarian and Bohemian were in high demand. The American Immigration Company ran boisterous ads in newspapers touting land in the Town of Round Lake, in Sawyer County, headlined, "Farmers Rush for Homes in the Round Lake Country":

Within a few miles of Round Lake there lies a vast tract of almost half a million acres of cutover timber land. The American Immigration Company have recently taken over this tremendous block of land and have opened it to settlement. Farmers are flocking by hundreds to this new country, for nowhere in the United States is there such an opportunity to secure the real advantage of pioneer work with so few disadvantages as at Round Lake.

This land has never been farmed but has lain for centuries untold under the leaves of the forest. Beyond doubt it is the most fertile land in the middle west.

Pretty convincing, no doubt, to an immigrant farmer, many of whom were ex-soldiers from European armies escaping a war-torn continent, looking for their own land to settle—a place to finally call their own, farm and raise their family. Convincing, especially coming from the American Immigration Company, whom they believed would help them obtain the resources needed not just to maintain in this new world but to succeed.

Even through the rose-colored descriptive language about the fertile land, nutrient-rich soil and freezing winters being apparently no big deal, there was some of the hardships of the cutover foreshadowed in the promotional literature, and some even the lens of H.J. Perkins couldn't hide.

The millions of stumps left from logging simply couldn't be avoided by the land-sellers. They were shown in the photos, and even on land that was purchased sight unseen, which there was plenty, the purchaser knew they

were present. In some instances, competing land dealers would offer services clearing a portion of the stumps and slash on the land as perks to procure buyers, but more often than not, the buyer was left to problem solve that on their own. Dynamite was often utilized by farmers to blast the stumps loose. Newspaper accounts of the day were riddled with horrific related accidents, injuries and deaths.

Also unavoidable in Perkins's photographs are the stoic faces of the settlers in the cutover. Contrasting starkly with their clothing, as many are dressed to demonstrate clearly well-to-do status, their emotionless faces seem somewhat disconnected from the scene. The photos display such an odd divergence of composition, as the farmers stand touting their success, but their faces exude the toil and labor needed to reach it. The faces almost warn the prospective homeseeker that nothing would come easy

Still, all that advertising of cheap land had an impact. The northern eighteen counties of Wisconsin, which make up a third of the state's land, contained only about a tenth of its population in 1900 at just over 200,000 people. That number catapulted by 1920, when it stood at over 320,000, a quarter of whom were foreign-born.

The newcomers of the time witnessed a much different environment than today, so much so that it's difficult for a modern perspective to envision. The forests were gone. In their place was a seemingly endless network of contorted limbs decorating every 40-, 80- or 160-acre plot like sculptures

"Stump land" on a cutover farm, circa 1895. *Courtesy of Rusk County Historical Society.*

spiraling from the earth, their broken bases often upward of six feet in diameter. The communities built by the lumber camps—their mills, general stores, post offices, boardinghouses, warehouses—were empty.

Whether arriving straight from the old country or having worked for several years trying to build money in southern Wisconsin, Illinois, Minnesota or Iowa, the new arrivals were now neighbors, having to form new communities, being largely left to their own devices, as the land agents didn't always follow through with their many promises. Rumors of unethical practices by two of the largest brokers in the area—James L. Gates (not-so-affectionately referred to as "Stumpland Gates"), a middleman speculator who sold over 456,000 acres of land in the cutover, and the American Immigration Company—slowed land sales in the region, causing sellers to increase provided services to assist buyers in starting their farms. A 1950 audio recording of an interview with Michael Beaudoin, a former employee of the Edward Hines Lumber Company, gave insight into this effort:

> *We were quite successful in bringing in settlers, farmers who were on rented lands in Iowa, Indiana, Illinois, in fact before long, say four or five years, we had settlers from mostly every state in the union. We encouraged these people and helped them develop their lands, and in many ways watched their progress.*
>
> *The land-clearing problem was a large one, and we employed an agricultural advisor who understood the clearing of land. We spent considerable money in experimenting and land-clearing machinery, and brought in carloads of dynamite and other large machinery: stump pullers, tractors, and so forth. These lands were sold to these people on very easy terms, generally ten years' time, with a small down payment.*
>
> *We also purchased cattle, and one thing we did insist, is that was the settler had feed enough to take care of his cattle before we would finance him to any great extent in the purchase of his cattle. We purchased purebred bulls. Some areas of the settlement were partial to Holsteins, while others were partial to Guernseys. There were a few Ayrshires. But in every case, we purchased purebred bulls, registered, and stressed the point that the settlers would develop paying herds from [them].*

"I always say—those pliers there," the farmer said to me, pointing to the old hand tool on the table, "that's what made farming out of the cutover land."

Even to a greenhorn laborer like myself, the vintage gadget was clearly not your average pliers. It had what appeared to be a crimper jaw on one

J.L. Gates Land Co. would run promotions attempting to entice prospective buyers to fill up passenger trains such as this one and purchase cutover lands in the north, circa 1910. *Courtesy of Rusk County Historical Society.*

end with another cutting notch on the side of that, with two different-shaped handles.

"How many things did this do?" I asked, intrigued.

"Well, it cut off the dynamite fuse. And then it crimped the cap onto the dynamite fuse. And the one handle there—it's kinda round and smoother…" His weathered and over-worked hands tremored a bit as they gestured toward it. "That poked down into the stick of dynamite to put the cap and fuse into it."

Over 125 years after the publication of *Northern Wisconsin: Handbook for the Homeseeker* and the unleashing of other propagandistic recruitment tools used to settle the region, I was in the Northwoods in search of an aftereffect. The residue of a vision orchestrated and carried out by those who never had to live it still clings, albeit with a weaning grip, to a landscape slowly returning to its natural self.

Standing in the old ballroom of the 1921 former Catawba Town Hall, now the home of the Jump River Valley Historical Society, Sherburn Mabie

is a descendant of cutover farmers. Small in stature, he's a quasi-expert in old machinery and vintage general tools. He's also a retired dairy farmer, as his father was before him, and so on and so on.

"I'll be eighty next week," he says as he moves on from the dynamite pliers to an eleven-by-fourteen-inch black-and-white overhead photograph of his dairy farm from the mid-1980s. "My first job was hauling canned milk."

"Where to?"

"Where did I…that was so long ago…" He looked at the floor, stumped, but only for a bit. "Zorn's! That was it." Zorn's was one of numerous cheese factories in the area for a time. The building is gone, the lot it sat on now strewn with empty trailers.

"I had fifty milk cows in the main barn. And then the loafing shed—that's out on this end over there—there'd be about forty in there." A finger from those same hardened hands gently roamed the glass of the framed print as he explained to me the layout of his farm. "And then the calf barn would've had another twenty head. That's over here. That was my wife's barn. She took care of the calves."

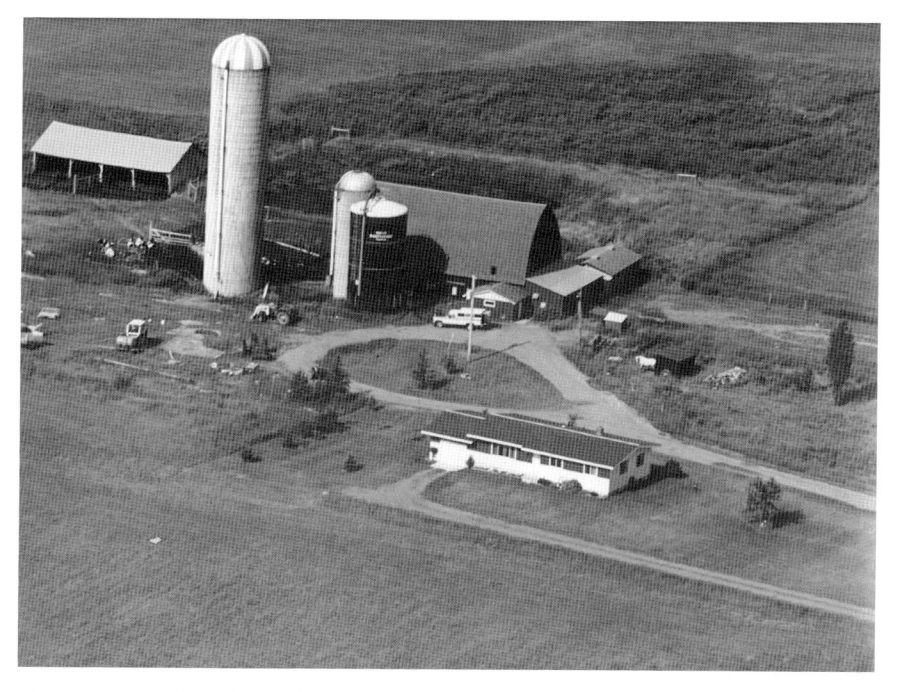

Overhead view, circa 1980s, of Sherburn Mabie's farm, Price County. *Courtesy of Sherburn Mabie Private Collection.*

The Mabie family moved into Kennan, Price County, Wisconsin, in 1919 and included Sherburn's father, Lester, at that time just a teenager. Lester's sister, Hazel, would eventually meet a young sawyer in the logging camps in Kennan and nearby Hawkins named Herman Seegar, a first-generation American whose parents emigrated from Germany. Herman served in the U.S. Army during World War I in Germany and France, and upon his return, he and Hazel, now his wife, dairy farmed in Kennan. By 1965, when Herman and Hazel were looking to sell their farm, Hazel's nephew Sherburn took it on.

"I wanted to live in this area," Sherb explained. "Pretty much all jobs around here, like Hawkins Sash and Door, that was all part-time work. I spent time on the farm growing up, and I wanted to stay here. So, my uncle was looking to sell…" he paused, almost second-guessing himself almost six decades later, "and I bought."

THAT SENTIMENT WAS LIKELY shared a century earlier by the homestead farmers who were lured to the cutover. Far too many were settled on land that was simply unsuitable for agriculture. The land had just been drastically altered by commercial logging and its related activities, though it was much too soon for science to discover that it was in such a cataclysmic way. This is not to assume ignorance of this subject on the land-sellers, as they were quite aware. Land speculators oftentimes would only offer land in large, multiple forty-acre swaths that they knew had mixed value, as in a "take the good with the bad" sale.

Even those who were able to pay off their initial land contracts often were unable to improve their farms, as capital from cash crops was virtually unattainable. Some were able to find work off the farm, mostly in residual logging operations still occurring in the area, though those were short-lived. Bills went unpaid. Taxes went into delinquency.

Some held on. Many more left. Others, quite simply, were stuck.

"THERE WEREN'T THAT MANY places for anybody to find work around here. You graduated from high school and then you left." Alan Larson, a descendant of Norwegian immigrants who came to the cutover in search of their own land, dairy farmed in Price County until the mid-1980s. Many of the experiences of the more recent farmer echoed those of their forebears.

"My dad came out here with my grandfather from the Minnesota/Dakota border when he was twelve. My grandfather wanted his own land, and there was cheap land here. So, he bought eighty acres, and he found out why it was cheap. Lots of rocks. He looked it over in the winter. Didn't know there was a whole corner that was a swamp."

Land-sellers often showed their plots to prospective buyers in the wintertime, snow-covered, to hide the blemishes of the terrain—its warts, pimples, stumps, slash and, apparently, swamps.

"Every year you got a new crop of rocks. You didn't even have to seed it," Larson joked, only partly in jest. "By the time my grandfather had been here two years, he decided he wanted to go back. He built the barn, paid cash for everything, but he couldn't get his money back. He put the barn up in '26, and not by professionals. By my relatives and neighbors. They just slapped it up."

He, too, shows me an overhead of his farm, circa late 1970s. "I was born right on that farm. The house is torn down now. The old barn is sagging every which way. Hasn't had any cattle in it since the late 1980s."

I took note of the verb he used: "slapped." He meant it in a way to describe doing it quickly and conveniently, with not as much craftsmanship as a professional likely would have. The word was not lost on me, as something that was "slapped up" by farmers in 1926 has been standing through ninety-five northern Wisconsin winters, tornado seasons and dry summers.

Alan's father eventually met his mother, who was from the area. "This area really started developing around 1920. You take a look at some of the old plat books, and a lot of these side roads didn't even exist before then. But my grandfather, he wanted out because he couldn't make any money here. He wanted to go back to the Minnesota/Dakota border, but then the war came, and he wound up getting TB. That was before antibiotics. Died when he was sixty-two. So, it never worked out the way he wanted it to."

This was true for many of the early settlers to the Northwoods, as much of what they were hoping for never came to fruition. The attitude of many of the land-sellers began to change as well, as there was a growing sentiment that the problems weren't necessarily with the land or soil but with the farmers themselves and their "ability to choose land wisely." Much more progressive tactics were proposed and put into place by speculators in what they believed were innovative methods to solving some of the problems settling the region. Some of the ideas included full-on, ready-made, created and designed, rural communities, federally regulated and corporately funded, for the homesteader simply to just move on in. One of these communities,

Circa 1970s overhead view of the Larson farm, Kennan, Wisconsin. *Courtesy of Alan Larson Private Collection.*

Present-day view of the abandoned dairy barn on the old Larson farm property, Kennan, Wisconsin. *Scott Wittman Visual, 2021.*

of which there were several, was Ojibwa, in Sawyer County, developed by land speculator Benjamin Faast. In his brilliantly researched book *Farming the Cutover: A Social History of Northern Wisconsin 1900–1940*, Robert Gough describes it as follows:

> *In early 1917, Faast's Wisconsin Colonization Company assembled about fifty thousand acres in southern Sawyer County. The centerpiece of this development was the village of Ojibwa, on the banks of the Chippewa River, laid out by University of Wisconsin professor, civil engineer, and town planner Leonard S. Smith, in consultation with the Minneapolis landscape and town planning firm of Morell and Nichols. The plan featured architecturally harmonious buildings in a style vaguely colonial-revival, with a radial street plan and careful adaptation of building and streets to local topography. Faast believed that maintaining such aesthetic values was important in making rural life attractive to settlers and keeping them on the land. In the country, the company sold 40 and 80-acre plots with houses already constructed for $25 to $40 an acre....The farmer began operation with a cow, some hogs and chickens and seed furnished by the company. Company representatives operated demonstration farms and gave advice to settlers. They organized contests with cash prizes to encourage farmers to clear land, and Faast lowered the balance owed him by settlers who met land-clearing quotas.*

Barely a decade after Faast's grand vision of a farmer's paradise began, it lay in ruins. Abandoned barns and empty houses littered Ojibwa, a result of Faast's own business dealings and lack of capital. Again, lured by promises never kept, the farmers were on their own.

For those who did find success farming in the cutover, as much as the luck of settling on suitable soil was a part of it, so was a decision to prioritize dairy. As production of dairy was mainly dependent on labor, as opposed to capital, it allowed the settlers to begin to financially recover by maintaining a profit. Expansion of commercial dairying also led to a rise in factory-produced cheese and butter, along with a market to sell to. High commodity prices during World War II finally made it possible for dairy farmers to improve their farms and increase their herds.

Eventually, due to the persistence of the dairy farmer, the landscape of the region began to come to life again. Dairy farmers pooled resources together and began cooperatives. Creameries and cheese factories opened, along with grocery stores, hardware stores, implement dealers, taverns and

A bed frame gate on a poverty-stricken cutover farm, northern Wisconsin, circa 1930. *Library of Congress.*

hotels. Communities once again began to rise from the ashes of the burned-over former forests of white pine.

"My grandfather Emil Koch, whose family came from Germany in the early 1900s, ran a cheese factory in Roseville, Minnesota." Bruce Koch is a bit of a cheese factory connoisseur in the area. "Then he came back to Wisconsin because there was land available here. A land grant tied to agriculture I believe. He bought two forties in the township of Wilson, Eau Claire County, and put up a factory there."

A cheesemaker himself, as his father and grandfather were before him, Bruce worked much of his life in the dairy industry. "I have pictures of that factory somewhere. There's no woods there whatsoever. It's all cut off. Had to blow out a few stumps, but all the trees were gone."

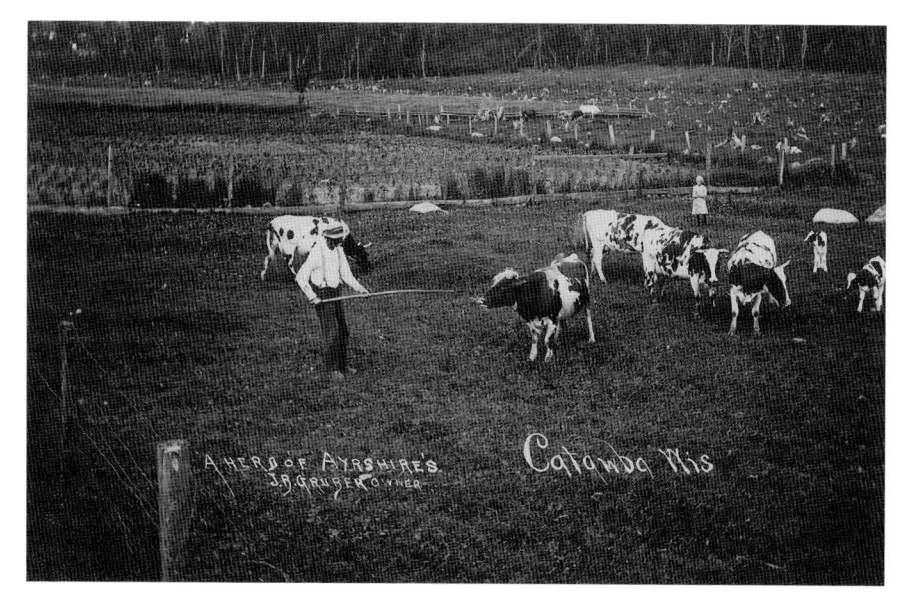

A dairy farmer in the cutover with a stump field in the background, Catawba, Wisconsin, circa 1930. *Courtesy of Jump River Valley Historical Society.*

When Bruce's father returned home from World War II, he and Emil purchased a cheese factory in Phillips, the Little Elk River Cheese Factory, where Bruce cut his teeth in the cheesemaking business growing up in the 1960s. "Everybody on every forty or eighty milked cows. We had 179 patrons at one time. The biggest one had probably twelve cans of milk. Our neighbor had twenty cows. That was a big farm back then."

Although it was obvious soon after the advertising-induced population increases of the early part of the century that farming would not be successful in the cutover, some dairy farmers were able to be the exception to the otherwise cruel realities of most.

"My dad was a dairy farmer. I got smart. I got the hell out."

Dennis Brayton grew up on a dairy farm, also in Kennan. On a sweltering July afternoon with temperatures in the mid-nineties, he and his wife, Beverly, the daughter of Bohemian immigrant cutover farmers, gave me a tour of the modern-day landscape of northern Wisconsin.

"We graduated from the same high school in 1965. I wrote in her yearbook that if there was any girl I wanted for my wife, it would've been her. I wound up in Kansas for a while after I got out of the service. Ended up getting

married down there and then divorced down there. Had a son. He still lives there now. When I got back here, almost ten years later, she was still footloose and fancy-free, and the rest is history. Forty-seven years this year."

We pulled up to an old rust-red brick building with obvious add-ons covered in cream-colored, corrugated aluminum siding.

"This here is the old Liberty Cheese Factory." The building sat empty with overgrowth protruding through cracks in the wooden, paint-chipped doors. Glass was heaped in a pile after having fallen, or being busted out, from what was one of the side windows. A modest house also sat on the lot, unlived in but apparently owned by someone outside the area.

"This is the factory my dad used. I lived right alongside of it, here." He pointed to the field adjacent to the building. "Right up 'til I left to go to the service."

Dennis narrated what he saw every day, approximately sixty years ago, as we circled the old factory.

"There was a whey tank on the side of the building here, and they drained the whey out over there where that larger patch of grass is down there. That was a pond. They called it the whey pond. We skated on it every winter.

"Now over here, you'll see the cement stand. They filled that whey tank up every day, and it would be drained every afternoon at four o'clock. There

Liberty Cheese Factory, abandoned since the mid-1980s. Price County. *Scott Wittman Visual, 2021.*

"These were all farms. All of this." Price County. *Scott Wittman Visual, 2021.*

used to be a door where that cement slab is there, we used to drive through—when I first started, I came down here with a team of horses pulling a wagon behind full of milk cans. There was a roller system here, and you'd throw the cans off the wagon onto the roller system. He'd weigh the can—each farmer had his own number—that's how he knew which farmer you were. Each of those cans, they held eighty-five pounds of milk."

We pulled out of the old parking lot where weeds were living in the fractures in the blacktop and slowly started down the county road on which he grew up.

"This land here, this was all my folks' land. Our house used to be back there by the lilac bushes. It's all gone now."

He went on naming the ghosts of his childhood, designating each vacant plot of old dairy farmland with a tap of his finger on the passenger-side van window.

"That place there, that was Bill Tewbs's place. That was all cattle over there. This was the Bushmans'. This was the Kellys'. That was Otto's…"

He gestures to the emptiness. "These were all farms. All of this."

BEVERLY'S FATHER, GEORGE KRALICEK, came from Czechoslovakia with three of his brothers.

"They came here because of the land they could get. Cheap land through different programs. There were twelve of them all together. They first came up into Racine and then made their way up here. This was a pretty big area for Czech and Bohemian people at the time."

Three-year-old Beverly Brayton picking mushrooms between stumps (*top*) with her father, George Kralicek, on their cutover farm, Price County, 1940s, and the same location today (*bottom*). *Courtesy of Beverly Brayton Private Collection.*

She showed me an old faded, black-and-white photo of herself at about three years old in a mushroom field with her father, picking them between the ever-present stumps. "That was a big deal in those days, picking mushrooms. People would come from way down south for those." It was imperative for cutover farmers to be on the lookout for every source of possible income.

"I helped with making hay, riding on the tractor, unloading hay, once in a while helping in the barn milking cows. That was all done by hand yet in those days."

She refers to the photo. "That was the pasture. That's all tall grass now. There's a few trees, but pretty much all tall grass. Some of those stumps are still there."

"Did he dynamite the rest to get them out?" I wondered.

"I would imagine so."

"Oh, I know he did," Dennis interjects. "I still have his old blasting caps. And I'm afraid to touch the damn things."

Beverly lives on the property still. "I had the barn torn down when I put up the new house because part of the side had blown in. The old house, the house I grew up in, is still there. Nobody lives in it. Now there's just a rented field behind it. Everybody around me used to farm, and now, in my township, there are zero dairy farms. None."

By the mid-1960s, it was becoming apparent that the dairy farmer, the rescuer of William Henry's turn-of-the-century vision settling the cutover, was in trouble.

"The Federal Department of Agriculture decided right about that time that dairy farms had to go big, and the demise of the small farmer began," explained Bruce Koch, who said that consolidation swallowed the little farms up.

Beverly Brayton echoed that thought: "A big turn happened when the milk haulers stopped coming to the small farms because they didn't feel they had enough milk anymore."

Small cooperatives or family-owned dairies and cheese factories were soon replaced by businesses like Kraft and Land O Lakes. "They didn't buy anything," said Bruce, referring to the larger cheese plants. "They just waited for the little guy to go out. The writing was on the wall."

Dennis's father held on until the late 1980s. "He was an Irishman. Only one of his family to farm. It just got to be too much for him."

Pieces of old equipment and machinery not used in decades, like this one on Sherb Mabie's farm, still decorate the landscaping of countless farm properties throughout the state. *Scott Wittman Visual, 2021.*

Sherb Mabie held on a bit longer but found himself in a similar situation. "My machinery—I made big investments in the late '70s, and my machinery was used up. I sat down and looked over everything, and I would've had to put about another $75,000 into the farm. We had two boys who were too smart to farm.

"It was just like....It finally hit me. I was milking about fifty cows, my wife and I. I came to the conclusion that I was too small to be a big farmer and too big to be a small farmer. Something had to change. So, I woke up one day and I said to my wife, 'You know, I'm scared to go another year,' and my finger found the telephone. We auctioned out the personal property and we stayed on the farm."

After selling his herd in 1995, Sherb was then faced with navigating life after farming.

"I started doing carpentry work, but I couldn't get a job. You tell them you're a dairy farmer and they say, 'Yeah, but what skills do you have?'

"I couldn't get an interview. Eventually, I managed to get into maintenance in the nursing home, and I did that until I retired."

SWEEPING OVER 1.5 MILLION acres in northern Wisconsin, the Chequamegon-Nicolet National Forest covers the lands once known as the cutover.

Barren ground, lying between millions of stumps and under fire-ravaged soil topped with bruised, hacked and disfigured tree limbs over a century ago, is now pristine new growth, restored by another hand-designed blueprint. A network of hundreds of glacial lakes, rivers and streams feeds wetlands, meadows and savannas of evergreens and spruce. Maple, ash, oak, birch and countless other species of trees rise, literally, from the ashes of an abused and neglected earth.

Officially two separate entities appointed into existence by presidential declaration in 1933, the Chequamegon and Nicolet Forests compose parts of eleven of the eighteen northern Wisconsin counties and have been managed as one national forest since 1993.

Among the more remote of the hiking trails that spiderweb the expanse of the forests is one that takes you along the North Country Trail and into the Marengo River Valley, seven miles northwest of Clam Lake. Traveling east from Forest Road 202, the 1,350-foot Juniper Rock Overlook offers a panoramic vista of the hardwood-hemlock forest below unseen anywhere else in the state. As you continue a mile farther, past a wooden bridge over the Marengo River, a peculiar scene begins to unfold. Stone and concrete foundations of a small community protrude from the brush trying to cover them, as if attempting to bury the memory that someone was once here.

A barn. A house. A school.

The ruins are from the farmstead of Gust and Ida Welin, Swedish settlers who claimed 160 acres here in 1902. The Marengo Valley was home to a small Swedish settlement that began about fifteen years prior to their arrival. Immigrants searching for a better life in America, they were promised a fairy tale. They were drawn to the Marengo River Valley for its rolling hills, reminiscent of their homeland and able to be seen now that the pines were down.

A crude log house was built initially by Gust, and improvements were made as time and capital allowed. The barn was built in 1917, the date inscribed and still visible on the northeast corner of the foundation, provided the dirt, weeds and thicket are brushed aside. It was large for a small farmstead. Gate notches for stalls to fit thirteen dairy cows are also still visible along the wall, a good-size herd for their situation, underlying the importance of dairy farming to survive. A concrete springhouse remains intact where the milk would have cooled in the summer months. Water from the spring, visibly active yet today, was fed to gutters along the barn for the cows. Cream,

which Ida separated from the milk, was brought to market in Grandview, a ten-mile walk through rocky, hilly terrain.

The house was also clearly added onto several times, partly for the reason to provide room and board for the teachers from the schoolhouse, on land that the Welins donated to build.

Subsistence farming fared no better in this small Swedish community than anywhere else in the cutover. The soil simply wouldn't allow for nutrient-rich crops to grow. Without a dedicated, dairy-to-market prioritization, these farmers, too, were wrecked, leaving to find opportunities elsewhere, anywhere—railroads, construction, road building, whatever they could find.

As a Depression was now looming, they couldn't find much.

The state could no longer avoid an obvious situation. The recruitment efforts of the previous three decades had led to an influx of poverty-riddled communities in the cutover. The farmers were poor, and the state was now facing the consequences of its push for an agricultural Eden in the north.

Many of the farmers were on state relief packages. Many had simply up and left, leaving the state and local municipalities with an even bleaker tax revenue outlook than when the farmers simply owed back payments. The farmers were also living in isolated communities, creating necessary expenses such as roads and schools in remote areas that current tax revenues simply couldn't pay for.

And conditions weren't going to improve. The soil, after being scourged by decades of logging and fire, simply wasn't conducive to growing crops, leading to questions of just how much the lumber companies, railroad companies, land speculators and the University of Wisconsin knew. Studies completed in recent decades have shown the soil in the northern eighteen counties to be 50 percent less conducive to farming than the rest of the state. How much the early century boosters knew is a legitimate question, but copious documentation demonstrates that their focus at the time was not on how their efforts would impact actual human lives.

Immigrants promised assistance by the American Immigration Company thought they would get the help they needed; however, the American Immigration Company actually had very little to do at all with immigration. The name of the organization, formed in 1907, was a strategic ruse. It was a union of nine lumber companies, all affiliated with Friedrich Weyerhaeuser, established for the purpose of selling off their remaining collective 500,000 acres of unsold cutover lands.

By the late 1920s, solutions were being looked at to combat the problem and zoning laws were enacted to discourage farming in the region, a

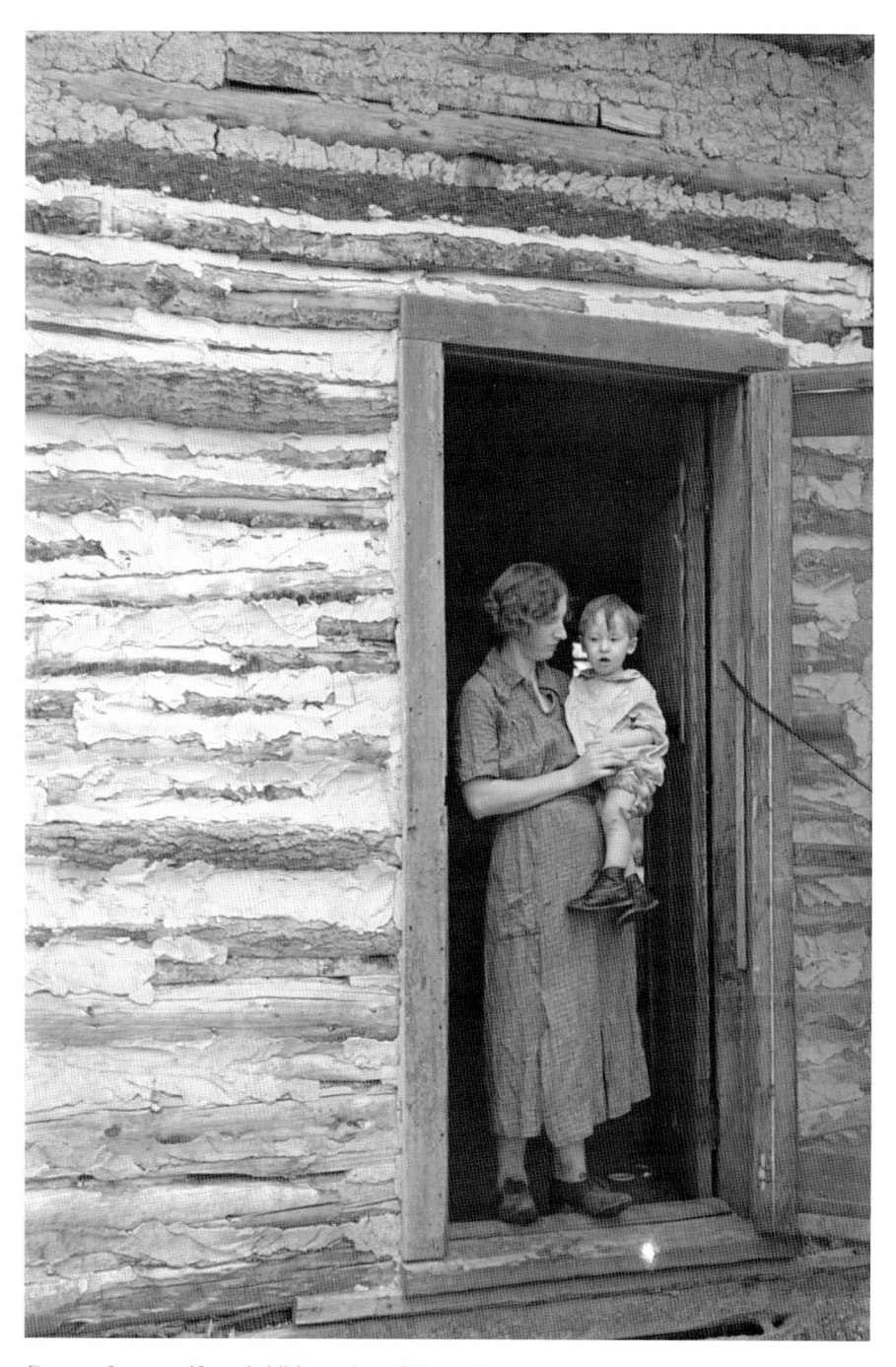

Cutover farmer wife and child, northern Wisconsin, circa 1930. *Library of Congress.*

complete flip from the state's position a generation earlier. The narrative of the best use of the region was now moved away from agriculture and onto tourism. Reforestation, it was decided, would be the goal of the cutover now.

Land that had been defaulted to the counties via tax delinquencies was sold to the federal government, which, in 1933, created the Chequamegon and Nicolet National Forests. Soon after, the state enacted various relocation programs to remove the settlers—the same settlers it had recruited thirty years earlier—off the land.

The abandoned Swedish settlement and the Welin farmstead are a reminder of what happened to those who came here looking for a better life. There are many more. Most do not have an interpretive sign or a National Scenic Trail running alongside. Most are no longer visible, lying in remote areas of overgrowth, their buildings and their stories hidden away in the forest—a forest seemingly created almost specifically for that purpose.

RUSK COUNTY, BORDERING PRICE County to the west, holds in its historical society archives a barn survey it had conducted in the early 2000s. The social media manager at the society, Lily Nichols, offered her experiences coming of age on a dairy farm in a dairy farming community.

"At that point in time, while I was growing up in Tony, [Rusk County] in the late '60s into the '70s, we had, I want to say about seventy farms. Now there are four." One is that of her brother, who still farms the land their grandparents bought in the early 1900s, taking over operations after their father passed. "He has fifty-two acres. About twenty cows. So, he's a small operation."

As part of a traveling exhibit by the Smithsonian titled "Barn Again: Celebrating an American Icon," which came to Ladysmith in 2003, Rusk County volunteers combed the area documenting, photographically as well as through oral history, the remaining barns in the county.

Presented in a binder, the Xeroxed copy of a picture of a large bow-roofed barn caught my attention immediately, as did the words of the former owner, Bernita Farley, accompanying the photo:

> *The original barn was log and was not large enough for our animals. Also, it was getting old.*
>
> *So, in 1949 we started building the new barn that now stands. Jarold and I did the footing all around the 32'X60' barn, which meant hauling a lot of rocks and gravel and mixing concrete.*

We hired a man to make the walls of concrete blocks, then neighbors helped put the hay mow and roof on. Jarold helped at Sarb's Sawmill up on the fire lane the winter before for lumber to build the top. Then a lot more cement work to get a floor done. Rocks were in plentiful supply on the farm.

In May 1961 or '62 a tornado blew the top off the barn so we had to put a new mow on. The field behind the barn was full of shingles and nails after the storm. Jarold placed a wood burning stove on his hayrack and pulled the wagon with a tractor. As debris was gathered, it was placed in the stove. Neighbors all came and helped clear the fields so we could make hay later. We surely appreciated their help.

This time, Jarold wanted a round roof covered with steel. We hired men who knew how to do that.

It's still standing but hasn't been used for livestock for several years. We retired in 1972 and moved to Ladysmith.

I drove the roads of Rusk County looking for many of these barns, most of them already in derelict condition when the survey was done almost two decades ago. Weyerhaeuser, Glen Flora, Dewey, Big Falls. Every village and township had them, many of them, at one time. Now, the ghost towns left after the exodus of the lumber camps have returned.

Abandoned gas station and general store in the returning ghost towns of the former dairy communities, Kennan, Wisconsin. *Scott Wittman Visual, 2021.*

Looking at the ruins of these wrecked farmers, pawned by various public-private programs designed by people who believed they knew better, people who set prices on their products, putting arbitrary value on their backbreaking work, I am struck, once again, by the words of Sherburn Mabie.

"I don't know if I should say it, but thinking back, I wish I hadn't farmed. My wife and I worked so hard at it. If we'd have put that kind of energy into most any other business, I think we'd have been better off."

Chapter 3

ECHOES OF THE DRIFTLESS

Walking through a mix of maple forests and open prairies in southwestern Wisconsin, Charles Shepard and his son, John, were heading into the unknown. It was a choice they made and were comfortable with, as the cause they were joining was worth, they felt, any loss.

The year was 1863, two years after the shocking fall of Fort Sumter in South Carolina to Confederate forces and the beginning of the American Civil War. At the time, President Abraham Lincoln requested a militia be formed by the remaining states of the Union, numbering seventy-five thousand men, and Wisconsin heeded that call. Alexander Randall, governor of the then-twelve-year-old state, issued a proclamation the very next day, in which he said, "For the first time in the history of this Federal government, organized treason has manifested itself within several States of the Union, and armed rebels are making war against it.…The treasuries of the country must no longer be plundered; the public property must be protected from aggressive violence; that already seized must be retaken, and the laws must be executed in every State of the Union alike.…A demand, made upon Wisconsin, by the President of the United States, for aid to sustain the Federal arm, must meet with a prompt response."

Within five days, twenty-nine volunteer companies had been formed throughout the state. Charles Shepard, forty years old as he walked with his seventeen-year-old son two years later, was unable to join the effort then. Not because he didn't want to, but because he was not allowed to. Charles

Shepard was African American and therefore prohibited from enlisting in the U.S. Army by federal law. Abraham Lincoln's Emancipation Proclamation of 1863 changed that, and Charles and John made the roughly thirty-five-mile walk to Prairie du Chien to enlist at Fort Crawford.

By this time, the war had been scourging the nation for two years. The dead numbered in the hundreds of thousands. Approximately one in four who left for the war never returned home. The conversations had between father and son on that walk one can only imagine.

What they did know, all too well, was what they were about to be fighting against.

Charles had been born a slave. Now, living as a free man in the North, he would possibly be sacrificing everything he had—his family, his freedom, his land and the farming community he helped found—in order for others to receive that chance.

Charles Shepard was enslaved, along with his family, in Fauquier County, Virginia, on a plantation owned by Sarah Edmonds. Freed in her will upon the death of Edmonds in 1848, the Shepard family traveled north, along with the grandnephew of Edmonds, William Horner, two years later. As a number of southerners were migrating north at the time due to rising tensions, the specific motivations of Horner to travel to Wisconsin are unknown, though the availability of fertile land is the likely reason, as the lead mining boom had largely passed by that time. Assistance in settling the land is undoubtedly what led to Horner offering the opportunity to the newly freed Shepards.

With Charles came his wife, Caroline, and their three children, along with Charles's younger brother, Isaac, and Sarah Brown, whom Isaac would later marry. William Horner purchased one thousand acres of rich farmland in Beetown Township in Grant County, on which the Shepards worked until earning enough money to purchase two hundred acres of the land from Horner, becoming the first African American landowners in southwestern Wisconsin. The land was on top of high ground, "which offered a pleasant view to all," leading to them calling their new community Pleasant Ridge.

In time, word got out about Pleasant Ridge, and the community grew. The Grimes family—Nancy, along with her children Thomas, Joseph, Henry, Martha and Nancy—arrived from Missouri with their former enslaver as well, William Ross. Thomas would eventually follow Charles and John Shepard in enlisting in the Union army, as would Thomas Greene, the son of John Greene, who arrived at Pleasant Ridge with his family after escaping enslavement in Missouri, via several stops along the Underground Railroad.

The farming community continued to build, cultivate and develop. Charles and Caroline Shepard would have seven more children born at Pleasant Ridge before Charles had gone off to war. Isaac and Sarah Brown-Shepard would have five children of their own, after Isaac paid $1,000 for Sarah's freedom, as she was still enslaved at the time.

Also still enslaved and remaining in Virginia were more members of the Shepard family, including Charles and Isaac's mother and other siblings. The will that freed the Shepards in Pleasant Ridge also stated that other members of the family could not be freed until reaching a certain age or level of maturity, meaning members of the same family were freed and enslaved simultaneously. Letters existing today illustrate the heartbreak this caused the family, separated by hundreds of miles. A letter to Charles from his sister, Elizabeth Williams, describes this:

> *I hope when these few lines reach you, they may find you enjoying the same good blessing. You cannot suppose, dear Brother, how much I have needed your presence here this winter, though I ought not to envy your happiness. Mother was in Warrenton [at] Christmas and the children will all be free at the expiration of this year. Emily is living with the same family that she was when you left. Ned, and Henry are living together with Faggins. Arche, and Bell are here living with me. Lucy also remains with me. They all expect to get their [freedom] papers next December.*

As the years went on, the letters began sounding more somber, and the family in Virginia started to believe they may be fading from Charles and Isaac's memory, as their brother Edward wrote, "We regret very much to think that we are forgotten by you. I have long hoped and wished to have been living in that happy land of freedom with you and wished to have done so, but the responsibilities that bestow upon me have thrown it out of my power." Later letters discuss efforts to hopefully join the brothers in Wisconsin and become more desperate sounding, asking for help from Charles and Isaac.

For reasons unknown, none of the members who remained in the South would ever reach Pleasant Ridge, and the family fades from history.

PLEASANT RIDGE, HOWEVER, CONTINUED to prosper, and by the year 1900, there were close to one hundred African American residents living there, with the Shepards, Greenes and Grimeses the patriarchs of the community.

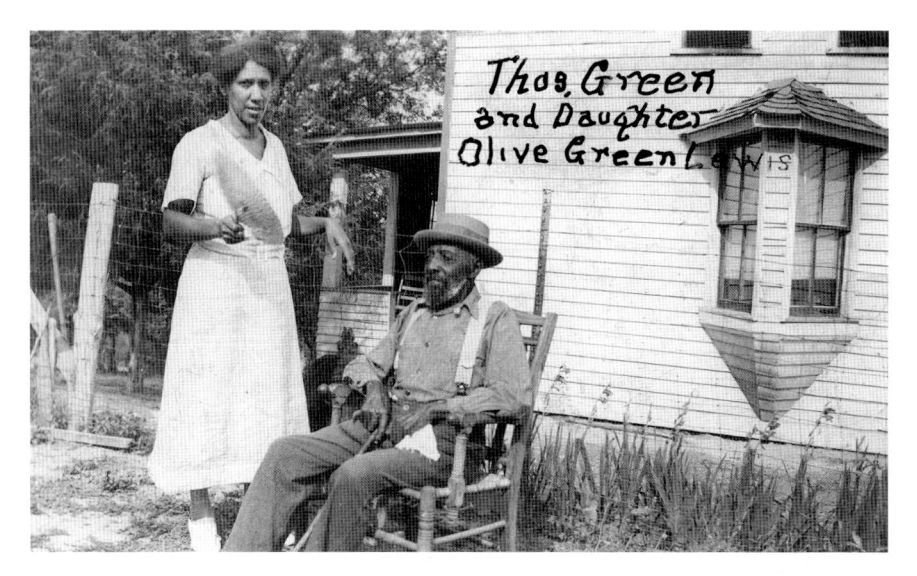

Thomas Greene and his daughter, Olive Greene Lewis, at Pleasant Ridge, circa 1920. Ollie Lewis was the last Black resident descended from the original settlers remaining at Pleasant Ridge, passing away in 1959. *Courtesy of Grant County Historical Society.*

Isaac Shepard grew in prominence and was known throughout the region, described by the *Lancaster Teller* in 1886 as "one of the quietest and most exemplary citizens. He is counted a wealthy farmer."

The community was virtually all farmland with no central commercial district, yet the farmers grew in affluence and prominence. Resources were invested into churches and schools, as education was a priority for both the Black and white settlers of the area, creating some of the earliest documented integrated schools and churches in the nation. Many went on to high school and then college, a rarity for African Americans at the time.

For almost one hundred years, Pleasant Ridge thrived as a mixed-race farming community, with residents living harmoniously among each other. As former Black resident Mildred Greene called Pleasant Ridge "a beautiful place to grow up," she related, "I never paid attention to skin color. People were just people."

A peer deeper into the farming practices of the community illustrates the factors that led to their success. In a 1976 interview with Zachary Cooper, author of "Black Settlers of Rural Wisconsin," known as the first comprehensive study of Pleasant Ridge, a ninety-year-old former resident, Jennie Hoffman Dewey, shed some light:

My father was a Civil War soldier. He was [discharged] because of an illness. And that illness affected him until he died. My mother was really the head of the family. We earned our living by milking cows. We always had a big herd of milk cows and my mother would milk by hand. That was our income.

Of course, my father helped with that, but my mother handled the milk check and the feed check.

When Jennie's father, William Hoffman, passed away in 1917, they had been on their farm for sixty years, raising ten children.

Area newspapers of the day were lauding the construction of numerous creameries, as the *Cassville Index* wrote:

The creamery conducted on the right principles is one of the best friends of the farmer, and if it can be started it should receive the intelligent support of those who raise the milk and cream for it....The day of the country butter has gone, and the farmers of any dairying region should recognize this and not waste their time in making it. The milk should either be raised for a creamery, or the farmers should join together and run their own creamery.

United Brethren Church at Pleasant Ridge, circa 1890. This building is now preserved at Old World Wisconsin. *Courtesy of Grant County Historical Society.*

The *Lancaster Teller*, regarding nearby Path Grove, reported, "Our town is swarmed, every morning with about thirty teams, bringing milk to the cheese and butter factory. Both cheese and butter are made every day. The delivery of milk has reached as high as nine thousand pounds a day."

In a March 8, 1894 edition of the *Fennimore Times*, while reporting on Pleasant Ridge, it states, "Isaac Shepard, one of our prominent farmers, went to Lancaster on Saturday last, to attend the co-operative creamery meeting in which he owns a share." Shepard was one of thirty-nine prominent farmers, white and Black and including William Hoffman, to purchase shares in the new creamery at $100 each.

Commercial dairy farming, it seems, was proving vital in Wisconsin, even for experienced agriculturalists from the South.

ALONG A QUIET COUNTRY road, five miles west of Lancaster in Grant County, lies a very small and peaceful cemetery. Although it is still clearly manicured and well taken care of, some of the headstones have cracked and fallen over time. This is all that remains of the one-time Pleasant Ridge. The longevity of the community was in a way a victim of its own success. The ability

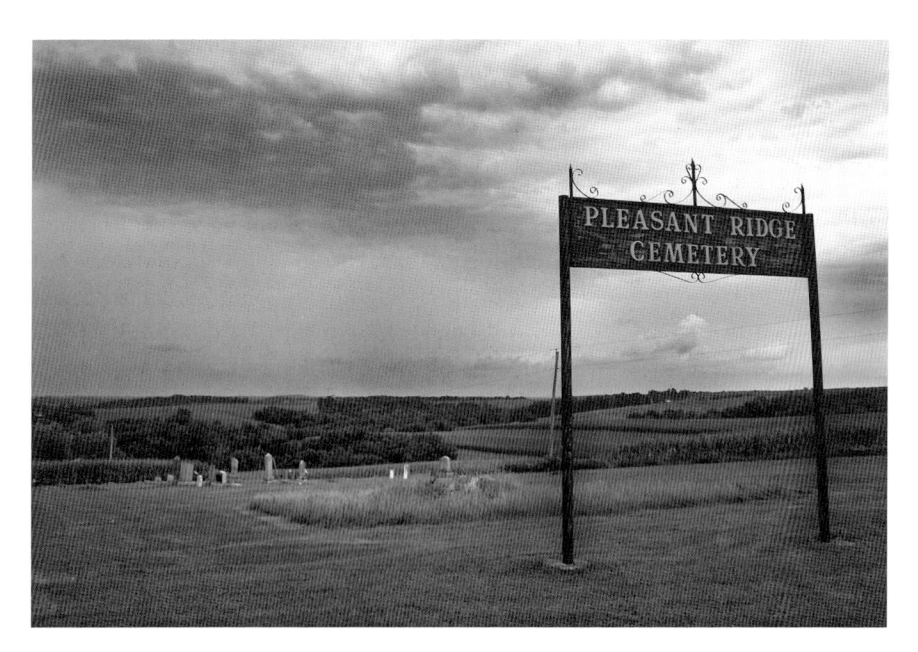

Pleasant Ridge Cemetery, present day. *Scott Wittman Visual, 2021.*

of the resident farmers to prioritize education, and provide such, led to subsequent generations moving elsewhere to further their education and careers until eventually, quite simply, there was no one left. The last Black resident, a descendant of both the Shepard and Greene families, passed away at Pleasant Ridge in 1959.

That long thirty-five-mile walk by Charles and John Shepard to Prairie du Chien in 1863 was their last trek away from Pleasant Ridge. Both being casualties of the war, neither made it back home. Charles, who was in the Fiftieth U.S. Colored Infantry Regiment, passed away in 1865 from anemia at Vicksburg General Hospital in Mississippi. (Not during the Siege of Vicksburg, which is sometimes erroneously accounted.) John, in the Forty-Second U.S. Colored Infantry, died from disease in Illinois while attempting to make his way back home after the war. Neither was ever able to fully realize his legacy left on the heritage of a grateful state.

ABOUT A NINETY-MINUTE DRIVE northeast from Pleasant Ridge, in the shadow of Wildcat Mountain, lies the Kickapoo River Valley in Vernon County. In the heart of the Driftless Region—so named as it was spared by the last glacial age—the river known as the "crookedest river in the world" stares up at steep, sculpted sandstone bluffs towering on either side. The unique topography of the Driftless lends itself a bit of a canvas for the agricultural artist, as strip-cropped fields decorate the landscape, providing a pleasing visual flow to the land.

Driving along the skinny, meandering country roads, it is hard not to be distracted by the lush, rich look of the terrain, and I found myself contrasting this land, where I could almost smell the nutrient-copious soil, to the manufactured forests of the Northwoods. It was not the land that I had come to see, however, but rather something else manufactured by the hands of the past.

Among the ridges, coulees and rolling hills of the Kickapoo Valley and Vernon County, a keen eye will spot a number of architectural structures standing among the scenic views offered throughout the region. Vernon County is home to the highest concentration of round barns in the world. A rarity throughout the country, about twenty of the circular predominantly dairy buildings stood at one time in the area, mostly built under the guidance of one man, an African American from another nineteenth-century, mixed-race, integrated community in Wisconsin. A place called Cheyenne Valley.

A present-day vista of the former Cheyenne Valley mixed-race settlement, Vernon County. *Scott Wittman Visual, 2021.*

The first permanent resident of what is now known as Cheyenne Valley, situated about eighty miles to the northeast of Pleasant Ridge, was a free Black born in North Carolina named Walden Stewart, who set down roots there with his family in 1855. Flaring racial tensions pushed scores of free people of color north, with some coming all the way up to rural Wisconsin. After spending twenty years in Illinois, Stewart brought his family to the fertile and available lands of Vernon County, named Bad Ax County at the time. Several other families followed. Not long after, Macajah Revels, along with his wife, Morning Star, and their children, arrived after migrating north from the Tallahatchie River Cherokee Reservation in Georgia, and over time, a community of Black, Native American and white members began to thrive. Macajah, who was a preacher and donated land for the community to build a church, quickly grew in prominence and influence in the settlement, which was named Revels Valley for a time. As Rebecca Mormann-Krieger writes in a 2017 edition of *Past, Present and Future*, the magazine of the La Crosse Historical Society:

> *Over their many years of marriage Mycajah and Morning Revels had 15 children, and their children had 10–15 children of their own. Other families joined the Valley, but this extended family formed the nucleus. By 1900 descendants of all the founders of the valley had intermarried with freemen, former slaves, and American Indians and Europeans from other nations. They were tri-racial in genetics and heritage. Most of the people in the valley today carry last names of the original inhabitants somewhere in their family tree.*

Thomas Shivers arrived in Revels Valley in 1879. Born into slavery in Tennessee in 1857, he was orphaned by the death of his mother by the age of eleven. Adopted with his siblings by former slaves Edmond and Charlotte Harris, the family eventually migrated north, settling in the town of Union, near Hillsboro, where Mr. Harris was able to purchase a farm on sixty acres of land, the operations of which Thomas took on after the deaths of his adoptive parents, ultimately adding over two hundred acres more.

Thomas married Millie Revels, a daughter of Macajah and Morning, and the two had six children, though the death of one in infancy threw Millie into a depression from which she would never recover, leading to Thomas acting as a single father.

Thomas Shivers became known as one of the most progressive farmers in the valley, as he was the first to purchase a tractor, the first to have indoor plumbing in his home and the first to incorporate electricity on his property. According to the *La Crosse Tribune* in 1976, in reference to Cheyenne Valley it reported, "In economic integration, it appeared the Negro farmer was superior to the white farmer, all conditions equal. At one time, two Negro farmers were thought to be the wealthiest farmers in Vernon County, considering real estate, livestock, and other worldly goods."

In a 1981 interview, Morris Moon, a former resident of Cheyenne Valley, was asked how the affluence was attained in the valley, particularly regarding the Revelses, who "must've had pretty good cash flow" for their rise in prominence and land accumulation.

"Yes, they did," said Moon, as he described having frame buildings, as the Revelses did, as opposed to log buildings, "That meant that you were in the upper bracket." A bracket, it seems, one accomplished through dairy.

"Usually, they had more of a hayloft, and they would build a basement for the cattle to live in....It was just much nicer." Verifying the interviewer's question that the new barn was indicative of an increase in the farm's dairy operation due to bigger haylofts and more space for livestock, Moon confirmed, "It would, and that meant more money." Cheyenne Valley farmers, like their contemporaries at Pleasant Ridge, turned their eyes, and their efforts, to dairy farming.

"At that time, they had some Durham cattle, what they called a milking Durham. You don't see those anymore. Guernseys were scarce because they couldn't take the cold weather, but after they got the frame barns and the basements, then they went into Guernseys. The Holsteins became quite prominent. The flow of milk made up for the lack of butterfat. They had lots of cheese factories. They began to sell lots of milk to cheese factories."

"Several of the original Negro homesteaders were quite wealthy when they died," the *La Crosse Tribune* went on, "but the most worthy of mention for his business sagacity was Thomas Shivers." It is believed that Thomas Shivers had the largest Black-owned farm in Wisconsin at the time.

But it was another member of the Shivers family who is most responsible for today's visual and tangible reminders of the dairy heritage of Cheyenne Valley. These are unique structures, most tucked back off the main roads, which serve as calling cards of another time and quietly illustrate the age of Wisconsin's experimentation, development and eventual dominance of the dairy industry.

Driving along the lesser-taken roads of Vernon County, I went in search of these relics of our past. This is an area steeped in picturesque vistas. Hollows among the many ridges and rugged bluffs still contain the ghosts of previous generations, as their broken cabins and empty old houses lie undisturbed among the sandstone outcroppings, rising upward of six hundred feet. It's easy to see why the state prioritized almost four thousand acres of these lands for protection by the establishment of Wildcat Mountain State Park, walking distance to the west of the dirt road I was now traveling on.

About a mile and a half off Wisconsin 33, through the brush and thicket of existing farms, and some clearly existing no longer, the first one came into view. A round barn, a "centric barn," as they are known, stood solitaire in the shadow of a large willow tree in an overgrown section of an otherwise neatly maintained farmyard. Behind a crude, rust-colored painted wooden fence along the dusty road, the barn still retained the look of its age under the more recent metal roof and obvious maintenance over the years.

The barn was built in 1906 on the farm of George Harris and family, Virginia natives who moved up to Vernon County after the Civil War. Thought to be the oldest round barn in the area, it was constructed by Alga Shivers, the son of Thomas and a prominent barn-builder in Cheyenne Valley, where Alga lived his entire life.

As a native son of Wisconsin, the story of an African American son of a former slave who was commissioned to design and build unique dairy barns, many of which still stand over a century later, was not one I remember hearing. Alga is thought to have designed and built about sixteen round barns in Vernon and Monroe Counties, giving the area the highest concentration of round barns in the world. Many have been lost over the last one hundred years, though those still standing, and even those that are not, remain a testament to our prominent dairy heritage.

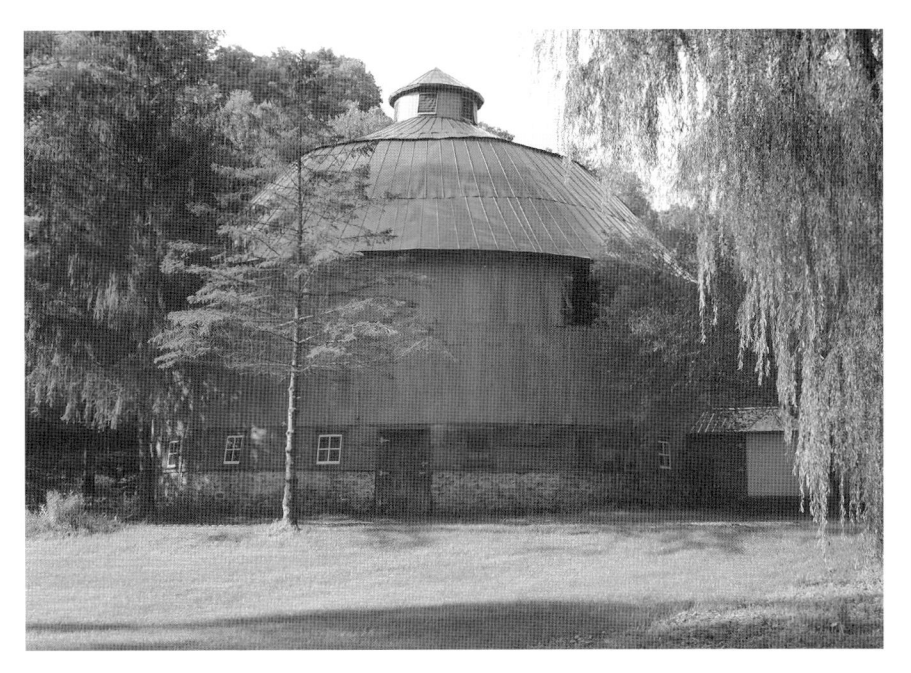

Harris/Kaplan round barn, present day. Cheyenne Valley, Forest Township, Vernon County. *Scott Wittman Visual, 2021.*

Born to Thomas and Millie in 1889, Alga attended George R. Smith College, a historically Black college in Sedalia, Missouri, after finishing the eighth grade in Cheyenne Valley's integrated schools, one of the earliest racially integrated school systems in the nation. Sharing his father's habits in progressive experimentation and practicality, it is believed that it was at this time, as a student in college studying construction, that Alga began to hone his knowledge of barn-building. Also around this time was the popularization of round barn construction, mostly between 1890 and 1920.

Understanding the current trend, Alga undoubtedly familiarized himself with the works of Franklin Hiram King, a professor of agricultural physics at UW-Madison. King was making a name for himself throughout the country with his views on soil management, storing silage, ventilation and barn construction. A proponent of the round silo, which to that time had been mainly square, King soon began to heavily promote the benefits of the cylindrical dairy barn as well. In his 1908 publication, *Ventilation for Swellings, Rural Schools and Stables*, King would enlighten on the motivations for the design:

In January 1889, we received a request to design a barn for a dairy farm which would accommodate 80 cows and 10 horses and which would permit of driving behind the cows in cleaning and in front in feeding. A silo, granary and storage space for roughage sufficient for all the stock were desired and it was specified that all should be under one roof, everything conveniently accessible and not relatively expensive. The barn was built during the summer of the same year on the farm of Mr. C.E. King, Whitewater, Wis., to accommodate 98 cows, and was the first structure to contain the ventilation system for stables here described. In describing the barn for the Seventh Annual Report of the [Wisconsin Experiment Station] *we said: Whatever conveniences a barn may contain these should in no way interfere with the best performance of the animals housed. It should be so built that the heat given off by the animals housed shall be sufficient to maintain the best stable temperature and at the same time admit of ample ventilation. It should admit the necessary amount of light to all the animals and be so constructed as to reduce caretaking to a minimum. The barn as erected…was of the cylindrical type, 92 feet in diameter, two stories, and costing at that time, with the average price of lumber $15 per thousand, a little less than $2,400, not including the board of the carpenters. The manner in which the ventilation was secured is…where the 32 spaces between the studding in the walls of the silo, 34 feet high, are utilized as outtakes, having an aggregate cross-section of 35 square feet. Here, not only are these outtakes centrally located in the warmest portion of the barn with the cows grouped about them, but the warmth of the inner walls of the flues, maintained by the heating of the silage, is utilized as a constant motive power to force the air movement through them. Intakes for fresh air are provided between every fourth pair of studding around the entire circumference of the barn.*

Utilizing these four benefits stated—ventilation, cost and material efficiency, ease of cleaning and warmth for the cows in winter—King promoted round barn construction to great success, and nobody perfected the design more than Alga Shivers.

The Harris-Kaplan barn was built, as all of Alga's works were, utilizing materials that were all found on the farm property. About a year before construction of the barn, Alga and his crew would cut the timber from the farmer's own lot, leaving it to cure, the time needed depending on the species of timber used. The Harris barn was sided in maple bent into a mold. Full construction took roughly three months.

Alga Shivers. *Courtesy of Vernon County Historical Society.*

As I gazed upon the structure in front of me, this centric barn the likes of which fewer than one thousand were ever built in the entire country, I took note of the documented date of construction: 1906. Alga was born in 1889, meaning he would have been about seventeen when the barn was put up, adding to the legendary feat. There are those who dispute whether Alga actually supervised the construction of the Harris-Kaplan barn, based on what they believe is just too young of an age to carry that responsibility, believing him rather part of the building crew. Those who knew Alga, however, and there are a number living yet today, have no trouble at all believing this was his work entirely.

"He taught me how to drive tractor at six," said Mike Thompson, a member of the Cheyenne Valley Heritage Association who was raised by Alga and his wife, Flora. "I thought that was the biggest thing in the world at that time, until the next year when my sister Patti turned six. Then she got to drive, and I had to load the wagons."

Alga married Flora, a widow and the great-granddaughter of Macajah and Morning Revels, later in life, when he was fifty-eight.

"We were raised by Alga Shivers and Flora," said Mike's sister, Barb Stanek, at a recent presentation in Hillsboro. "They also raised my mother and her brother. And they also raised her mother. Alga and Grandma—we called her Lil Grandma—had no children of their own, but they took in and helped raise many children."

"I was five years old when I started mowing the lawn with the push mower. Helping in the barn, I got to milk my first cow at six."

Seventeen seems like the age of a wily old veteran.

In the files of the Vernon County Historical Society, tucked between manila folders holding old photos and newspaper clippings about Cheyenne Valley, there is a typewritten essay by Lon Reuters, a writer for the now-defunct *Ocooch Mountain News*, which was a magazine highlighting southwestern Wisconsin culture, published between 1974 and 1981. Written in 1978, when Cheyenne Valley was down to its last few Black

residents and well on its way to being forgotten, Lon relates how he was told by his editors about Alga Shivers and that the "elderly carpenter farmer might be of interest to talk to." Lon describes their meeting in his essay "What's So Special 'Bout Us?"

> *I turned in at the round barn, parked the car and was greeted by two small dogs as I approached the back porch door. A short man wearing suspenders and glasses met me before I had the chance to knock.*
>
> *"Howdy there," he said. "Come in. Come in."*
>
> *Across the room sat an elderly white lady who put down her reading glasses while Alga offered me a chair and took one himself. We shared complaints about the heat a bit and then he asked,*
>
> *"Well, what brings you here? Oh yeah," he answered, "Yeah, we've had those before."*
>
> *"Pardon me?" I asked.*
>
> *"We've had people come out to write about us before. What's so special 'bout us?"*
>
> *"Well," I began, "first of all you both are no longer spring chickens and…"*
>
> *"I'm 88," he broke in, "and Flora there is 95."*
>
> *Flora had heard him state his own age but missed him giving hers as well. Her high and cracking voice filled the room.*
>
> *"I'm 95," she proudly beamed, "I just celebrated my 95th birthday."*
>
> *Perhaps mixed elderly couples are common in the deep south, I don't know, but here was an 88-year-old black man, a spry white lady of 95, in a rural Wisconsin community wondering what was so special about them. Not much.*

"We believe they had the earliest integrated schools, churches and athletics in the nation," said Mike Thompson, referring to Cheyenne Valley. The area was so integrated that people's racial listings often changed in census listings every decade, from mulatto to Black, white to mulatto, Black to Native American and so on. Skin complexion would sometimes fluctuate within the same immediate family. Lon Reuters touched on this when he asked if Flora's mother was white. Flora "burst into laughter."

"That's the $64,000 question," Alga stated. "Her daddy was a full-blooded Irishman and her mother an Indian, so you answer the question. What was she?"

A round barn built by Alga Shivers in Mount Tabor, Vernon County, 1911. *Courtesy of Winding River Library Systems, public domain.*

CENTRIC BARNS STARTED TO fall out of favor with farmers in the mid-1920s. As the dairy industry continued to evolve, new inventions required dairy barns to become mechanized, as machinery and pipefitting required straight line construction. Dairy herds began to grow, leading to more farmers building long, prefabricated metal pole barns. By the Depression years of the 1930s, the round barn era was over.

Alga and his crew never slowed down, however, as they built conventional barns, outbuildings, houses and pretty much anything Alga wanted to take on.

The George Harris family, who housed their herd of Jersey cattle in the barn, eventually sold the property to the Kaplans after over a century of owning it. The Kaplans continue to care for the barn, though it is no longer utilized for dairy purposes. Inside, the original wooden stanchions remain in place, though today they are filled not with cows, but firewood. Old wooden plaques that once identified the name of the cow that stood there continue to hang above them.

MUCH OF THE RECENT renewed interest in Cheyenne Valley can be attributed to Wilbur Arms, the great-grandson of Samuel Arms, a former slave who was freed when Union soldiers captured the plantation on which he was

working. Eventually making his way up to Wisconsin, Samuel Arms became a significant member of the settlement. After spending many summers of his youth in Cheyenne Valley at the farm of his great-uncle Otis Arms, Samuel's son Wilbur began to look into his family's heritage in the area as he noted attitudes about it began to change and the once celebrated Cheyenne Valley was now more of a "secret" to keep quiet.

"I found that people were hard to talk to," Wilbur relates in a 2014 documentary, *The Round Barns of Vernon County*.

Over time, the advent of better roads and automobiles left Cheyenne Valley much more open to the arrival of outsiders, and the ugly truth of racism and discrimination would eventually rear its head. By the 1990s, there were no Black descendants left in the area. Their stories started to fade, their impact forgotten.

After talking with the mayor and the city administrator, Wilbur Arms, the Cheyenne Valley Heritage Association and the City of Hillsboro began the work of righting too many wrongs.

To fully understand the extraordinary accomplishment the settlers of Cheyenne Valley and Pleasant Ridge were able to achieve, to be able to succeed and thrive in an unfamiliar place such as the rugged lands of

Abandoned remains of Fairview School at Cheyenne Valley, Forest Township, Vernon County. *Scott Wittman Visual, 2021.*

southwestern Wisconsin, one must know what they overcame to get here. Historic markers and passages in history books are one thing. Hearing Otis Arms in a 1975 interview with Zachary Cooper talk about his father, Samuel, is quite another:

> *I wish that I had taken notes of all the things my dad had told us back when he was alive. They'd be nice now to refer to cause a lot of things that he talked about we'd forgotten all about. He used to talk to us children about his life, how it was in the south. He'd talk a while then he'd cry a while.*
>
> *He'd talk about the old planter was so mean to him, he run away. He run up in what they call the bayou and there was an old cabin there and he went in that cabin, and he stayed in there. And this planter—this overseer, rather—he sent some men up there, 18 men went up there to get my dad, but 18 of 'em couldn't get him. There was no other way in the house only just through that door. No window. Just a door. And he had an old homemade table, he jerked the leg off that table, that's what he defended himself with. They couldn't take him. 18 men.*
>
> *So, they went back to the plantation. They told the master. So, the master brought the whole plantation up there. And he told him what he had to do. He had to either give up, or if he didn't give up, they were gonna overpower him anyway and take his right arm off at the shoulder. So, he gave up.*
>
> *They had a board there. They laid him out on that board, and they whipped him, with a cat o' nine tails. They give him 49 lashes with that.*

Beginning at the state historic marker in Hillsboro commemorating the settlers of Cheyenne Valley, the self-guided *Cheyenne Valley Heritage Road Tour* takes the interested motorist on a journey through time. In these forty miles, one can wind through Forest Township and the remnants of one of the most unique and fascinating lost communities in our nation's history.

As you pass the ruins and foundations of some of their schools and churches, their cemeteries and an old town hall, several of Alga Shivers's remaining round dairy barns come into view. Many of the sixteen round structures he is thought to have built are gone today, including two that were taken down during construction of Wildcat Mountain State Park. There are thought to be ten round barns remaining in Vernon County. Not all were built by the hands or the guidance of Alga, but all were undoubtedly built under his influence.

This stone foundation is all that remains of the Revels Valley Free Methodist Church at Cheyenne Valley. *Scott Wittman Visual, 2021.*

The Stoddard round barn in Vernon County. This still-working barn is thought to have been built by Alga Shivers, though officially the builder remains unknown. *Scott Wittman Visual, 2021.*

THERE IS NO EVIDENCE that the settlers of Pleasant Ridge or Cheyenne Valley, though only eighty miles apart and arriving at roughly the same time, had any idea the other existed. For far too long, much of the rest of our state didn't either.

When referring to his great-uncle Otis Arms in *The Round Barns of Vernon County*, Wilbur Arms relayed a conversation: "He said to me, 'It's a sad thing when a man can't show that he's ever existed on this earth; When he's got nothing to show that he's been here.'"

Their exemplary human spirit, of fighting through horrible beginnings to leave a better world for their children, is befitting of others who helped create America's Dairyland. Their contributions in creating and furthering that heritage is clear, and a complete history of it can no longer be told without them.

Where the name Cheyenne Valley came from is a mystery yet today. Nobody seems to know how it started. Primary accounts from settlers say they don't know. Descendants say they don't know. Historians say they don't know. When the name change occurred seems to be a mystery as well.

The settlement wasn't initially called Cheyenne Valley. It wasn't initially called Revels Valley, either. The first name for the settlement? Hopeful Valley.

Students at the former Eastman School at Cheyenne Valley, Vernon County, 1905. This building still stands on private property in dilapidated condition. *Courtesy of Vernon County Historical Society.*

ABOUT SEVENTY MILES DUE east of the former Pleasant Ridge and ninety miles southeast of Cheyenne Valley, another hopeful settlement was being established just a few years earlier. Although they were experiencing differing circumstances from the southern Blacks and Native Americans who came into Wisconsin seeking refuge, Europeans also were fleeing deplorable conditions in their homeland for a better chance at prosperity in Wisconsin.

The canton of Glarus, in east central Switzerland, was reeling in the mid-nineteenth century due to overcrowding, poverty and starvation. In 1844, local authorities and leaders in the community attempted to find ways to relieve the dire conditions, and emigration out of the area and into America was initially discussed. As described by John Luchsinger in *The Planting of the Swiss Colony at New Glarus, Wis*: "The agitation finally culminated in the idea that an organized emigration, under the care and control of the government, would be the best, surest, and most reliable method of affording the necessary relief."

Two men, Nicholas Duerst and Fridolin Streiff, were chosen and agreed to travel to America to find a locality "similar to Glarus in climate, soil, and general characteristics." A journal exists today of these men and their travels to the New World, tasked with finding a new home for their countrymen, friends and families. Duerst recorded:

> *Although we had traveled now through a number of states, we had not yet decided to buy anywhere, for the reason either that wood or water was wanting, the location unhealthy, or not a sufficient tract of suitable land in one body; so we traveled farther into Wisconsin Territory, touching Platteville and Belmont, and arriving at Mineral Point June 16, [1844]. At the land office, we really found a prospect to make suitable selections. Having at this place received a letter from a Mr. Blumer stating that the emigrants might be expected at Milwaukee, we at once proceeded to that place but were disappointed. At the Milwaukee land office we found, after examination, that the land in that district was not favorable to our emigrants. On the 24th of June, we therefore left Milwaukee, via Troy, to Exeter, in Green County. Here, at last, we found in town 4, range 7, a large extant of land suitable for our purpose, containing the prescribed qualities, as: healthy climate, copious springs, fertile soil, timber, and prospect for convenient market for produce.*

In April 1845, 193 Swiss colonists were on their way to meet them. After a grueling five-thousand-mile voyage and a desperate search for Duerst and

Streiff, 108 remained on their reunion on August 15, birthing the colony of New Glarus and commencing large-scale Swiss migration to Green County.

As much of the rest of the state at the time, the Swiss immigrants initially were wheat farmers, though decades of plowing fields without replenishment and insects, namely the chinch bug, had destroyed the practice as a viable income source, and other options had to be explored.

"Either cheese or nothing, and happily we got cheese," exclaimed Conrad Zimmerman in a written history of New Glarus in 1884. The colonists turned to dairy. Their wheat fields were reseeded with grass and clover, and increased dairy herds were brought in.

Making cheese was nothing new to the Swiss, as it was a common staple in every household. As dairying evolved, so, too, did their cheesemaking methods, moving it from their homes into separate "cheese houses," or sheds. A new arrival, Nikolaus Gerber, a Swiss immigrant who was previously a limburger cheesemaker in New York and Illinois, began to promote the idea of cheese factories, which was initially rebuked by the farmers, as they didn't believe the milk for cheese should be worked in large volumes.

Their attitudes changed when they saw the success of Gerber, who would operate several cheese factories in the area, including the first Swiss cheese factory in Wisconsin. It was located on the farm of Dietrich Freitag, who bought the old farm property of Fridolin Streiff, one of the original two colonists who came from Switzerland hoping to find suitable land. Freitag took over operations from Gerber in 1875, and then his sons, Nicholas and Henry, after him.

Within fifty years of Gerber first producing limburger and Swiss cheese in New Glarus, Green County was turning out over a quarter of the entire nation's supply. Hundreds of small cheese factories operated in the county during this period.

Upon Gerber's death in 1903, a poem was found among his items written to him by John Luchslinger, who went on to write *The Planting of the Swiss Colony at New Glarus, Wis.* The sentiment echoes what seems to have occurred at nearby settlements Pleasant Ridge and Cheyenne Valley, in that initial sustenance farming transitioned to commercial dairy for survival and subsequent profitability. Titled "A Song of Cheese," an excerpt reads:

> *Our lands to us no harvest gave,*
> *the ground was almost bare,*
> *earth washed down from every hill*
> *and stones most anywhere.*

A savior was surely due
to help us in our need.
And he arrived, and then he said,
"Change your affairs with speed."
"Bid all the chinch bugs go abroad
by seeding your acres down!"
"Keep only cows and feed your hogs
I'll quickly change your frown.
"Plant only corn and nothing more
to feed your hogs and swine.
Build better barns, milk more cows
and riches will be thine."
He started in and showed us how
to turn the milk to gold.
With two or three cheese factories
to which the milk was sold.
Then money soon commenced to flow,
a full, great, golden stream
which all into our coffers came—
It was just like a dream.

Gaining in popularity in the latter half of the nineteenth century, in the decades after the Civil War, was condensed milk. The United States military purchased large amounts of condensed milk as field rations for Union soldiers, providing a healthy dose of calories, fat and carbohydrates in one ten-ounce can. It did so again during the Spanish-American War. Soldiers after both wars talked of its benefits, and soon demand was high for the canned milk.

Due to the rising demand and the number of dairy farmers in Wisconsin continuing to increase, Helvetia Milk Company, headquartered in Illinois, opened several milk plants in the state, including New Glarus in 1910, where it almost immediately became the community's largest industry and employer.

In November 1910, Helvetia began operations in a 140-by-220-foot building, with fifty employees, on the north end of the village. Although a boon to local dairy farmers, as they now received better pay and more stability for their milk, it was the end of the road for many of the smaller cheese factories that couldn't compete with such a large operation. In order to recruit good employees, Helvetia even built row houses to provide good

Peter Schroeder delivering cans of milk to the Helvetia Condensing Company, New Glarus, 1912. *Courtesy of New Glarus Public Library.*

housing for its workers within several blocks of the main plant. The homes were built in 1914 and still stand and are lived in today.

After another drive in demand during and after World War I, Helvetia was renamed Pet Milk Company and added on to the New Glarus plant campus several times, including several warehouses and a canning factory. By the end of World War II, Pet Milk employed about 150 people in the small Swiss village.

NERVOUS EYES IN NEW Glarus read the news articles out of Sparta, 130 miles to the north, in 1961, when Pet Milk announced it would be closing its plant in that city. One of the oldest businesses in Sparta at the time, the plant was built in 1916, and fifty-six people were soon to be unemployed. "This was a difficult decision to make," said Fred E. Meyer, the district superintendent of Wisconsin's Pet Milk Plants and a New Glarus resident, "but changing conditions have made it economically unsound for us to continue operating the Sparta unit."

For the previous decade, sales of condensed and evaporated milk had been trending downward. Seventeen different plants had closed in Wisconsin during that time.

In January 1962, New Glarus's Pet Milk plant was the next to fall. Virtually one-sixth of the village's workforce was about to be out of a job. The very next day, a smaller Pet Milk plant in Rock County received the news of its closing as well.

The *Capitol Times* of January 16, 1962, reported, "The plant was the pride of the village. The farmers who were wooed away from the cheese factories never regretted it. The Swiss and limburger cheese industries of Green County originated here, but now there is no factory in all of New Glarus Township. Pet Co. got most of the milk from area farmers." Farmers who sold Pet a total of a half million pounds of milk a day now had to look elsewhere.

For over half a century, Pet Milk was the staple of prosperity in New Glarus. A stable workforce and a consistent place for farmers to sell their milk led to much of the growth of the village, including new construction, a commercial district and a happy and contented community. Today, only the small canning factory building yet remains on the site of the former ninety-thousand-square-foot milk plant.

Pet Milk, however, came out a little better. The brand of dairy products is now owned and sold by two companies, Dean Foods and Smucker's.
When traveling along State Highway 69 between New Glarus and Monticello in Washington Township, a long, white, gabled-roofed, banked dairy barn can be seen among some tall brush and long grasses. Although seemingly in good condition from the outside view, it is clear the barn is no longer in use.

This was the farmstead of Dietrich Freitag, on which Swiss cheese was first made in Wisconsin in 1869 by Nikolaus Gerber. The dairy barn, built by Dietrich in 1880, is one of five structures extant on the property, including the home built by Fridolin Streiff in 1862, which was the primary residence of the farm until Dietrich and Verena Freitag's son Nicholas built a new home on the property in 1906. The barn still has two wooden-louvered vents perched on the roof ridge, high above arched louvered openings along the side walls, all utilized for ventilation for the cattle that produced the milk for much of America's Swiss cheese consumption for decades leading to the turn of, and well into, the twentieth century.

After buying out his brother for sole ownership of the property, Nicholas Freitag and his wife, Elsbeth, built the still standing red-brick Queen Anne house for their growing family. The large home welcomed its visitors with

Site of Pet Milk Factory, New Glarus, 1925 and present day. *Courtesy of Wisconsin Historical Society (*top*) and Scott Wittman Visual 2021 (*bottom*).*

The unused dairy barn on the Freitag farmstead as it appears today. *Scott Wittman Visual, 2021.*

an elegant, wraparound, wooden veranda with a corner turret and ornate Tuscan order columns. The interior featured varnished oak and cherry throughout, maple and dark walnut parquet floors and ornamented Corinthian columned, varnished oak grillwork.

Although Nicholas continued dairy farming his entire life, he no longer made cheese on the property after assuming ownership. Advances in refrigeration and transportation made it easier for farmers to ship their milk to larger cheese manufacturers rather than produce it on their own farms. Today, cheese manufacturing remains Green County's most important industry; it is also the largest Swiss cheese industry in the nation. The Freitag farmstead, quietly sitting unobtrusive along a two-lane road, is where it began.

The original cheese factory on the property in which Nikolaus Gerber produced the first Swiss cheese in Wisconsin was torn down not long after in 1877 by Dietrich Freitag. He built another in the same vicinity, just to the north of the 1862 Fridolin Streiff house. The later cheese factory was converted to a machine shed by Nicholas Freitag after cheese making was no longer being done on the farm. Dilapidated, the saltbox-roofed building was torn down by the family in the 1950s.

In 1969, members of the Freitag family held a centennial celebration at the home in honor of the family's 100th anniversary year of ownership of the property. Although the Freitag family continues to own and financially care for the house and utilize it for reunions to this day, the home has been unlived in since Nicholas's death in 1952. The home remains in its pristine, mostly original condition.

The 1862 home built by Fridolin Streiff continues to be occupied by caretakers of the property, over 170 years after his desperate search for relief for his poverty-stricken hometown in Glarus, Switzerland.

AN INCONSPICUOUS ARTICLE OF a few paragraphs ran in several newspapers throughout the state in March 1935. Overshadowed by other news of the day, and likely unnoticed by most, the article told of a recent death in the Swiss village of New Glarus. A Mrs. Anna Engler, six days before her ninety-fifth birthday, died at the home of her daughter-in-law, Mrs. William Engler Sr. The article told how Anna came to America as a five-year-old child, the daughter of Mr. and Mrs. Balth Duerst, in April 1845.

The last surviving member of the original 108 Swiss colonists was gone.

Cheesemaker Victor Winiger with his wife, Anna, and son, Victor Jr., outside the no longer existing cheese factory on the Freitag farmstead, Green County, 1909. *Courtesy of New Glarus Public Library.*

SPIRITS OF THE CENTRAL PLAINS

Gotta be careful now, cause there's some holes in the floor," the owner of the old barn told me before leading me in. "The north side, here, was replaced in the late '50s or early '60s, my dad told me. And I had to replace this area here about five years ago," he said as he pointed and gestured to the high walls. "But the rest of this would be original from the Muir days."

"The Muir days," I marveled as I processed where I was standing.

As I walked in, conscious of every step, I looked around the barn lit by sunlight peering in through cracks in the wallboards put in place in 1857. The distinctive rustic smell of old weathered barnboards and earthiness, with a hint of aged sweet hay, filled my head with nostalgia as I peered up at the massive rafters above.

Daniel Muir, the father of John Muir, who would become the most famous preservationist of natural lands the world has ever known, built this barn on the second Muir homestead in Wisconsin, which he named Hickory Hill Farm. The barn was not, however, built as a dairy barn.

"My great-grandfather Thomas Kearns is the one that raised that barn up and put the foundation under it," Paul Kearns, current in a line of successive Kearnses to own the farm, told me as he provided a tour and history of his family property. When the barn was built by Daniel Muir, it would have been at ground level, likely with a dirt floor. "Thomas raised it and they started milking cows in it. Milked by hand in those days."

The Daniel Muir family immigrated to America from Scotland in 1849, when John was eleven, settling initially on a farm in rural Montello, in Marquette County, named Fountain Lake Farm. After several years clearing, improving and farming the land at Fountain Lake, the Muirs ran into a familiar-sounding problem in that their wheat crops stopped growing. Discouraged, Daniel Muir purchased new land six miles away, on which he would build Hickory Hill Farm, which was on higher ground that he thought would provide improved prospects for crops.

Kathleen McGwin of the Marquette County Historical Society believes there may be another reason why Daniel left Fountain Lake. "I think that Daniel Muir was restless. I think he was done with that one and he wanted a new one to start on."

Not everyone was happy about leaving Fountain Lake Farm, including Daniel's eldest son, John, who wrote in his autobiography, *The Story of My Boyhood and Youth*:

> *After eight years of this dreary work of clearing the Fountain Lake farm, fencing it and getting it in perfect order, building a frame house and the necessary outbuildings for the cattle and horses—after all this had been victoriously accomplished, and we had made out to escape with life— father bought a half-section of wild land about four or five miles to the eastward and began all over again to clear and fence and break up other fields for a new farm, doubling all the stunting, heartbreaking chopping, grubbing, stump-digging, rail-splitting, fence-building, barn-building, house-building, and so forth.*

The "barn-building" aspect I was currently bearing witness to, as I was standing in the very barn that they built. Forty- and fifty-foot-long pine logs were carted down from Stevens Point by oxen, hand hewn into the beams that are still seen crisscrossing the interior today, many still containing bark and appearing as if just axed down yesterday, as opposed to 164 years ago.

The "home-building" remains evident today as well, as the original house the Muirs built on the property still stands, bricked over but largely intact. The basement, where John created many of his famous inventions that were later displayed at the state fair at Camp Randall, is virtually identical today as when John would wake up at 1:00 a.m. to work on them, as chores began on the farm by 4:30 a.m. These inventions, whittled from oak and hickory or crude metal tools, included clocks, thermometers, a self-setting rotary saw and various water wheels and sundials, among other things.

At twenty-two, John left Hickory Hill Farm and enrolled at UW-Madison, soon to begin his adventures that would lead to him being forever known as the "Father of the National Parks." Driven by many of the curiosities he betook at Hickory Hill and Fountain Lake Farm prior, John Muir's preservation activism led to the creation of the American National Parks system, the protection of millions of acres of wild lands and the founding of the Sierra Club. His subsequent writings have become required reading for many millions of students, ecologists and preservationists since.

While at Fountain Lake and then Hickory Hill Farm, John saw his father utilize old-world farming methods of continually exploiting the nutrients available in the land, though never replacing them. By 1873, the thin, sandy soils of the central plains could no longer hold Daniel's interests, and John's parents sold Hickory Hill Farm and moved to nearby Portage.

A year later, the farm was purchased by Thomas Kearns and his family, Irish immigrants who had settled in Pardeeville. Thomas, as well, initially raised wheat, though during the height of dairy farming, he raised the barn, put a foundation under it and housed dairy cattle in the basement. "My grandfather Harry Kearns [Thomas's son] remembered that process," said Paul. "He would talk about that, when they raised that barn." For roughly a half century, milk was being shipped from the old Muir barn to a creamery in Marcellon Township in neighboring Columbia County, the building of which still stands today as a private residence.

"They had sheep as well. They would have the dairy over here," Paul relayed, as he pointed to where the cattle used to be housed, "and there was a wall in between them. The sheep were over on this side, here, see? Hogs and chickens, too. Farmers back then had a little bit of everything. My dad had a fair amount of hogs, chickens, sheep, steer and cows. He always said he wanted to be diversified. If one market wasn't good, hopefully another one was. He raised corn, oats and alfalfa but pretty much fed it all. Didn't sell anything."

Paul's father, Maurice Kearns, was the last generation to have dairy cows on the property, however.

"When my dad was drafted into the army for the Korean War, his dad sold the milk cows. He didn't have any help. My dad was off to the army, so my grandfather sold the milk cows, and he almost sold the farm, but [other family] talked him out of that."

One of the most famous aspects of the farm is a story that John Muir told himself in *The Story of My Boyhood and Youth*, about a near-death experience while digging the farm's well:

The land was better, but it had no living water, no spring or stream or meadow or lake. A well ninety feet deep had to be dug, all except the first ten feet or so in fine-grained sandstone. When the sandstone was struck, my father, on the advice of a man who had worked in mines, tried to blast the rock; but from lack of skill the blasting went on very slowly, and father decided to have me do all the work with mason's chisels, a long, hard job, with a good deal of danger in it. I had to sit cramped in a space about three feet in diameter, and wearily chip, chip, with heavy hammers and chisels from early morning until dark, day after day, for weeks and months....

One morning, after the dreary bore was about eighty feet deep, my life was all but lost in deadly choke-damp—carbonic acid gas that had settled at the bottom during the night. Instead of clearing away the chips as usual when I was lowered to the bottom, I swayed back and forth and began to sink under the poison.

His father realized something was amiss, as John was unresponsive to his father's attempts at communication. John, almost completely succumbed, was able to get into the lowering bucket for his father to hoist him out of the hole and drag him out, "gasping for breath."

"We drank that water back to about the 1970s," said Paul, talking about the well, now capped with a fifty-foot windmill over it. "We had a bucket in the refrigerator, because the water in the house was softened, so we'd drink water out of that well. We used it to water the cattle into the '90s. There was a wooden lever on the side with a wire that engaged that drive system up on the top [of the windmill] and that would go up and down and pump the water. That windmill's been there my whole life."

Paul Kearns still works the farm built by Daniel and John Muir and continued by generations of his ancestors. There are no longer any milk cows on the property, as the farm now raises steers and cash crops. Trevor Kearns, Paul's son and future fifth-generation owner of Hickory Hill Farm, aspires to one day restore the home to what it looked like when the Muirs were there. "It'll be a job," he said, but it's one he's willing to take on. The home is unlived in, as the Kearns have a modern home elsewhere on the property, but it remains cared for and maintained. Periodically, Muir scholars, "busloads of people from California" and the occasional film crew show up on the property due to its historical significance, all of which the family is happy to oblige.

"I don't mind sharing it at all," Paul said, with full understanding of where he had the pleasure of growing up.

Upon leaving UW-Madison, John Muir began his travels west, establishing Yosemite and Sequoia National Parks in California and growing his influence on such noted conservationists as photographer Ansel Adams and President Theodore Roosevelt.

Although he never spent much time back in Wisconsin after the mid-1860s, there does survive an account of John returning to Hickory Hill Farm and the neighboring community in 1898, when he was world-renowned, visiting old acquaintances. By then, Wisconsin had wholly entered the dairy age, and the landscape was changing from what he would have remembered as a young twentysomething.

Standing in the doorway of the barn looking out toward the long driveway to the road, the same driveway cut by the Muirs, I gazed upon a large oak tree, represented as a small sapling in an old John Muir sketch. Now giant, the burr oak casts its massive shadow over the farmyard. The farm is, for obvious reasons, unique in its representation of Wisconsin's legacy, but also that it stands the test of time and tells our story, consolidated on one piece of land: built for wheat, transitioned to dairy and now proceeding on, long after dairy has gone from it.

"It's taken on a lot of storms," said Paul, "but it's still standing."

A converted dairy barn on Hickory Hill Farm, former home of John Muir. Rural Montello. *Scott Wittman Visual, 2021.*

ALONG COUNTY ROAD F, outside Montello in Marquette County, a short jaunt down from the restored prairie lands and meadows of the original Fountain Lake Farm property, lies a cornered wall from an old fieldstone barn foundation. The wall is all that remains of the one-time dairy farm of Reginald and Bessie Eggleston, the last to farm this 198-acre tract of land, portions of which were once owned by a long line of early settlers of Buffalo Township. Familiar names in the area, such as Muir, Ennis, McReath and McGwin, all owned this plot, including 38 acres of which were part of Daniel and John Muir's Fountain Lake Farm.

The former Bessie McGwin, a descendant of the Ennis and McGwin families, left Marquette County after high school for West Allis, where she lived with her husband, Reginald Eggleston. During World War II, Bessie was recognized for her work at the Allis-Chalmers Supercharger Plant in Milwaukee, at which almost 80 percent of the workforce was women in wartime, working to increase flight altitudes for airplanes.

After the war, Bessie and Reginald returned home to Buffalo Township, where they purchased this farm from her uncle Howard McGwin. Here, Bessie was back in her element, milking cows and raising chickens on the dairy farm, far away from the high-tech world of wartime aerospace engineering.

Bessie fell in love with the land and the lifestyle of farming. Although decades after John Muir had gone, her farm, which overlooked the lake and meadows that spurred Muir's love of nature, retained that same influence on others. An article in the *Wisconsin State Journal* described the vista as "a scene of beauty and the woods are most abundant of flowers of all kinds than probably any other single community in southern Wisconsin. Here the Turk's Cap brushes your car as you ride by the roadside. The Indian Paint Brush is brilliant and the daintily perfumed Ladies' Slipper and the daisies and Black-Eyed Susans seem like acres."

Although the Muirs went on to become the most well known from the community, they were simply one of many families. As Samuel D. Ennis, a descendant of the original Ennis pioneers, wrote in 1975, "Samuel Ennis and his seven brothers and two sisters were too busy building homes and raising families to become even well known. They were, as were the rest of the pioneer settlers of Marquette County, plain, simple, God-fearing farmers, who were responsible for the development of Marquette County and the state of Wisconsin."

Bessie's world turned upside down in 1963 when, in the milk house with Reginald, a heart attack took him away from her forever. He died in her arms.

Bessie McGwin Eggleston in her barn with her cows, circa 1970s. *Courtesy of Kathleen McGwin Private Collection.*

Unable to live solely off the farm on her own, Bessie went back to school to earn a bachelor's degree from UW–Stevens Point and taught school in Montello until retirement. As long as her health allowed, Bessie remained on the farm, milking her cows and raising her chickens.

A 1979 proposal by the United States Fish and Wildlife Service (USFWS) to acquire land to create a wildlife refuge through the area, much of which was on private farms owned for generations, brought out the fight in Bessie. In letters to landowners within the proposed refuge site, dated May 16, 1979, without any forewarning, they were told about the project, that their land would be appraised and a government representative would be arriving in the coming days for inspection. One of those letters went to Bessie Eggleston, who went to the *Portage Daily Register*, which reported:

> *After landowners received the May 16 letter, Eggleston said she was visited by a USFWS representative the following week, as mentioned in the letter. She said that when she informed the gentleman that she had no intention of selling her land to the government, "he said, 'If you don't want to sell it and we want it, we can condemn it and get it anyway.'"*

The landowners refused. Rallies and protests were held. Then–state representatives Tommy Thompson and Tom Petri joined their plight.

The USFWS wouldn't relent. A committee was formed with members of the USFWS and community members to attempt to come to a resolution,

on which Bessie Eggleston served. The refuge was eventually created on about half of the proposed two thousand acres the USFWS initially wanted.

In testimony before the U.S. House Appropriations Interior Subcommittee the following year, Petri excoriated the USFWS tactics as "an outrageous example of bureaucratic land-grabbing, intimidation, and harassment of rightful owners" of private property.

Candy Bulgrin, a landowner in neighboring Columbia County, later stated, "I think one thing they've overlooked on their endangered species list is the family farmer."

BESSIE DIED IN 2014 at 101 years old. That partial barn wall still stands as a symbol of the spirit and resolve of the Wisconsin family farmer. That wall, built by the hands of men who lived decades before her, still holds the energy and emotions of all those years in between. Daily milkings with her beloved cows, hours of conversations with her husband, the despair of death.

The Natural Heritage Land Trust purchased 198 acres from Bessie Eggleston's heirs in 2015 to preserve the land this Marquette County farmer and teacher loved. "I don't think she'd be displeased," Bessie's nephew Ken

The remains of Bessie Eggleston's barn. Rural Montello, Marquette County. *Scott Wittman Visual, 2021.*

McGwin said when I spoke with him. A dairy farmer himself in Marquette County for thirty-five years, Ken said the preserved land is what she wanted. "There won't ever be any building development on it. It's just prairie and woods, like it was long ago. It's really a nice piece of property there."

"This farming community respected the land from which they earned their livelihood," reads an informational kiosk placed next to the remains of the barn. "Bessie McGwin Eggleston was an example of the many farm women, men, and families who have worked hard and long hours to make their lives, as well as the community, stronger and richer."

THE HEARTBREAK THAT BESSIE experienced with the death of her husband, Reginald, on their dairy farm is indicative of the hardships that many farmers endure with the high physicality and often grueling work that the lifestyle entails. Accidents with heavy machinery are commonplace, and newspapers are riddled with dreadful accounts of scenes most others not in the industry are insulated from.

From a long-ago edition of the *Marshfield News*, a vague headline that reads "Farmer Killed in Accident" in a small section on page six describes the horror of one particular incident:

> *While at work harvesting his hay crop, Gottlieb Kressin, a well-to-do farmer residing in the town of Mequon, south of Sheboygan, met with a horrible accident which caused his death a short time after. He was in the field with his son, and had his horses hitched to the hay tedder, when the pole broke. The horses being a span of broncos, became unmanageable and ran away, throwing Mr. Kressin beneath the tedder and dragging him along for a distance, the iron forks piercing him in all portions of the body. When released, he was unconscious and bleeding from his head and body. He died about a half an hour afterward.*

Other, similar headlinese were common: "Farmer Killed Under Tractor-Drawn Plow," *Green Bay Press Gazette*; "Farmer Killed Blowing Stumps," *Marshfield News-Herald*; "Farmer Killed When Dragged by Mad Cow," *Appleton Post-Crescent*. The articles are seemingly never-ending in a plethora of back-page, "Other Area News" sections in papers all around the state for over a century and a half.

In 2018, one tragedy hit a bit of a nerve and became a story in several national news outlets when a silo collapsed on a rural dairy farm in the small

community of Hillsdale, in Barron County. Fifty-one-year-old Daniel Briel and his teenage son, David, were buried under eight feet of grain while working inside the silo. It took a rescue team forty-five minutes utilizing thermal imaging equipment to find them and pull them out.

Daniel was already dead when rescuers arrived. David passed a short time after. He was fourteen.

"In the farming world, these accidents do happen," the Barron County sheriff would say.

The city of Black River Falls, in Jackson County, today is a typical American small town, with a promoted historic downtown and big box stores straddling the outskirts. In 1973, however, the community was immortalized in Michael Lesy's 1973 book, *Wisconsin Death Trip*, featuring the work of local nineteenth-century photographer Charles Van Schaick. Lesy took Van Schaick's photos, most taken in and around the city of Black River Falls from 1890 to 1910, and interspersed them with newspaper reports, often of a shocking and disturbing nature, creating an uncomfortable look inside this community of mostly German and Norwegian immigrants. With the residents devastated and demoralized by an economic downturn caused by a string of bank failures and a depleted gold reserve throwing many communities throughout the nation into poverty, Lesy scatters Van Schaick's portraits, illustrating much of the anguish and stress of the day, with headlines about madness, suicide, crime and murder.

Many of the subjects of Van Schaick's photos were farmers and miners, both industries hitting rock-bottom in the area during that time. The mines were used up, as was the soil, in an all-too-familiar story, and their crops no longer grew. As dairy farming was taking hold in other parts of the state, alleviating much of the financial hardships caused by bad crops, Jackson County, it seems, was slower to make this transition, as Charlotte Louise Quinney puts forth in her master's thesis, "Wisconsin Death Trip: An Excursion into the Midwestern Gothic":

> *On the other hand, Black River Falls, located in Central Wisconsin, also suffered as a beleaguered town as it became evident that the area was particularly lagging behind the industrial development of the surrounding country. In the 1870s, wheat farming begins to move to larger tracts in the West which were more ably farmed with technological progress, resulting in falling wheat production shortly after 1870. In the 1880's, iron mining*

Jackson County barn raising, location unknown, early twentieth century. Photo by Charles Van Schaick. *Courtesy of the Jackson County Historical Society.*

develops in the north of Wisconsin, and lumbering becomes the state's most important industry, followed by the paper and wood produce industries. The meatpacking and brewing industry arises in Milwaukee, and in the south, the dairy industry develops with the influx of skilled dairy farmers from New York and Scandinavia. The region of Black River Falls was left to scrutinize its marginally sufficient base position.

The similarity of the problems facing the Black River Falls community over a century ago to those facing dairy farmers today is striking. Small dairy farms being swallowed up by corporate farms, plummeting commodity process, skyrocketing debt, bankruptcies, labor shortages, bad weather and ending farming operations that have gone on for generations have led to a modern-day mental health crisis for dairy farmers.

According to the Centers for Disease Control, farmers are among the most likely to die by suicide, compared with other occupations. Hundreds of dairy farmers have committed suicide in the Midwest in the past decade, the numbers of which are likely much higher than reported.

Although numerous private and nonprofit organizations have heeded the call for help, Congress continues to Band-Aid the crisis with window-

Milk maiden, unidentified, circa 1890. *Courtesy of Jackson County Historical Society.*

dressing. In 2008, Congress passed the Farm and Ranch Stress Assistance Network Act, which was to be a resource of behavioral health interventions for agriculturalists, providing states grant money to combat the rising mental health issues in the field. Once passed, it went nowhere, as nobody realized for over a decade that it wasn't ever funded.

"DEPRESSION AND SUICIDE ARE real. Many families are affected by depression and suicide, and I'm not ashamed of this story."

Jody Hartl Smith grew up in Loyal, Wisconsin. A descendant of a locally well-known farm family, the patriarch of whom was Lawrence Smazal, Jody grew up learning about the trials and tragedies that occurred in her mother's family.

Settling first in Kewaunee County after emigrating from Bohemia, Lawrence and his wife, Anna, traded their land in 1879 for 80 acres in section 21 of Milladore Township, Wood County. Soon adding 120 acres more, the Smazals elected to clear the wild land and build their permanent home there, among no roads or improvements at the time. Lawrence worked for several years with the R. Connor Company in Auburndale, a timber

R. Connor Company dairy farm, once the largest in central Wisconsin, 1922. Nothing remains of it today. *Courtesy of North Wood County Historical Society.*

company that owned one of the largest dairy farms in central Wisconsin, to support his family while proving up their land.

After the deaths of Anna and Lawrence, in 1904 and 1905, respectively, one of their four children, Joseph Smazal, retained ownership of the farm, clearing 120 acres, fully tillable, along with "having a good herd of Holstein cattle with a pure-bred sire at the head." On this land, in a farmhouse across from his parents' home, Joseph raised his family with his wife, Emma.

Operations and ownership were transitioned to their son Frank Smazal when Joseph passed away in 1943 at the age of sixty-six, as their first-born son, Walter, had died many years earlier. Frank, his wife, Mayme, and their eventual fourteen children ran the farm along with Emma, who remained for a time, though distraught over losing her husband.

The depression over losing Joseph, the love of her life, became too much of a cross to bear, and Emma Smazal was admitted to Winnebago Mental Health Institute later that summer for despondency. In a cruel twist, Emma's only brother, Joseph Brozek, was hit by a train car and killed the same year, for which she came home to the farm to be with her family and attend his funeral. As reported in the *Marshfield News-Herald* of October 6, 1943:

Declaring that she was too weak to attend, she remained alone at the farm home 2 and a half miles northwest of Blenker Tuesday morning while other members of the family attended the rites. Upon their return they found her body suspended from a rafter in the barn. The children said she had taken the news of her brother's death well and had given no indication of any wish to take her own life.

Three years later, in 1946, Frank and Mayme's fifteen-year-old daughter, Vivian, was found in her bed, having died of an epileptic grand mal seizure. Three years after that, their thirteen-year-old son, James, who had early in life suffered severe brain trauma due to being kicked in the head by a horse, passed of pneumonia.

Jody relates some remaining trepidation in the extended family of her great-grandmother's suicide, still today, as the stigma still endures.

"This happened eighty-two years ago. No one that is alive ever even knew her," she says, as she relates that some in her family may never have spoken about it.

"That is [their] choice as it was my mom's choice to tell me about it, as it's our history, too."

The Smazal family on the family farm, Wood County, 1940s. *Courtesy of Jody Hartl Smith Private Collection.*

The Smazal farm, Milladore, Wood County, undated. The barn no longer stands. *Courtesy of Jody Hartl Smith Private Collection.*

The dark secret of suicide has infiltrated dairy farming families in Wisconsin almost since its inception. The Smazals are not alone in that plight. They have persevered. Generations have become husbands and wives, raised children and served our nation in the armed forces and on the farm fields that feed our families.

Jody, also, made a lasting mark on Wisconsin's dairy pop culture, when, as a six-year-old, she was the winner of a naming contest of over three thousand entries for the famous Niellsville roadside attraction Chatty Belle, known as the Largest Talking Cow in the World.

The Smazal farm, since recognized as a Century Farm, remains in the family. The barn was taken down several years ago, though Jody saved some of the wood.

"Think of the family history these pieces saw."

In the town of Seven Mile Creek in Juneau County, on the crest of a modest hill known historically as Keegan's Hill, Highway K bisects a well-maintained farm property featuring a two-story stucco house on one side of the road and a large dairy barn and several aged outbuildings on the other. In this quiet town of about three hundred, pulled off to the side of the road, I heard only the chirping of birds and the echo of cars in the distance, including the sporadic passersby.

A solitary, small black car was parked at the end of the driveway to the house, down toward the road from the garage, which boasted a swinging, double-leafed door, circa 1930s. The vehicle likely belonged to a guest, as the home now acts as a bed-and-breakfast.

Just taking a few moments in the serenity, I noted how the car in the driveway, and mine, felt out of place here. I tried to picture this property in another time, almost a century ago or more, when this property, even in 1925, was being remembered. Cattle would have roamed the fields behind me, in which now there were none. This unassuming stucco house along this unassuming county road was a marked destination for the vice president of the United States, and before that, the origin of a portion of one of the most legendary military fighting machines in American history, the Iron Brigade.

This peaceful land was first settled by Henry Dawes, who came to Wisconsin from Ohio to purchase real estate in 1855 to be closer to his father and brother, who were residing in Fond du Lac. His two youngest sons, both teenagers, came with him. A man with a fascinating family lineage, Henry was the grandson, father and grandfather of three of the most accomplished Americans in history.

April 18, 1775, was the night of the famous occurrence in Boston involving Paul Revere. As the famous tale is told, Revere was dispatched from Boston by Dr. Joseph Warren with a very important message to warn revolutionaries John Hancock and Samuel Adams in Lexington, Massachusetts, that the British militia were on their way to arrest them. Because it was believed the British would then go on to Concord to capture the city and destroy the budding rebellion, Revere's next mission was to get to Concord to alert the city of the impending clash ahead.

As the city of Boston was swarming with British troops controlling the roads into and out of the city, the likelihood of such a mission succeeding was not high; therefore, the real story is that there was another messenger dispatched with Revere to take a different route. That man was William Dawes, the grandfather of Henry Dawes, who later built his farm in Juneau County.

Both Revere and Dawes made it out of Boston and to Lexington to allow for the escape of Adams and Hancock. There, they met up with fellow Son of Liberty Samuel Prescott, and the three were off to Concord, though they were stopped by the British before leaving the city. Dawes escaped into the woods on foot, though Prescott was able to ultimately elude capture and carried on to Concord to complete the high-stakes operation. Revere was captured, though later released.

In 1860, Henry Wadsworth Longfellow's fictional poem "Paul Revere's Ride," which also made famous the saying, "One if by land, two if by sea," omitted Dawes and Prescott from the adventure and therefore from popular history. All three members, however, are rightfully memorialized at Minute Man National Historical Park in Lexington at the actual site of Paul Revere's capture.

AFTER GRADUATING FROM MARIETTA College in 1860, Henry's son Rufus Dawes returned to Seven Mile Creek—so named as the mouth of the creek is seven miles upstream from the mouth of the Lemonweir River—to help his father clear the land on the property in preparation of building a new house. Rufus also enrolled at the University of Wisconsin at the time.

Soon after, the attack on Fort Sumter in South Carolina created a massive uptick of patriotism throughout the North. As in Crawford County described earlier, Juneau County was also quick to heed the president's call for organization. Rufus Dawes, himself, led the effort in Mauston, as he wrote in his memoir, *Service with the Sixth Wisconsin Volunteers*:

> *Fort Sumpter was fired upon, and recognizing the full import of that event, on the fifteenth day of April 1861, President Abraham Lincoln issued his proclamation calling for seventy-five thousand volunteers to suppress the rebellion by force of arms. This first bugle call of war found the author of this book in the sparsely settled County of Juneau in the State of Wisconsin. I was then twenty-two years of age, and had come out of college with the class of 1860. With the proclamation of the President came the announcement that the quota of the State of Wisconsin would be only one small infantry regiment of seven hundred and eighty men. It seemed quite evident that only by prompt action I might secure what was then termed the "glorious privilege" of aiding in crushing the Rebellion, which undertaking it had been estimated by one in high authority, could be accomplished in sixty days. It is pleasant to remember that at that day few questions were raised as to the rates of compensation for service, and so remote a contingency as realizing upon the promise of a pension was not considered. Nothing beyond the opportunity to go was asked. What seemed to most concern our patriotic and ambitious young men was the fear that someone else would get ahead and crush the Rebellion before they got there. Drawing up the following pledge and signing it, I began the work of gathering Volunteers on the twenty-fifth day of April 1861.*

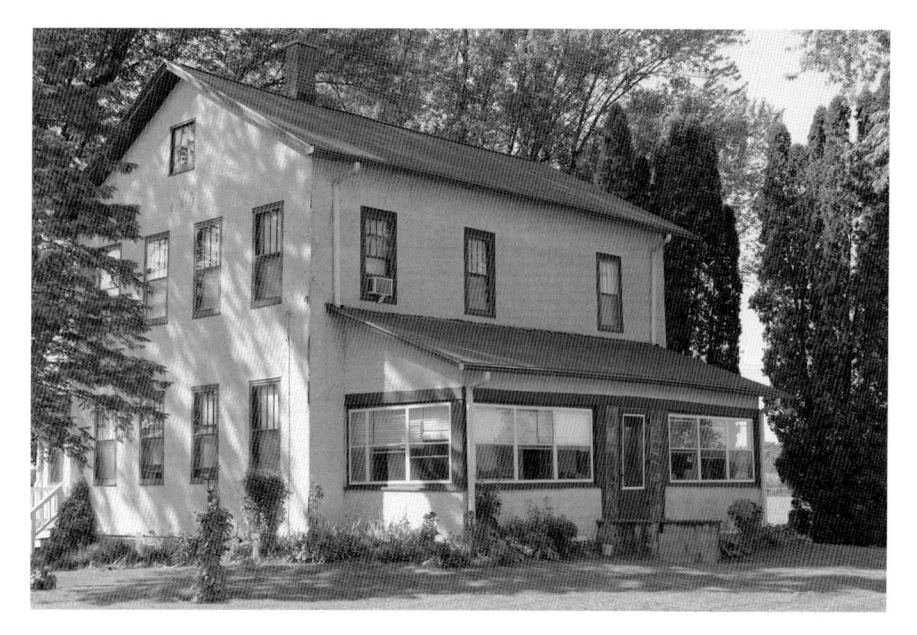

The home originally built by Henry and Rufus Dawes, Seven Mile Creek, Juneau County, 1860s. *Scott Wittman Visual, 2021.*

"We, the undersigned, agree to organize an independent military company, and to hold ourselves in readiness to respond to any call to defend our country and sustain our government."

They were a wide-eyed clan of one hundred lumberjacks and raftsmen from the local logging camps, and they called themselves the Lemonweir Minutemen. Mustered into Camp Randall in Madison as Company K of the Sixth Wisconsin Volunteer Infantry, they all signed up for the full three-year term, rather than the required ninety days, as they thought this would be easier than working in the pineries. The war, they were told, likely wouldn't last sixty days.

For over a year, the regiment saw no real action other than a few small skirmishes with Confederate sympathizers. In August 1862, however, they were caught off-guard by a regiment of five thousand Confederate soldiers near Gainesville, Virginia. The inexperienced Lemonweir Minutemen held their own alongside Union troops from New York and Indiana and fought off the attack.

The five thousand Confederates they turned back were led by Stonewall Jackson, and the battle proved to be the opening firefight of the Battle of

Second Manassas. Dawes would go on to earn great praise for leading his men in that engagement.

Later that year, as the Wisconsinites climbed the steep slopes of South Mountain and overtook a Confederate stronghold on the crest, General George McClellan, watching from below, famously remarked, "Those men must be made of iron," and the Iron Brigade was born.

Dawes would go on to see action at Fredericksburg, Antietam, Chancellorsville, Spotsylvania and Cold Harbor, among others, and would eventually be promoted to lieutenant colonel.

But it was at the Battle of Gettysburg that Dawes and the Iron Brigade charged into immortality. On the first day of the battle, July 1, 1863, all of the Iron Brigade regiments, except for the Sixth Wisconsin, were ordered into heavy firefights in the woods against Confederate forces from Tennessee and Alabama. Dawes and his men were ordered to support the right flank of Brigadier General Lysander Cutler's brigade against troops from Mississippi and North Carolina.

Cutler's troops were being destroyed by the Confederates, who began jumping into an unfinished railroad cut, thinking it would provide cover when firing into the Union lines. Dawes initially mistook the move as a retreat, as he was unaware the railroad cut was there. Soon realizing his mistake, he recalculated:

> *I now ordered the men to climb over the turnpike fences and advance upon them. I was not aware of the existence of a railroad cut, and mistook the maneuver of the enemy for a retreat, but was soon undeceived by the heavy fire which they began at once to pour upon us from their cover in the cut. John Ticknor, a dashing soldier, one of our finest officers, fell dead while climbing the second fence, and others were struck, but the line pushed on. When over the fence and in the field, and subjected to an infernal fire, I saw the Ninety-fifth New York regiment coming gallantly into line upon our left....Farther to the left was the Fourteenth Brooklyn Regiment, but we were ignorant of the fact. The Ninety-fifth New York had about one hundred men in action. Major Edward Pye appeared to be in command. Running hastily to the major, I said, "We must charge," and asked him if they were with us. The gallant major replied, "Charge it is," and they were with us to the end. "Forward, charge!" was the order given by both the major and myself. We were now receiving a fearfully destructive fire from the hidden enemy. Men who had been shot were leaving the ranks in crowds. Any correct picture of this charge would represent a V-shaped*

crowd of men, with the colors at the advance point, moving firmly and hurriedly forward, while the whole field behind is streaming with men who had been shot, and who are struggling to the rear or sinking in death upon the ground....Meanwhile the colors were down upon the ground several times, but were raised at once by the heroes of the color guard. Not one of the guard escaped, every man being killed or wounded. Four hundred and twenty men started as a regiment from the turnpike fence, of whom two hundred and forty reached the railroad cut.

Once Dawes and his men reached the cut, the Confederates found it impossible to return fire, due to the steep angle of the trench they were in. They were trapped in a literal grave with Dawes and his Iron Brigade staring down at them. Realizing their fate, the remaining Confederates in the cut dropped their weapons and were taken prisoner.

Dawes, who left a treasure-trove of detailed accounts of his experience in the war, continued:

It would require many pages to justly recount the heroic deeds of all, but one incident is so touching in its character that it should be preserved. Corporal James Kelly, of Company B, turned from the ranks, and stepped beside me, as we both moved hurriedly forward on the charge. He pulled open his woolen shirt, and a mark where the deadly minnie ball had entered his breast was visible. He said: "Colonel, won't you please write to my folks that I died a soldier?"

When Major General Abner Doubleday wrote his official report on the Battle of Gettysburg, he told of the moment he saw Cutler's regiment being devoured and he knew the Union was in danger of being entirely routed on July 1. He sent for Dawes and the Sixth Wisconsin, whom "I knew could be relied upon." The actions of the Iron Brigade are still credited today with delaying the advance of the Confederates on July 1 until the Union army arrived, ultimately ending in victory at Gettysburg on July 3.

The Iron Brigade had more casualties, killed and wounded, than any other Union brigade throughout the duration of the Civil War. Although Rufus Dawes, it is said, "probably took part in more battles than any other commissioned officer," he is the only commissioned officer in the brigade who served throughout the war without receiving serious wounds.

Rufus Dawes was ultimately promoted to colonel, though he declined. After the war, he returned to Ohio in 1865 with his brother Ephraim, who

lived in Wisconsin with Rufus and their father prior to the war. Ephraim was shot in the face with a Minié ball at the Battle of Dallas, resulting in reconstruction of his lower jaw. Later that year, Rufus's first son, Charles Gates Dawes, was born.

THE FARMSTEAD AT SEVEN Mile Creek passed through a number of hands after the death of Rufus's father, Henry, in 1867, until being obtained by William Shelton in 1907. Shelton married the daughter of the owner at the time. Recognizing the transitioning of Wisconsin to dairy, the Sheltons improved the 240 acres of the farmstead to reflect this change in operations.

The house, built by Henry Dawes as a frontier farmhouse, was modernized by the Sheltons in the 1920s. Stucco was added over the original clapboard siding of the home, and the inside was remodeled to reflect the modern farmhouse of the early twentieth century. Improved technology also was implemented into the home, such as electricity, central heat, running water and operational indoor bathrooms.

The dairy barn owned and utilized by Henry Dawes burned down in 1926. A new modern barn was rebuilt by the Sheltons the next year. At 35 by 98.5 feet, the barn was built to the specifications promoted by the

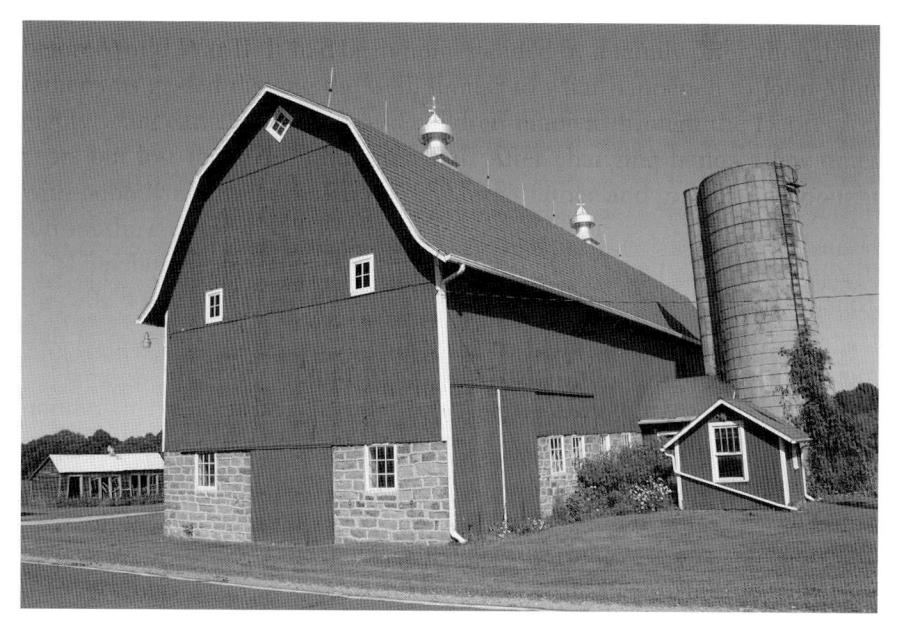

Dairy barn on the Shelton farmstead, present day. *Scott Wittman Visual, 2021.*

Agricultural College at UW-Madison at the time. The Franklin King system of ventilation for traditional barns was utilized, as well as an elaborate water system pumped by a large metal windmill.

A silo, milk house and small animal barn—all structures built in the early 1920s and '30s, likely by the Sheltons—remain on the farmstead today, along with a granary and machine shed, earlier structures possibly dating back to the Daweses.

The farmstead remains owned by descendants of the Shelton family yet today.

Viewing the property today, on the land cleared by Henry and Rufus, the home built originally by their hands, in the serenity of the countryside, one can still get a sense of the legacy that this old dairy farm represents. One can get a sense of the stories that Henry undoubtedly told Rufus and Ephraim about their great-grandfather and the rise of the Revolution and those values that Rufus, Ephraim and this community in Juneau County fought to the death to uphold.

In 1925, the vice president to Calvin Coolidge, Charles Gates Dawes, visited the farmstead of his father and grandfather in Seven Mile Creek. After laying a wreath at Henry's grave at Evergreen Cemetery, he spoke at the Juneau County Fairgrounds and watched a re-creation of his father delivering an impassioned speech after Fort Sumter was attacked by Confederate forces.

Upon a rollcall of names that was read of the original one hundred volunteers organized by Dawes at Mauston so many years prior, two faint voices were heard responding, "Present."

They were Franklin Wilcox, eighty-five, and Thomas Ellsworth, eighty-eighty—the last two surviving original members of Company K's Lemonweir Minutemen.

A solitary tile silo, still standing where it was once part of a larger farmstead, no other structure of which still exists. Along Highway 13, Wood County. *Scott Wittman Visual, 2021.*

Chapter 5

SKELETONS ON THE EASTERN RIDGE

Across the Mullet River in Plymouth, which separates the downtown commercial district from the industrial sector south of the city, stand several large, neglected factory buildings. Rising above a split in the railroad tracks, ancient white paint flakes off the structures in chunks, exposing the old exterior brick.

These buildings, the only ones remaining from the era, are from a past in Plymouth unique to anywhere else in the country—a past that witnessed, within decades, a dairy farmer pressing curd collected from his neighbors into cheese in his kitchen, to the city boasting the moniker, with cause, "Cheese Capital of the World."

The dairy farmer, John Smith, a New York native, was the first to attempt commercial cheese, which he made in his home, as a new industry in Sheboygan County in the mid-1800s. By the early decades of the twentieth century, the county was producing more cheese than any other in the world. The city of Plymouth, the center of much of that activity, would feature a business park in which most of that cheese was stored, aged, graded, packaged and shipped. The area came to be known as "Cheeseville."

"One of the industrial show places of the city is 'Cheeseville,'" the *Sheboygan Press* of February 8, 1941, would report about Plymouth. "In this center are all the large cheese concerns and visitors come from all parts of the country to view the capitol [*sic*] of the cheese industry in action."

MANY DECADES EARLIER, DESPITE John Smith's best efforts to sell his cheese, even taking it to bigger markets in Chicago, the endeavor proved unsustainable for him. His cheese was often passed over by merchants who believed any cheese not coming out of New York simply was not worthy. Finally, Smith offered a prospective buyer one dollar for thirty minutes of his time to inspect his lot of fifty-eight barrels of Wisconsin cheese. "So surprised was he at the quality and flavor of this first Wisconsin cheese that he took the whole lot and eight cents a pound."

The reputation of New York's cheese, however, was too much to overcome. As Smith's cheese was continually and prejudicially deemed inferior, sales lagged, causing him to end his enterprise.

Fortunately for the future of our state, his brothers Hiram and Joseph arrived in Plymouth, with Hiram carrying on the cheesemaking practice and Joseph later becoming an associate editor of *Hoard's Dairyman* and well known as one of the most influential agricultural writers in the state.

Hiram Smith continued making cheese as begun by his brother John, though he tweaked the process from collecting curd from his neighbors to collecting milk, therefore controlling the entire process, start to finish.

Hiram's brother-in-law Hiram Conover also tried his hand at cheesemaking in Plymouth and sent his son Seth to New York to learn the most advanced tricks of the trade. Seth Conover returned to Plymouth and became very successful in the trade, ultimately operating one of the most successful cheese factories in Sheboygan County.

As the cheesemaking industry in Plymouth grew, so, too, did the prominence of Hiram Smith and Seth Conover. Records kept by Conover's daughter Amy, who was his factory secretary, document several overseas trips Seth took to Europe, making him the first known exporter or Wisconsin cheese, as well as, according to the *Sheboygan Press*, "the largest dealer in the northwest."

As Conover is widely credited with the advent of commercial cheese in Sheboygan County, and thus the state, it is Hiram Smith who is credited, as mirrored throughout the state following W.D. Hoard, with forwarding the transition from wheat farming to dairy. As described in the *Sheboygan Press* in April 1917:

> *We had learned to grow wheat extensively as a money crop and it was hard to make the change but through the inspiration that the people of Wisconsin received through Hiram Smith, the veteran dairyman of Sheboygan County, we were brought to realize that we should abandon the ruinous process of wheat growing and turn to the dairy cow to solve this great problem*

> *of making Wisconsin one of the most prosperous agricultural states in the Union. Hiram Smith preached his doctrine well, not only through Sheboygan County, but all over the entire state. His hearers were convinced by his logical argument and immediately began seeding down their farms to grasses and clovers and where once stood their wheat fields scattered with Canada Thistles and other noxious weeds, roamed the dairy cow.*

It was also through much of Smith's effort and influence that the University of Wisconsin's College of Agriculture was created, becoming the first dairy school in the nation.

Due to the number of cheese factories beginning to successfully conduct business in Sheboygan County in the later decades of the nineteenth century, what eventually became Cheeseville began to form. The first warehouse for storing cheese was built in 1892, the first cold storage building for perishable merchandise was put up in 1895 and another soon after in 1899, along with three more warehouses, all rented to dealers in cheese. More buildings would eventually join them. As location always matters, the campus of Cheeseville

Lakeshire Cheese Company at "Cheeseville," Plymouth, Sheboygan County, 1936. *Courtesy of the Sheboygan County Historical Research Center.*

was set in between the Chicago, Milwaukee, St. Paul & Pacific and the Chicago & Northwestern Railroads, right where the tracks split.

Prominent cheese companies that set up shop in Cheeseville were Kraft-Phenix Cheese Company (eventually Kraft foods), Bamford Cheese Company and Lakeshire-Marty Cheese Company, all heavyweights in cheese production, as well as several cheese accessory and support companies. By the 1940s, roughly a quarter of all of Plymouth's population worked at one of the cheese concerns at the campus of Cheeseville.

Also producing cheese here was Pabst-ett, a quintessential-sounding Wisconsin product, as the beer manufacturer moved to making cheese during Prohibition. Pabst-ett was initially sued by Kraft for copyright infringement, as Kraft believed Pabst-ett's spreadable cheese was a bit too similar, but Kraft just wound up buying the brewery's cheese venture after Prohibition ended as the food giant's ways of consolidating the market began to increase.

Several blocks north of Cheeseville, across the Mullet River, sits one of the largest buildings in the downtown district of Plymouth. Two floors of red brick with Classical Revival architectural features sit atop a stone first floor. This building, a large commercial block on the corner of East Mill and South Stafford Streets, the geographic center of commercial activity in the city, was built as the Plymouth Exchange Bank in 1905. It had the bank on the main floor, office space on the second floor and a large ballroom on the third. The Exchange Bank, established in 1896, had outgrown its first location on Division Street before building this elegant structure, hallmarked by an overhanging terra-cotta cornice terminating the third floor.

Beginning in 1918, on the third floor of this building, the Wisconsin Cheese Exchange was organized, eventually setting the price of the commodity of cheese throughout the world. As Wisconsin was by that time the largest producer of cheese in the nation, 301 East Mill Street in Plymouth became the center for business across the entire state.

Before the Exchange, cheese dealers would purchase their products directly from the cheese factories, but as this proved inefficient, they created "call boards" utilizing telephones, new technology for the day. The call board would facilitate offers and bids, with the sale going to the highest bidder. As most buyers and sellers remained local to each other at the time, Wisconsin had many call boards throughout the state, though in 1918 these centralized in Plymouth as the Wisconsin Cheese Exchange. It was, however, an exchange in name only, as it was virtually still just a statewide call board.

That changed on August 19, 1938, when the bylaws of the Exchange were changed to establish the cheese prices of the nation. Promptly at 1:00 p.m. that day, Horace G. Davis, president of the Exchange, sounded the gavel, arose and briefly explained the rules. The *Sheboygan Press* relayed the scene after several "cars" (approximately forty thousand pounds) of cheese had been sold:

> *After the four carloads had been sold, Floyd Zimmermann, names interpreter as a disinterested party by the Exchange, walked over to the blackboard on the right of the big board and chalked up 10½ cents as the price for twins and cheddars and 11 cents as the price for daisies and longhorns. A moment later a telegraph boy rushed into the room and out again, and in the course of a few minutes the nation knew what prices for cheese had been established at Friday's meeting of the Wisconsin Cheese Exchange.*

For four decades, cheese was bought and sold the world over through the third floor in the old Plymouth Exchange Bank building, with meetings held every Friday. Because of the expansion of the Exchange and the influence on pricing around the globe, travel became an issue for Plymouth, as in the mid-twentieth century, Plymouth was only accessible from far distance by train or bus. Because of the need for better access for attendees, the board voted to move the location of the Exchange to Green Bay in 1956, citing its access to air travel.

For the next four decades, the Exchange, which changed its name to the National Cheese Exchange in 1975, continued meeting every Friday morning at 10:00 a.m. for thirty minutes. Although the Exchange never officially set prices for cheese, its closing prices were published weekly throughout the dairy industry, greatly influencing markets.

Dairy farmers, however, were skeptical. As the prices set for cheese heavily impacted the prices farmers were paid for their milk, farmers believed the Exchange was skewed toward large cheese manufactures, and the market was ripe for price manipulation. Evidence seemingly verifying their concerns was easy to find.

Due to the ongoing political upheaval regarding the distrust of the markets, the Exchange moved out of Green Bay and into the Chicago Mercantile Exchange in 1997. For the first time in eighty years, cheese was traded outside of the state that made the most of it.

By that time, Cheeseville had already begun its disappearing act long ago. After Kraft left for the greener pastures of Chicago in 1949, many of the

Cheeseville, Plymouth, Sheboygan County, 1940s. *Courtesy of the Sheboygan County Historical Research Center.*

Remaining buildings of Cheeseville, present day. *Scott Wittman Visual, 2021.*

other factories and warehouses also moved to larger industrial areas where product could be moved with refrigerated trucks over the highway system or were swallowed up by consolidation. Most of the buildings are gone now, wiped off the landscape after their usefulness had passed. A few, however, remain standing, as does the old Plymouth Exchange Bank downtown, remnants of when Plymouth really was the "Cheese Capital of the World."

Doing its best to stay true to that moniker today, Plymouth remains the home of several cheese giants in the industry, as Sartori, Sargento, Masters Gallery and Great Lakes Cheese all either produce or are headquartered in the city.

HEADING SOUTHWEST OUT OF our bustling capital city, past subdivisions and new construction, a broken-down old farmstead lies, quiet, on the side of the road. Buried under debris, overgrowth and disregard, the abandoned property looks out of place among the modern, hybrid vehicles streaking past at forty-five miles an hour, most unaware of the structures entombed under the brush.

A recently paved manicured bike path runs within feet of the farmstead's former home, giving those interested—of whom there aren't many—a glimpse of the foundation where the two-story, red-bricked American Foursquare farmhouse once stood. The ventilators along the roof ridge of the long dairy barn, standing south of where the house did, are seemingly the only items the thicket hasn't been able to canvas over.

This was the home and farmstead of the Herman Blumke family, lifelong residents of Verona, just south of Madison. Lying on the far western boundary of the eastern counties, where the scenic valleys are beginning to be replaced by the ridges of the Driftless area, Verona retains a rural feel, though its proximity to urban areas just miles to the north likely makes many of these acres of farmland "opportunities for development."

The Blumkes built the house around 1920, the exact dates and year seemingly not documented. Here, Herman and his wife, Emma, farmed and raised their family, consisting of four sons and three daughters. Their last child, Herbert, passed away in infancy, living only one day in October 1930. Sons Robert and William Blumke both stayed and farmed the family homestead the entirety of their lives, passing in 2003 and 2007, respectively.

Herman and Emma Blumke were born in Dane County, both first-generation Americans to German immigrant parents. Upon moving to the property, they commenced building their farm and their livelihood.

Blumke farmstead seen approaching from the bike/walking path, present day. Vernoa, Dane County. *Scott Wittman Visual, 2021.*

The timber-framed barn sits on a stone foundation with vertical wood plank siding, cracked, wrecked and broken through years of weather and neglect. An attached milk house sits alongside, its metal roof peeking through the wild grasses. One concrete stave silo is visible behind the wayward branches of a large willow, likely hiding others as well.

A long, rectangular machine shed, somewhat mirroring the dairy barn, stands right off the path to the west of the farmhouse foundation, with large wooden sliding doors hanging open, displaying piles of debris inside. Extension cords. Boxes. An old tube TV.

This property was last surveyed by the Wisconsin State Historical Society in 2019, when it documented twelve standing structures still on the property, including the house:

2019—

The two-story American Foursquare farmhouse was constructed c. 1920. It is sheathed in red brick with decorative belt courses around the roofline and raised basement; the foundation is not visible. The low-pitch hip roof

is covered in asphalt shingles and features a central brick chimney and flared, wide eave overhangs with original wood soffits accented by decorative wood brackets at the corners. Central hip-roof dormers with flared eaves project from the front (north) facade and side (east) elevation; they are clad in clapboard siding. Additional American Foursquare features include the house's square massing, broad proportions, and a one-story, full-width porch. Windows are a mixture of original, wood, three-over-one, four-over-one, and multi-pane fixed; in addition to one-over-one replacement metal. The windows feature original wood surrounds and decorative brick lintels and sills. The front, side, and rear entry doors are original, multi-light, wood fixtures....

The interior of the vacant house was visible through windows during field survey. Fixtures appeared to be largely original including wood floors, wood trim around windows, and a wood staircase. The interior layout follows the typical American Foursquare plan with four large rooms on each of the two floors. The central entrance is also common of some American Foursquare variations.

In December 2015, the UW-Milwaukee Cultural Resource Management staff conducted a field survey of the town of Verona "to identify the finest representative historic farmsteads." The Herman Blumke Farmstead was one of those identified as an "important cultural resource" on which "future planning within the community should minimize the effects…in order to preserve the character of the community."

Upon my visit, two years after the historical society survey, only the foundation of the house remained. Six of the twelve structures were still standing or at least within view through the sea of wild shrubbery.

THE BARN ON THE Blumke Farm was originally built around 1920, although much of it was destroyed in a 1928 tornado and rebuilt in 1930. The tornado is still remembered in the upper Midwest region today.

On Friday, September 14, 1928, a tornado touched down in Rockford, Illinois, leaving a swath of destruction and multiple deaths. The region had already been reeling from tornados in Nebraska and South Dakota, which had taken a dozen lives earlier in the week. After leaving behind 14 dead and 250 wounded in Rockford, the tornado came up through Dane County, sweeping through Middleton and Verona and right through the Blumke Farmstead.

The *Capitol Times* of the following day describes the destruction to area farms:

> *Before hitting the Gordon Schoolhouse in Verona township, barns, windmills, silos, and many other farm buildings were blown down in that township. At the George Gordon Farm, the barn was blown off its foundation, and all small outbuildings and the wind mill were blown down. Windows and doors were blown in on the dwelling house.*
>
> *Windows were blown in and trees were felled on the Jesse Gordon farm in Middleton township.*
>
> *The roof was blown off and doors and windows blown in on the dwelling house and the machine shed was wrecked on the Herman Blumke farm in Verona Township. The wind mill blew down and the poultry house was demolished. The lid blew off the cistern and many chickens were blown into and drowned.*
>
> *Coming into Middleton township, the storm passed about a mile and half east of the speedway, taking all the buildings except the dwelling of the Wilbert Westphall farm. At the C.E. Easton farm all the small buildings and the silo was demolished.*

The wooden-framed, 1859 Gordon Schoolhouse was destroyed when the roof collapsed, with twelve students and a teacher in the room. All survived, as the teacher, Mrs. Seeley, huddled all the children under the piano, which covered them from falling debris. The school was rebuilt in brick the next year.

Drought, flooding, heat and severe cold all pose serious threats to dairy farmers in Wisconsin, though it seems tornados have been the recurring scenario that causes the most devastating damages. Memoirs, journals and newspapers retell the terrifying ordeals in archives throughout the state.

A tornado hit the Frank Ballweg farm on top of Springfield Hill, seventeen miles north of Madison in Dane County, in July 1948. Frank's ten-year-old daughter, Lucille, was killed, and Frank, his wife and all nine of their other children were hospitalized with injuries.

A 1994 tornado swept through Adams County, killing two people and causing almost $5 million in damages, most of this to dairy farms.

Jeff Severson was milking his cows when the funnel cloud hit his farm, taking out his barn, house, silo, shed, car and 75 of his 125 cattle when the barn's ceiling, supporting sixteen thousand bales of hay, fell onto the cows. The *Burlington Free Press* reported, "C.M. Putnam, 45, was instantly killed

Top: An unidentified farm destroyed by a tornado, circa 1940. *Courtesy of Jackson County Historical Society*.

Bottom: Blumke Farmstead, present day, Verona, Dane County. *Scott Wittman Visual, 2021*.

when struck by a bolt of lightning as he stood in a barn doorway of his farm east of Darien, Wisconsin, Tuesday afternoon. His brother, Roy, sitting beside him, was stunned."

The Blumkes were able to rebuild when a tornado, remembered throughout an entire region a century later, tore through their farmyard. Many others are never able to recover.

Herman passed away at sixty-one in 1948, five years after his wife, Emma, died at fifty-one in the sanitarium at Prairie du Chien. The farm that they built for themselves and their family continues to lie empty along a busy suburban road, calling out to anyone who will listen.

SIMILAR TO THE DESERTED Blumke Farm and countless other abandoned remnants throughout the state, another relic stood, broken in its beauty, along a highly traveled highway entering one of Wisconsin's most treasured destination areas.

Door County has many nicknames, it seems, "Cape Cod of the Midwest" being the most popular. "The California of the North" is also prevalent. All of them are in reference to the more than three hundred miles of shoreline and small coastal towns featuring boutiques and art galleries that drive tourism to the area.

Early settlers of the peninsula had a bit of a different view, however, as the rugged rocky ground and limestone bluffs proved brutal for most. Some, who were able to hammer out a living quarrying the rock, reaped the benefits, but the thin soil was a barrier for many early comers to Door County, especially after the timber had been exhausted.

Several hundred Belgian immigrants, who had just survived a disastrous journey to Wisconsin from their homeland in the mid-1850s, settled in northern Brown, as well as parts of Kewaunee and southern Door Counties, as they were virtually the last remaining vacant lands available. Today, their Belgian heritage is part of our own, influential through the area still, over a century and a half later.

As the popularity of dairy farming lagged in northeastern Wisconsin, early agriculture centered on wheat, as in the rest of the state, as well as peas. The Reynolds Preserving Company began canning peas in 1896 in a large cannery in Door County, one of the first three canning operations in the state. By 1907, the company was outputting over 3.3 million cans and employing over two hundred people.

"Door County was the pea capital of the world," said local historian Don Rudolph. "More peas were grown here from 1895 to 1915 than anywhere else in the nation. There was big money in that for a while."

Reynolds Preserving Company's business, however, was unsustainable. As in wheat, growing peas was slowly killing the already rock-infested, shallow soil they were able to plant in. Only about a quarter of the crops planted were able to be utilized for product, and in 1917, they transitioned from canning peas to canning cherries.

"Right about the time the pea cannery shut down," Don relayed, "that's when my grandfather put up a silo and built a dairy barn. They had no other choice."

Around this same time, embodying the initial successes of recruitment efforts in the Northwoods two decades prior, Door County also began

A Door County farmstead displaying rocky ground, 1940s. *Library of Congress.*

promoting itself as a dairy haven. In 1914, the Door County State Bank published a promotional booklet pushing the success of the dairy industry in Door County, before one even existed:

> *While the dairy industry in Door County is only in its infancy, the fact that it has met with such a marked degree of success may be attributed to a large extent to the fertility of the soil and the certainty with which crops and grains are grown each season. The lime soil of Door County is a natural clover producer and with the length of the growing season corn can be grown in an abundance for ensilage and fodder. It is a recognized fact that grasses grown in latitudes such as the Door County peninsula are more palatable and more nutritious than those grown farther south. The grasses here grow faster in the early summer because of longer days and more sunlight, which is conducive to the formation of starch and sugar in plants, and this makes hay, forage crops and small grains very nutritious for the feeding of the dairy cow.*
>
> *In order to produce a large quantity of rich, wholesome and sanitary milk dairy cows require clear, fresh water. Door County has a large number of*

natural flowing fresh-water springs, small lakes and streams conveniently scattered throughout its territory. Climatic conditions have a decided effect on dairy cows. Where there is a long growing season, plenty of sunshine, good forage and clear fresh water, one will find healthy stock producing maximum returns. In cooler weather dairy cows need to be well housed. One of the noticeable things which impress one traversing Door County is the great number of large, warm and sanitary barns found on nearly every farm and which are the pride of the community.

Those "large, warm and sanitary barns" were not due to the dairy industry, according to Don Rudolph.

"The big, beautiful barns you still see today were bought with pea money. By the time dairy really took hold here, this would be 1914–17 or so, pre–World War I years, prices were good. Dairy was really fostered in up here with good times. Those barns stopped being built after World War I."

In 1917, the Van Camp Company, which had earlier operated a cannery that had closed, reopened its factory in Door County as a condensory, with a contract with the U.S. military, doubling the price for milk that local cheese factories were able to pay. Echoing the happenings in New Glarus with Pet Milk, the thirty-five cheese factories and five creameries that had sprung up in Door County were no more.

IN RECENT DAYS, TOURISTS driving north into Door County, at the split of Highways 42 and 57, would pass a scene unchanged in many decades, except for the continuing deterioration of the buildings that remained there. Featuring a main house, several barns and smaller tenant houses, the neglected farmstead of Meyer Klass, one of the most colorful and infamous characters in the town of Sevastopol's recent history, was reaching a reckoning.

The barns one would see along the highway were likely commissioned by the original owner of the property, Solon Birmingham, a prominent resident of Sevastopol's early days. A New York native, Birmingham served in Company K of the Thirty-Fifth New York Militia in the Civil War. Participating in action in the Battles of Cold Harbor, Petersburg, Fisher Hill and Bermuda Hundred, he was ultimately captured and imprisoned by Confederate forces and released at Appomattox following Lee's surrender.

After the war, Birmingham returned home to New York to begin family life, where he stayed until his wife passed away in 1879. Looking to engage

in the logging industry, Birmingham then came with his brothers to Door County, where he eventually purchased this plot of land, eighty acres in Sections 27 and 28 in Sevastopol township. According to his biographical sketch in the *History of Door County Wisconsin, the County Beautiful*, "For many years he industriously cultivated his fields and looked after his stock but for some time before his death lived practically retired, enjoying a period of leisure to which he was well entitled. He passed away on the 6th of March, 1913, and his demise was the occasion of widespread regret."

By 1938, a somewhat mysterious personality was living on the property, making a name for himself that still permeates today, five decades after his death. With conflicting documents stating his place of birth on Christmas Day 1898 in both Illinois and Lithuania, Meyer Klass owned one of the largest dairy herds in Door County at the time, milking over fifty cows on his farm, a large number for the day. Never personally milking the cows, Klass always had hired help who would live on the property. Klass himself seemingly spent more of his energy on the implement aspect of the business, as he was also a dealer in Case tractors. "When You're Under the Wire— Buy From Meyer and Save Money" is strewn about in every area newspaper of the day. Meyer's reputation of a conniver, however, still resonates with those who knew him.

"I remember playing over there while my dad was talking business with him," Don Rudolph said. "One time, my dad had a flat tractor tire, and he took it to Meyer to have it fixed. Went back the next day to pick it up, and Meyer had sold it to someone else," he said, laughing. "Gave my dad a crappy tire to use instead.

"Those are the kinds of things he did. And he always said, 'Oh, I got such a deal for you. Such a deal for you,' while he chewed on a cigar. He never smoked it, just chewed on it constantly."

Don then relays how the adjacent property owners once wanted to purchase ten acres from Meyer, which he said he'd be more than happy to do, and then quoted them three times the actual value. Desperate for the land, the owners got a bank loan to purchase the property, but Meyer made them borrow the money from him. "And he charged them 2 percent higher interest than the bank and wouldn't let them pay it off early," Don relates, still laughing as he reminisces about the notorious Meyer Klass.

As he was always looking for hired hands to milk his cows while he managed the implement, newspapers are flush with classified ads placed by Klass, as in the *Green Bay Press Gazette* in 1956:

MARRIED MAN WANTED to operate and manage a 120-acre dairy farm. All new machinery to farm with, such as combine, chopper, baler, and tractors. All new modern house to live in. $200 per month and bonus…. Do not apply for this position unless you are a first-class farmer and know how to handle Grade A milk.

Ten years later, he was selling his cows, placing adds exclaiming, "Must sell. Having labor trouble."

By 1978, he was dead. His buildings remained untouched until 2020. Ownership of the farmstead moved to his only living relative, a niece who lived in New York City, who continued paying taxes on the property for many years, until she didn't.

The buildings decayed. The barns crumbled. The tenant house resembled a time capsule from the 1970s with old TVs, card tables and floral-patterned curtains to go along with ripped-up green carpeting and ancient vinyl tile flooring among mid-century lamps tipped over under a caved-in ceiling.

The age of the farm buildings isn't specifically known. "The original barn, the one that's facing the road," Don continues, "that had a

Meyer Klass's home as it stood for decades after his death. It was razed in 2020. Sevastopol, Door County. *Scott Wittman Visual, 2020.*

Meyer Klass's barn in the process of being razed, 2020. *Scott Wittman Visual, 2020.*

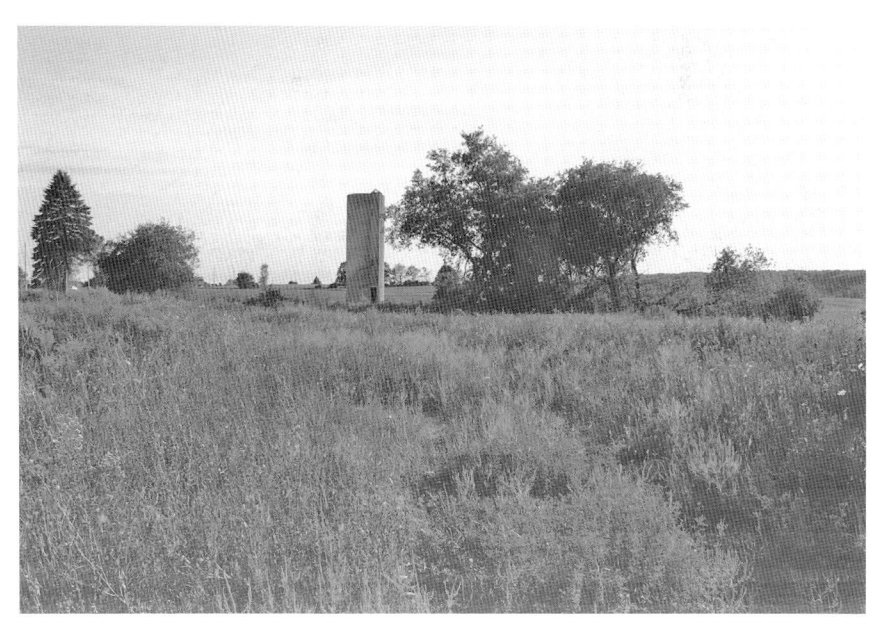

A lone silo remains the only sign of the Meyer Klass property, Sevastopol, Door County, 2021. *Scott Wittman Visual, 2021.*

German cross on it, which was the signature of a builder by the name of Peter Schaubel. So, we know it was built sometime before Peter Schaubel died."

The August 22, 1901 edition of the *Readsville Herald*—a four-hour drive from Door County—reported the demise of the well-known barn-builder:

> *STURGEON BAY: Peter Schaubel committed suicide at an early hour this morning by cutting his wrists and throat with a razor. He had been drinking freely of late, causing his family to leave him. They refused to return to him and he killed himself. He was about 60 years of age. Most of his life has been spent in this county* [Door] *and city.*

The buildings came down in the fall of 2020. After the land was condemned and the owner refused to clean up the property, the town had legal authority to do it themselves.

A solitary concrete silo, along with ghost tracks through long grass, is all that remains of 140 years of farming activity on this forty-acre tract of land entering picturesque Door County.

"He [Meyer] always had a new Cadillac," Don said. "That's just one of the things I'll always remember about him."

DURING MY RESEARCH FOR this project, I viewed thousands of photographs of our state's dairy heritage. Many that I was struck by illustrated traditional barn raising ceremonies, when communities looked out for one another and offered help when help was needed. Barn raisings were common in the nineteenth and early twentieth centuries, when friends and neighbors would collectively build or rebuild a barn for a community member.

As it was not unusual for attendance to number one hundred or more people at a time, depending on the expected size of the project, and culminating in a massive outdoor celebration with large amounts of food and often a dance, barn raisings were how communities met one another, socialized and stayed in touch when the "neighbors" were several miles away. One particular barn raising kept drawing my attention, and I chose to take a closer historical look.

Taking place on the Frank Freihammer dairy farm in the town of Wilson, about six miles south of Sheboygan, the old photos pulled me in, as they were a tremendously detailed illustration into a long-gone past, preserved only in these 115-year-old photographs: The builders holding a small tree at

Barn raising at the Freihammer farm, town of Wilson, Sheboygan County, 1907. *Courtesy of the Sheboygan County Historical Research Center.*

the top, signifying the framing of the structure was done and it was time for the beer to flow. The men holding their beer mugs up for the camera after a long day's work was done.

I wanted to find the barn.

Frank and Anna Maria Freihammer originally settled in Wilson after emigrating from Austria in 1859. The farm in the photo was that of their son Frank Jr., a widower, as his Bavarian-born wife, Augusta, died in 1889 at the age of thirty-nine. Before her death, she bore seven children, one of whom, Michael John, took over operations of the dairy farm after Frank Jr. died of a heart attack while driving a milk wagon back from a cheese factory eight years after these photos were taken.

Michael went on to become one of the more successful dairy farmers in the area, consistently having the highest butterfat tests of the Falls Wilson Cow Testing Association—cows that were housed in the barn being built in the photo.

Barn raising celebration at the Freihammer farm, town of Wilson, Sheboygan County, 1907. *Courtesy of the Sheboygan County Historical Research Center.*

Also occurring in the barn was something much more tragic, as a hired farmhand committed suicide by poisoning himself in the hay loft while Michael was vacationing in Minnesota in 1929.

Michael's life also ended tragically just twenty-six years after these photos were taken, when, at the age of forty-six in 1933, he was driving along County Trunk KK, not far from the farm, when he was struck by another vehicle. Michael was thrown through the windshield and run over by his own car. His twelve-year-old daughter, Veronica, was in the car with him, unharmed.

There is always something of an intrusive feeling when looking at a photo of people from long ago whose fates I know. Their victories, their unforeseen pain—all of it yet to come after this fraction of a second in time they are captured in, that I, decades later, can witness.

I was unfamiliar with the area, but subsequent research seemed to show that the barn was still standing. Soon, I was en route to see this place that

had been the scene of so many human emotions over the last one hundred years. Joys, tragedies, laughter, sorrow. I wanted to see the farmyard where such a jubilant celebration was held in the shadow of the barn that was built by neighbors helping neighbors.

But as is often the case with historical research, it was inaccurate.

The suburbs beat me to it.

Present-day scene of the old Freihammer farmstead, currently being lotted off for new homes. *Scott Wittman Visual, 2021.*

Chapter 6

SURVEYING THE LANDSCAPE

While traveling on the rural Terrytown Road, just a few miles outside Baraboo in Sauk County, west of the intersection with Cornfield Drive, an ancient-looking, three-story stone building rises on the side of the road. As it's the only structure on the south side of the roadway for quite a stretch, opposite a string of clean, well-maintained houses and smaller farms, the building easily catches your eye. The somewhat archaic appearance looks a bit out of place along this quiet country road with green, manicured lawns and straight-lined crop fields.

Standing so close off a moderately driven road, it's easy to get a close look at the building. With no distinguishing characteristics easily visible, it's likely most passersby have no inkling of what the structure is, or was, as there is no plaque, sign or recognition of any kind that the unique structure is anything of note at all.

Such acknowledgements are often subjective, as many aspects believed by some to be noteworthy are dismissed by others; however, it would seem to be commonplace to believe one of the oldest intact dairy-themed structures still standing in the Dairy State, which at one time was producing butter deemed by esteemed organizations that know to be the best in the world, would demand some bit of stature.

Built initially as a cheese factory around 1868 by the owner of the 240-acre farm at the time, Nelson William Morley, it was used as a creamery to make butter after Morley's twenty-year-old daughter quit her teaching job to run the dairy operations on the farm. Fannie Morley later stated that she

An unidentified dairy barn, central Wisconsin, circa 1940s. Photo by Andrew J. Mueller. *Courtesy of Marge Van Heuklon Private Collection.*

spent nearly half of her time working on the farm in the creamery. Utilizing only her own experience of trial and error, along with reading dairy trade publications and convention reports, Fannie learned to perfect her butter-making methods, at a time when butter made here was mocked throughout the nation as "western grease."

At the base of a small bluff on the property and in proximity of where the Morley farmhouse stood, a spring produced fresh sparkling water "sufficient both in quantity and quality for use in the house and creamery, also for watering stock," Fannie would later write. "It is an established fact that good water is one of the most essential things requisite for making first-class butter." In what seems like a fairly sophisticated system for the day, the spring water was pumped through iron pipes from a large water tank in the spring house and finally into a large wooden tank in the milk room of the creamery.

After Fannie won the Sweepstakes Butter of the World Prize, naming her butter as the best in the world, at the 1879 International Dairy Fair, the forerunner to today's World Dairy Expo, W.D. Hoard and the Wisconsin Dairyman's Association requested her presence at the 1881

annual convention, where she was interviewed and asked to write about her processes.

After the milk was collected, strained and poured into four large pans of 650 pounds of milk each, she wrote:

> *Milk is skimmed after standing twenty-four to thirty-six hours. Usually it is not curdled, only slightly acid. My cream as I skim it from the milk is poured into a tin can holding thirty gallons, which, when full, constitutes a common-sized churning. Churn by horsepower, and usually four times a week. Because it is most convenient to do so, my cream stands overnight and is churned early the next morning before the children go to school, as it requires someone to drive the horse. The cream is put into the churn at a temperature of about fifty-eight degrees, the butter color is added, and the churning begins. Think the better way is to churn slowly until the butter forms in little pellets the size of wheat grains or smaller. Then draw off the buttermilk, add a bucket of strong brine made of cold spring water and Higgins' salt; wash the butter, draw off the brine, and salt while yet in the churn, at a rate of one ounce of salt to one pound of butter; work in the salt, remove the butter from the churn and let it stand eight or ten hours before working over and packing.*

A present-day view of Fannie Morley's creamery, rural Barbaoo, Sauk County. *Scott Wittman Visual, 2021.*

Despite her successes as a champion butter-maker, Fannie's life did not culminate in such a positive way. Around 1885, she moved to Honolulu, Hawaii, as an unknown illness forced her into a milder climate. There, she became a music teacher at the Kawaiahao Female Seminary, making improvements at the institution that made her "much beloved" in the community. After teaching for three years, Fannie became ill in May 1888 and never recovered. After ten days, she died of what newspapers called "sad and peculiar circumstances." She never made it to her twenty-ninth birthday. Her family had to wait until late that September before her body was returned home to the farm.

The creamery that she used to spend so much of her time in is still standing where it always was, right across the road from the old Morley farm. Now, however, nobody is piping in fresh spring water to make butter. Some of the windows are boarded up with planks of wood, themselves antiques, several of which have fallen out, giving the air and the elements free reign.

Although the windows and the roof don't seem to be in it for the long haul, the three-story stone structure itself doesn't seem to be going anywhere, as it stands sturdy as it was the day the Morleys put it there a century and a half ago—just exactly as you'd think a world champion would be.

SMALL FAMILY-OPERATED CHEESE FACTORIES and creameries played a vital role in the shaping of Wisconsin culture throughout the latter decades of the nineteenth century and well into the twentieth. Crossroads cheese factories were part of the fabric of the landscape, reaching a peak of over three thousand documented in the early 1920s, although there were almost certainly more than that.

In early days, milk cans were hauled every day by a horse and wagon team to a central location. Because transportation was much more cumbersome and difficult than today, when a few miles could take hours, the factories became numerous and only a few miles apart, depending on the number of farmers in the area. Cream was separated and brought to a local creamery usually on a weekly basis.

The factories became the hub of the community, where farmers and haulers would congregate to socialize and talk of the news of the day, as the milk was delivered in the morning, creating timely, natural gatherings. Where there were cheese factories, there were farmers, and where there were farmers there were hardware stores, grocery stores, farm implements

Ourtown Cheese factory, Sheboygan County, 1892. *Courtesy of the Sheboygan County Historical Research Center.*

and so on, creating the modern-day rural small town. Oftentimes, children were dropped off at school by the milk wagon conducting the morning drop-off.

Eventually, the small family-owned factories were having trouble keeping up with larger companies that saw openings in the market. The drawbacks of the small factories were well known, and competition with companies with higher levels of capital proved daunting. The economics of it were quite elementary and easy to understand, as smaller cheese factories that took in less milk had a more difficult time compensating dairy farmers. As the amount of milk taken in and processed was the most important factor in efficient operations, companies with larger-volume capacity were able to make cheese at a lower cost, received better pay for what they sold and were able to pay dairy farmers higher prices for raw product.

What used to be a landscape of crossroads cheese factories and creameries simply fulfilling a market with available product, soon became a struggle of the haves and have-nots for survival. Farmers like Sherburn Mabie went where it worked for them.

Germania Creamery, Marquette County, circa 1890. *Courtesy of Marquette County Historical Society.*

"First, I started at Woodlawn. Then I went to Zorns. AMPI [Associated Milk Producers, Inc.] bought out Zorns, and I didn't like them, so I went to Morning Glory. Then AMPI bought Morning Glory, so I ended up back with them."

By 1930, the landscape had already begun to visibly change. Smaller factories were going away, either being whisked away by a wrecking ball, converted to a residence or other place of business or abandoned. The *Sheboygan Press*, in April of that year, posted an editorial titled "Bring Back the Corner Cheese Factory," in which it excoriated dairy farmers for passing control "from the little fellow to the big fellow."

> *The cheese industry that we have acquired is an inseparable part of our daily life if Wisconsin is to thrive and Wisconsin farmers are to prosper. Selling the raw milk to a Milwaukee, Chicago or New York market may be inviting for a time but the day that you see the cheese factory eliminated through your lack of support, that day will you witness a dislocated dairy state.... Do not be led into a false position by the statements that consolidations are for the benefit and prosperity of our people. We are having too many consolidations and too many mergers in the competitive field today. When you kill off an enterprise you are jeopardizing the nearby communities and you are hastening the day for tomb stones.*

Abandoned Woodlawn Cheese factory, Price County. *Scott Wittman Visual, 2021.*

The tombstones were already piling up. Kraft was one of the largest companies buying up much of the dairy market in the state, as illustrated by Joe Hermolin of the Langlade County Historical Society, as he wrote in 2018:

> *In 1923 a major change in cheese production occurred. At the time there were 31 small cheese factories in Langlade County. Kraft Cheese, based in the Chicago area, expanded and purchased a small Antigo-based creamery. Kraft expanded production, took over the closed Antigo Brewery (due to Prohibition) and grew into the world's largest cheese producer. Kraft began purchasing milk at prices slightly higher than what small local factories were offering. Within two years it is estimated that about half the milk produced in the county went to Kraft. Kraft bought out the [C.E. Straubel Cheese Company] creating concerns among farmers and local businessmen of a monopoly.*

Pat McCormick knows firsthand the wreckage that consolidation in the first three decades of the twentieth century created for today's market.

"I used to think I make cheap food for the American consumer. I don't do that anymore. Now, I provide cheap raw product for the milk plants to make lots of money from. There aren't any family-owned cheese factories anymore. They're all CEO'd."

Rock Cheese and Butter Factory, Auburndale, Wood County, circa 1900. *Courtesy of North Wood County Historical Society.*

A likable guy with a quick, sarcastic wit, Pat has been working the same farm his parents did before him in Price County, although now he's looking to sell. Along with Dennis and Beverly Brayton, I visited Pat on his farm on a hot July afternoon.

"I've been farming…it's gonna be forty-nine years. But you gotta have money if you're gonna keep going."

"Years ago," he pauses, accentuating the timeline, "years and years ago, most companies, if they made 5 percent profit, they were happy. Took care of their employees and everything else. Then they got to a point for a few years where they were making 10 or 15 percent before the numbers went back down again.

"Well, of course you had the stockholders [who got involved], and they had to figure how to make those profits back. Labor is always the biggest expense, right? So, you can see where that was going.

"But without us, they have nothing, you know? Someone's gotta make this stuff."

Dennis Brayton offered advice on my quest to explore the demise of the culture of small family-operated cheese factories.

"Talk to the Kraft boys."

ONE AVENUE SMALLER FACTORIES took to try to combat their impending demise was the formation of cooperatives, with farmers pooling resources together to operate for the benefit of their members and not investors.

In 1938, the executive secretary of the Wisconsin Council of Agriculture, Milo K. Swanton, told a grouping of two hundred dairy farmers that the

state and the university would begin work for the promotion of farmer co-ops. Although he "would not predict the elimination of the cross roads cheese factory," he highly suggested that farmers begin changing course.

The benefits of organizing as a co-op were seemingly obvious, mostly increased bargaining power over the sale of their raw product. Without such an organization behind them, individual farmers were all but powerless when it came to receiving a price they deemed acceptable.

"No matter how much milk you produce, you have to have a market for it," explains Sherb Mabie. "A farmer could decide, 'I'm going to double my operation,' and the minute the milk hits the bulk tank and the truck picks it up, he's got a market for it—but he doesn't have his price. The farmer isn't able to name his own price."

There were other benefits with organizing into co-ops, including more oversight over the quality of the raw product, uniformity in the final product and saving money on large purchases by combining financial supports.

Prior to the obvious obliteration of the small cheese factory and the push for cooperatives by the state and the Agricultural College, the small town of Westfield in Marquette County already had a couple-decade head start. In 1906, eighty-eight dairy farmers in and around Westfield organized a butter and cheese association, a progressive move for the day, which took a fair share of vision and a lot of courage.

"If you have money, you can make money, because you can take a risk," Pat McCormick relates. "Whereas us little guys that don't have any money, it's a lot harder for us to take those risks."

But farmers like Pat have to take risks all the time, as he did this past year when he contracted a portion of his milk due to the Covid-19 pandemic. It turned out to be a net negative move, as he lost money.

It was a risk for those eighty-eight farmers in Westfield in 1906, just like it was a risk for Isaac Shepard and thirty-nine other farmers in and around Pleasant Ridge two decades before when they organized into co-ops to market and process their own products together to achieve the highest possible price.

What would become the Westfield Dairy Co-op Association set up its first creamery in an old wood-framed building and opened for business. Initially only dealing in butter, operations were successful enough to move into a much larger brick building just north of the creamery in 1928, with another large addition added in 1949 after cheese production began in 1941 and milk retail and delivery in 1945.

Original Westfield Creamery building, Marquette County, circa 1910. *Courtesy of Marquette County Historical Society.*

By 1954, the initial 88 members had grown to 468, utilizing a factory producing 26 million pounds of milk, 2 million pounds of cheese and 200,000 pounds of butter annually, while supporting the families of close to 50 full-time employees, making the co-op "the most important single employer in the area" at the time.

Just five years later, the Westfield Dairy Co-op ran an advertisement in local newspapers that displayed a changing climate. In terse and somewhat cryptic ad copy, after touting its successful history since 1906, the advertisement changes tone, as in the January 23, 1959 edition of the *Portage Daily Register*:

> *THINK IT OVER!*
>
> *After 52 years of service to Westfield area, your cooperative is being taken for granted. Its importance to all whom it serves is likely to be ignored.*
>
> *Supposing the plant and all of its facilities were to mysteriously disappear overnight. To have something and lose it brings to realization of worth.*
>
> *If the sun quit shining you'd realize how truly wonderful it is. Imagine your Westfield Co-op as a smaller sun, but shining just as brightly within its sphere. Don't let its constant shining blind you to its great day by day importance.*

Westfield Co-op staff photo, circa 1940s, and present-day view of abandoned building. *Courtesy of Marquette County Historical Society (*top*) and Scott Wittman Visual, 2021 (*bottom*).*

Two years later, citing an overlapping service area, Westfield Dairy Co-op Association merged with Portage Cooperative Creamery, located about thirty miles south. They formed a new organization, Central Wisconsin Co-op Dairies, increasing their raw milk producers to over eight hundred. This, in turn, merged with Alto Cooperatives of Waupun in 1971.

By 1984, the Westfield plant was put on "standby" basis by Alto, which had built a brand-new cheese manufacturing plant northwest of Waupun, and "would be maintained for cheese production when needed."

Antigo-area farmers also countered the rise of Kraft with the organization of the Antigo Milk Products Cooperative in 1930. Under the guidance of the College of Agriculture, they worked to secure four hundred members in Langlade County. They received seven hundred.

A building was completed in 1931, and the first deliveries were made in March of that year. Even through the lean years of the Great Depression, milk strikes and low prices, the co-op was successful and was soon a member of the Land O' Lakes Creameries, Incorporated, with representation on the board of directors.

For four decades, the Antigo Milk Products Co-op provided a robust and fair market for Langlade County dairy farmers. In 1970, the organization was absorbed into the American Milk Producers Incorporated.

The building was initially repurposed for other industrial operations and now is part of the Antigo Unified School District.

The Westfield Dairy Co-op Association's building wasn't afforded the same productive future. The "when needed" never came, and the large red-brick building, built in 1928 after those eighty-eight farmers took a risk and organized together, lies dormant and neglected today. Somber in its current state, it still remains a reminder of when "the little fellow" took back control of the industry that has seemingly always been trying to push him out.

Our landscape today is a palette of our ancestors' dairy-related endeavors, some realized to full fruition, others crushed. Since the number peaked in Wisconsin during the years leading up to World War II, the state has lost over 190,000 family-operated dairy farms—a complete cultural shift in less than one average human lifespan. The number of ancillary businesses lost that supported the dairy industry will never be known—the cheese factories,

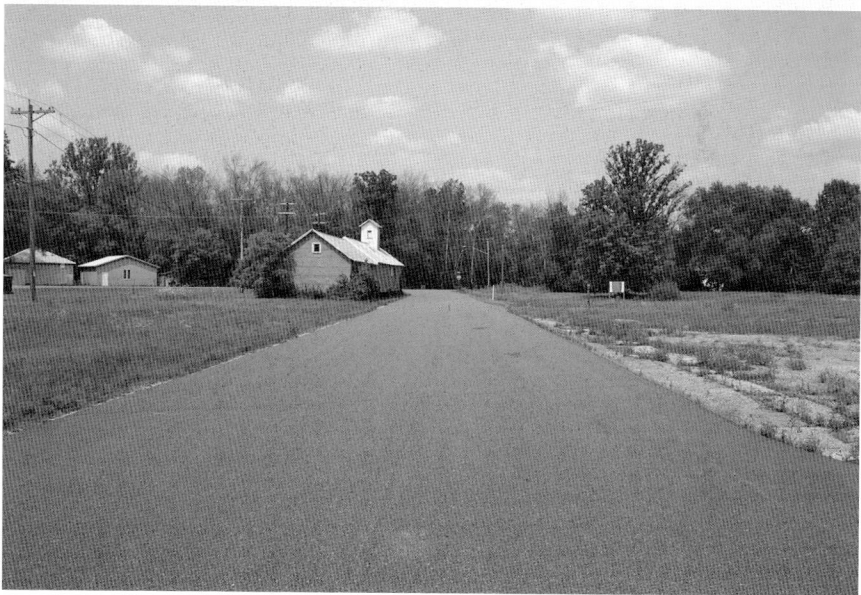

The Westfield Co-op fleet of trucks and drivers has long vanished. Circa 1950 and present-day views. *Courtesy of Marquette County Historical Society (*top*) and Scott Wittman Visual, 2021 (*bottom*).*

Butternut Creamery, circa 1900, and the same site at present. *Courtesy Butternut Area Historical Society (*top*) and Scott Wittman Visual, 2021 (*bottom*).*

creameries, condensories, farm implements, feed mills, warehouses, cold storage, milk haulers, packagers, shippers, truckers and endless others.

Many of these buildings have been physically wiped from the scene. Others have been repurposed or remain standing as they were, empty, as

Monroe "Cheese Row," circa 1940s, and the present view, now a parking lot. *Courtesy of Monroe Public Library (*top*) and Scott Wittman Visual, 2021 (*bottom*).*

the world passes them by, further distant every day. Old farmyards have become parking lots. Factories and warehouses have become industrial condominiums or shopping centers, targeting a generation of young adults today who are more likely to have never set foot on a dairy farm.

Still, there are those lions in winter that survive, such as Fannie Morley's creamery and Alga Shiver's round barns—structures that remind us of the days when dairy was king and a state was grateful.

FEW CHARACTERIZATIONS ARE MORE emblematic of nostalgic dairy-themed Americana than the milkman. Home milk delivery from dairies and creameries was routine through the first half of the twentieth century. Residents would place orders with the delivery driver and would then have fresh milk and other dairy products delivered right to their front doors the next morning. They would often leave insulated boxes on their porches for the milkmen to place the products in, while taking and reusing the empty glass bottles the milk came in the day before. Home dairy delivery was so ingrained in American society that many new homes built in the 1930s and '40s had milk boxes built in to the porch or side of the house.

In Manitowoc in the early days of the 1900s, that milkman's name was Alois Fischl.

Born in Bavaria, Germany, in 1880 and immigrating with his family to the Chicago area at age twelve, Alois eventually made his way to Francis Creek in Manitowoc County and began working as a farmhand at fifteen, driving a horse and wagon on a residential milk route.

By 1899, just four years after beginning employment, Alois, still a teenager, purchased the dairy herd of Manitowoc Rapids farmer John Jarr and started his own dairy, milking the cows well before dawn every morning for home delivery by 7:00 a.m. Driving a wagon with several large three-hundred-pound milk cans, Alois would use a one-quart measuring cup to divvy out the accurate order in containers, usually china, that had been previously set out for him by the residents.

Starting several other successful dairy concerns in the next few years, including the Manitowoc Creamery, Fischl began building a home on Marshall Street in Manitowoc and operated his dairy out of the basement. Delivering milk initially in tin bottles, Fischl switched to the widely known glass bottles by 1910 to provide improved cleanliness. Glass bottles also kept the milk fresher for longer and eventually became a requirement for home delivery services in many cities.

Soon, Alois's dairy grew out of his basement, and he commissioned a new building to house his business. Here, he began pasteurizing the milk, added ice cream to the menu and incorporated as Fischl Ice Cream and Dairy Company in 1922. Always evolving, he razed part of his dairy building in

Milk men standing outside Kennedy Dairy Company, Madison, 1929, and present view, now utilized for the University of Wisconsin's Center for Healthy Minds. *Courtesy of Wisconsin Historical Society (*top*) and Scott Wittman Visual, 2021 (*bottom*).*

1928 to add a modern factory and eventually incorporated a fleet of trucks to replace his six teams of horses.

His sons, Alois Jr. and Paul Fischl, both graduated from Lawrence College in Appleton and joined their father's business venture in the early 1930s. According to the *Manitowoc Herald Times*, Paul was an outstanding athlete and was offered a contract by Curley Lambeau for $100 a month to play running back for the Green Bay Packers. As his father could pay him $150 a month, Paul elected to stay with the family business.

Alois Fischl Sr. passed away in 1955 after over fifty years in the Wisconsin dairy industry. Alois Jr. and Paul ran the company until retirement in the early 1970s, when they sold the business to Verifine Dairy of Sheboygan, which closed the plant in 1977. Verifine Dairy itself was bought by Dean Foods in 1987 and has subsequently been permanently shuttered as well.

The milkman left the scene as advancements in milk's shelf life increased and refrigerators became mainstays in every American household, along with automobiles and a rise in popularity of retail grocery stores. As more families shifted to urban areas, prices for delivery increased, making it much more cost-effective for consumers to purchase their dairy products in stores.

At the intersection of Fifteenth and Marshall Streets in Manitowoc sits the old Fischl Dairy. Appearing well past its prime, the brick building has

Present view of former Fischl Ice Cream and Dairy Company, Manitowoc. *Scott Wittman Visual, 2021.*

housed many businesses over the course of the forty years since it was last collecting, pasteurizing and delivering milk and ice cream.

With a glance up above the top row of windows and under the roofline along Fifth Street, the words "Fischl Ice Cream and Dairy Co." are clearly visible, etched into the brick when the clopping of horses delivering milk door-to-door was still a familiar sound throughout the community.

NUMEROUS PURVEYORS OF HISTORY throughout our state have attempted throughout the years to document the physical remnants of the dairy industry before they are no more. Rusk County's "Barn Again" Initiative, Vernon County's round barn research and Mount Horeb's work on cheese factories in that community are examples of first-rate dairy research, and they are certainly not the only ones. There are many more hiding in the shadows that will continue to be located and explored to expound the spiderweb of stories of our past.

One building that isn't so hard to find is in the southwest corner of the Central Wisconsin Fairgrounds in Marshfield, covering over a third of an acre of land area. Known as the "World's Largest Round Barn," it is over 150 feet in diameter and contains stalls for hundreds of heads of cattle and space able to hold one thousand people.

Standing seventy feet tall to the top of the cupola, the gargantuan two-tiered roof is the dominant visual feature of the exterior of the barn, which originally was covered with 188,000 white cedar shingles. Last replaced in 1989, the roof is now of reddish-brown asphalt. Painted bright barn red, both levels of the barn are covered in tongue and groove siding with evenly spaced, white-framed windows around the circumference.

Built between 1915 and 1917 by the Central Wisconsin Holstein Breeders Association, its construction came toward the end of the round barn phase in agriculture promoted by Franklin King and the College of Agriculture at UW-Madison.

This barn, although likely inspired by King, was built by another Wisconsin native, Frank Felhofer, born in Medford in 1886 and the most prominent of a family of builders. Upon the rise of dairy farming in central Wisconsin at the turn of the century, Felhofer soon after began making his mark on the region's architecture, building over four hundred agriculturally purposed structures. Although most of the original buildings on the campus of the Central Wisconsin Fairgrounds were likely built by Felhofer, only the round barn and the old exhibition hall remain.

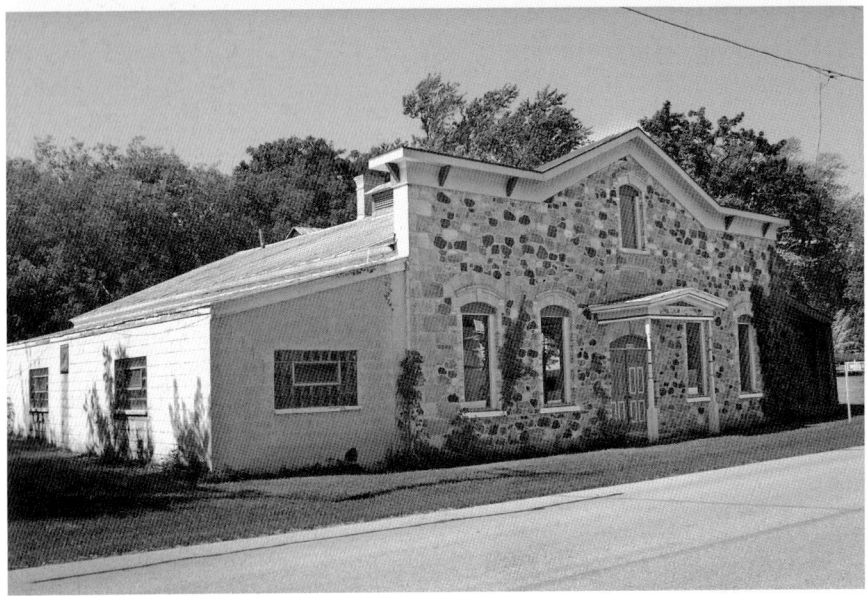

Rhine Center Cheese Factory, Sheboygan County, circa 1900, and present view. *Scott Wittman Visual, 2021.*

Showing and selling cattle by the Breeders Association was the main reason for the barn's construction, though the fairgrounds were chosen as the location to utilize during the recently formed Central Wisconsin State Fair as well.

County fairs had already become state agricultural institutions by the time the Central Wisconsin State Fair was formed in 1903. Marshfield's proximity to three counties—Wood, Clark and Marathon—constituted the "Central" word selection. "State" was chosen, rather than county, in hopes that more state aid would be given than what county fairs usually received.

For roughly the first decade of the Central Wisconsin State Fair, harness racing was the main attraction, and the harness horse was king. However, a shift in culture throughout the state from the prior decades was about to cause a major change in philosophy of county fairs, as stock breeding was growing throughout the state and the dairy cow soon kicked the horse into virtual obscurity.

The high interest in purebred cattle led the Central Wisconsin Holstein Breeders Association to examine the prospects of a new cattle barn for their members to centrally show, judge and sell their stock. The ensuing partnership with the fairgrounds seemed a natural fit.

When the "Largest Round Barn in the World" held its first cattle sale the year it opened in 1916, the receipts weren't as good as hoped, as reported in the *Marshfield Herald* the next day:

> *The sale developed somewhat of a disappointment to the breeders who had cattle listed, as the prices throughout were low—in most cases not over eighty percent of the estimated value of the animal being bid. This condition is accounted for by the absence of outside buyers and the necessary keen bidding competition. It is also understood that the sale was not given enough outside publicity to insure a large attendance, as the catalogues were sent out only a few days prior to the sale dates.*

The small attendance numbers would not continue. Dairy became the dominant agricultural commodity in the first half of the twentieth century in Wood County. As its importance grew, so did the emphasis put on the breeding, health and care of cows.

Since the success of the first Wisconsin State Fair in Rock County in 1851, the benefits such events could bring to the agricultural industries throughout the state were obvious. As the early state fairs moved to alternating locations before ultimately residing permanently outside Milwaukee, attendance

continued to rise, and counties took note. Forming their own versions, local county fairs have since been instrumental in spurring local interest in, and the promotion of, agricultural education in Wisconsin. By the early decades of the twentieth century, a central fairground area was becoming commonplace in almost every county in the state. Today, those fairgrounds are treasure-troves of early barn architecture.

As classic dairy barns on the countryside are lost virtually every day, fairground architecture remains one of the few places to view barns built with the best methods of the day they were constructed. These were special-purpose barns, meant for showcasing livestock to further the commercial successes of the industry. Because of this purpose, and the success of the county fairs throughout the state, these barns had direct impact on the eventual domination of the dairy industry by Wisconsin farmers. Showcasing advancements in agricultural technology, farming methods and outlets for rural socialization have led to the continuing popularity of the annual harvest festivals, as today the state boasts over seventy county fairs, three district fairs and one massive state fair every year.

All the while, the numbers of farms and farmers sharply decline.

In 1989, the "Largest Round Barn in the World" was renovated to best ensure its longevity. The original bleachers were removed along with several

"World's Largest Round Barn," Marshfield, Wood County, 1916. *Courtesy of North Wood County Historical Society.*

staircases, as the second floor is rarely utilized anymore. A new concrete foundation was also poured.

Wood County has contributed some of our greatest cheesemakers and milk producers. The round barn is still beloved today and stands as a celebratory monument to Wood County's and Wisconsin's dairy history. The impressive structure is yet another reminder of how the Wisconsin dairy farmer fought through volatile pricing, consolidation, price-fixing and market saturation to rise to the top of the world dairy chain.

THE RECLAIM

On a cool gray October morning, a strong breeze whipped up the already fallen leaves on the Steffens Dairy Farm in Seymour. This is the farm of my in-laws, where my wife grew up and my children get taken for tractor rides and play in the haymow. Before I married a farmer's daughter, I had been on a farm barely a handful of times in my life, naive to all the lifestyle entails.

On this day, which started with a cold drizzle before turning more seasonable, a group of workers had arrived early in the morning to prepare for an event, which they were clearly expecting to garner some attention. I watched as they maneuvered through the wind, setting up tables and a podium under a tent, with the customary advertising paraphernalia in plain view. My wife and in-laws were talking with some of the organizers, along with state patrol officers and various security personnel. All the while, several cars pulled in containing media members and the like.

After several minutes of last-minute set-up and final plans being discussed, the last two vehicles pulled in—black Dodge Chargers—and parked opposite the tent area. Out stepped, among others, Wisconsin's current secretary of the department of agriculture, trade and consumer protection, Randy Romanski, along with Governor Tony Evers.

The event was the announcement of a public-private financing partnership in an investment totaling $168 million to build a new cheese factory in the village of Little Chute in Outagamie County. With a joint state investment of $4.5 million in tax incentives, Agropur, the Canadian-

Dairy herd scene, central Wisconsin, circa 1940s. Photo by Andrew J. Mueller. *Courtesy of Marge Van Heuklon Private Collection.*

based dairy cooperative, would build the factory to expand its facility already in Little Chute. It was the culmination of a partnership among Agropur; the Wisconsin Economic Development Corporation; the Department of Agriculture, Trade and Consumer Protection; the Village of Little Chute; and the governor's office.

"We did have options," said Agropur president Doug Simon. "We could've constructed it anywhere, but we chose Wisconsin because of the high-quality milk supply we have here, the hardworking team of employees we have located here and also the support we receive, not only from the State of Wisconsin, but the Village of Little Chute. We are united in our commitment to stimulate the local economy, support dairy farmers and to support the dairy industry as a whole."

The Simon family is well known throughout the area as cheesemakers. Doug's grandparents Art and Anne Simon began Simon's Specialty Cheese in Little Chute in 1940. Dave and Judy Simon, Doug's parents, eventually took over operations, with Doug being the third generation.

"As a teenager, I actually used to pick up milk from this farm," he said, referring to Steffens Dairy Farm. "I even remember their producer number: twenty-two."

In 2003, Simon's Specialty Cheese merged with two other area third-generation cheesemaking families, Krohn's Dairy of Luxemburg and Weyauwega Milk Products, to form Trega Foods, employing over three hundred people. Within five years, Trega Foods agreed to sell, "to ensure long-term viability" to Agropur Cooperative, a top-five dairy producer in Wisconsin and the sixteenth-largest dairy company in the world. Now, a 210,000-square-foot, state-of-the-art facility was to be built, expanding the current plant's milk-processing capabilities by more than double, from 300 to 750 million pounds a year.

Along with creating fifty-four new jobs, the expansion of the milk plant would lead to a significant increase in milk demands from local farms that supply Agropur, and millions of dollars in additional revenue for those farms—an additional $60 million—will be paid out annually.

THE EVENT WAS HELD at my wife's family farm due to the long-standing and loyal relationship the farm has had with Agropur and its other previous local iterations, Simon's Cheese and Trega Foods.

Purchased in 1971 by Joe and Lorraine Steffens, the original 80-acre farm has since been increased to 240 acres.

"We've known the Simon family for many, many years," Lorraine explained. "As they grew, we grew. I'm confident that by this new building we'll always have a place for our milk to go, and that's important because farmers don't always know if that's going to be continuing."

After raising a family of five children, my wife being the youngest and only daughter, Joe became ill and passed away in 2004. Two of his sons, Steve and Dan Steffens, remained on the farm to help Lorraine keep it running, forming Steffens Dairy Farm, LLC, in 2014. Improving their farm in recent years, the Steffenses built a new barn, doubled their herd and added robotic milkers and enhanced data management systems in 2016.

What an announcement like this meant to local dairy farmers in the Fox Cities cannot be overstated. The enjoyment and security of knowing that my wife's family farm, the vision of her father and the pride of her mother, will continue for many years, likely not meeting the same somber fate of so many others, is comforting. My mind, however, could not help but return to the many farmers I had spoken to in the year prior to this

event—those who had invited me into their homes and told me their pain, their regrets, their cherished remembrances, their family secrets, struggles and tragedies.

The economic numbers spoken about during the press event—$168 million total investment, $60 million in added revenue, $100 million for ancillary suppliers and subcontractors—are numbers they can likely never dream of hearing.

"DURING THE WINTER OF 1985, the government said there were too many cows. They said they'd pay all accepted bids of purchase to buy out individual herds. So, I took a walk around my barn."

Bill Kratz and his wife, Carol, operated a dairy farm outside Columbus, northwest of Madison. Bill grew up on a dairy farm that his parents rented from the Columbus Hospital Sisters in Columbia County, not far from their current farm.

Approaching his mid-eighties and navigating through some recent health issues, he seems to have the energy level and sense of humor of someone much younger.

"After graduating high school in 1956, I worked on my dad's farm for a while before going to work for a contractor building corncribs and milk houses, installing barn cleaners and bulk tanks and other odd jobs to go along with."

At a small park carnival in June 1960, Bill and Carol met, and they were married a year later.

"We moved to this farm in September of '62," Carol said as we sat around their kitchen table. "There was an older couple farming it at the time. They were here for thirty-five years or so, I believe."

The history of the farm was a bit of a mystery, as the landowner Bill and Carol purchased the property from had been renting it out to the previous couple, who had no children. "According to the owner, this whole neighborhood belonged to this farm at one time. We're not real sure how or when it all got lotted off."

Walking around the barns and outbuildings of the property, Bill and Carol show me countless items left here by past generations of farmers: a yoke likely used by teams of oxen, an ancient baby stroller converted to a hose reel, numerous horseshoes.

"We still haven't seen everything that was left here once we moved in. His corner was back over there." Bill gestured to a corner in the old barn, filled

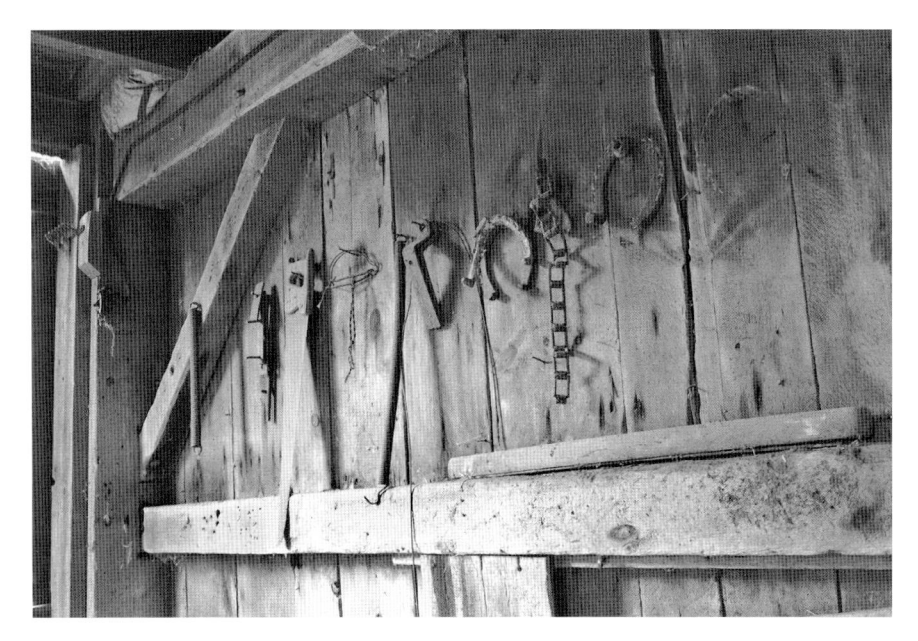

Old tools and items left around the Kranz property from prior to the Kranz ownership. *Courtesy of Bill and Carol Kranz Private Collection.*

to the brim with items. By "his," he means the previous tenant who had been here for thirty-five years, Ben.

"That's all Ben's stuff?" I said, a bit surprised.

"Yeah, that's all his. Just never could get myself to go through it yet."

Ben died in 1968, six years after Bill and Carol purchased the farm he was renting. His wife, Selma, whom Ben married in 1925, passed away unexpectedly en route to an area hospital after a heart attack in 1962, just a few months before Bill and Carol purchased the property. Sixty years later, many of Ben's items remain undisturbed.

"He'd come back here and look at things we were doing, periodically," Carol relayed. "Criticize mostly. He didn't ever really want to talk, so we never got to visit much with him."

They're unsure whether Ben and Selma were milking cows, as the buildings, including the milk house on the property, likely predate them.

"The whole neighborhood had cows, twenty, thirty years ago," according to Bill. "Now, there's really just one left that still does."

When Bill and Carol were presented with the opportunity to sell their cows, they made the tough decision to move on it. American dairy farmers had a deadline of February 28, 1986, to establish a bid to participate in the

Former residents of Kranz Farm, circa 1930s. *Courtesy of Bill and Carol Kranz Private Collection.*

Federal Milk Production Termination Program. Due to an oversaturated market, the federal government was hoping to eliminate milk surpluses by buying out whole herds from farmers to reduce milk production in the United States by twelve billion pounds.

Bill and Carol were one of 1,681 other Wisconsin dairy farming families and 13,988 nationwide to have their proposals accepted for the herd to be purchased and sent to slaughter or to overseas markets. To be sure the cattle couldn't be hidden or sold to another farm in the meantime, the U.S. Department of Agriculture required that the cows be branded on their faces with a four-by-four-inch X.

"What all went into that decision?" I asked.

"The amount of money and time it was going to take to…we would've had to overhaul the barn," Bill shook his head. "We couldn't do that."

"May 1, 1986, our cattle were loaded up, and down the road they went," Carol said. "Of course, there were tears, as our favorite cows left. But our life changed a lot then. We didn't have the vet bill. We didn't have the feed bill. We didn't have to make hay. It changed a lot. That ended our life as dairy farmers."

The month wasn't through with life-changing events, unfortunately, as Bill relayed.

"Our youngest daughter, Lisa, was in the eighth grade that spring. Her principal, Sister Carol, and another sister came for lunch that Sunday, May 18. We went down to a small woods where Sister Carol wanted to take the eighth-grade class to enjoy a day with God. Lisa had taken one of our three-wheelers down there and was going to head home while we finished visiting. Shortly after she left, we heard a loud noise, which Sister Carol thought was a tire blowing out. I hurried down to the intersection and saw the van that Lisa hit."

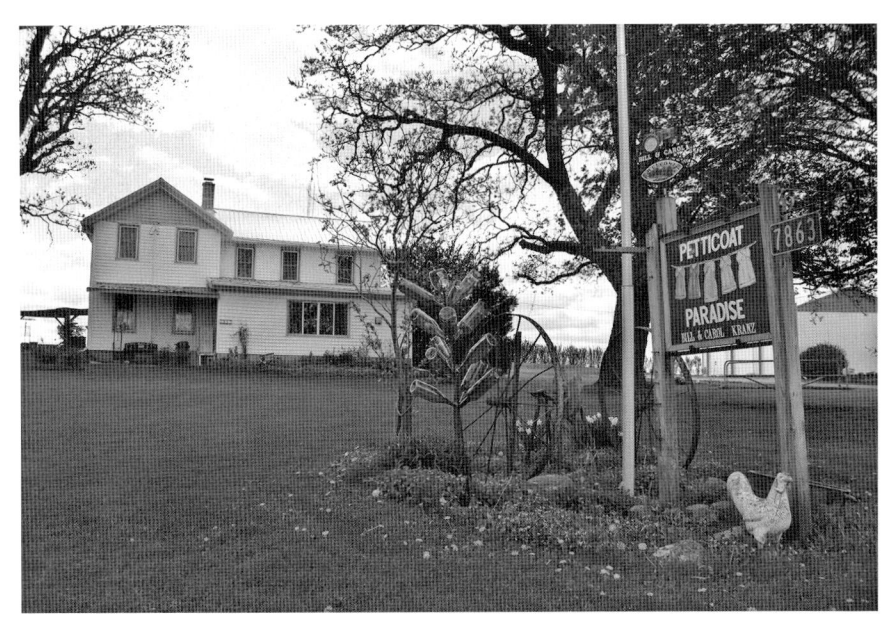

Present view of "Petticoat Paradise," Kranz dairy farm, rural Columbus. *Courtesy of Bill and Carol Kranz Private Collection.*

An ambulance soon arrived and took Lisa to the hospital, with Carol following close behind with a neighbor driving her, as Bill stayed back to talk with police. Before Bill arrived at the hospital, Lisa had passed away.

"She's our forever fourteen-year-old," Carol said, softly.

Bill and Carol continued to crop farm until recently, when age and health made it impossible to continue. An auction was held at their farm in the winter of 2020, sending them into a well-deserved permanent retirement.

By THE MID-1980s, THE village of Tony in Rusk County had already begun to resemble the landscape that I found there in 2021. Large dairy barns lay empty on old farmsteads amid deserted businesses and ruined houses. Tony certainly is not alone in the decay, as rural small towns throughout the north have been turning back to the slumber the lumber companies left them in over a century ago.

"My dad used to tell me, 'I won't see it in my lifetime, but you'll see it in yours: there won't be any more dairy farms north of Highway 29.' Pretty sure north of Highway 64 that'll be true."

Paul Lindegren operates a small dairy farm outside Tony, presiding over the farm his parents worked and he grew up on. "I sat down at the table one morning—just the basic bills—feed bill, light bill, diesel fuel, phone, internet, TV, charge card, odds and ends, case IH card. I wrote out $6,000 in checks that morning. I didn't get to keep none of it."

I sat at that very table with Paul and his sister, Lily Lindegren Nichols, a member of the Rusk County Historical Society, on a summer afternoon, talking about Rusk County, Paul and his experience as a dairy farmer in today's world. A lifelong bachelor, Paul milks about twenty cows, a number that used to be common for the average family farmer though now is virtually unheard of. "Most I ever milked was twenty-six."

After emigrating from Sweden, Paul and Lily's grandparents started this farm, among others, as they were prominent landowners in the area in the late nineteenth century. "They were kind of the land barons of the day. They were the big cat." Their father was a railroad worker, as Tony was founded around 1885 when the Soo Line came through, eventually taking over the farm when their grandfather fell ill.

Originally named Deer Trail, the village changed its name to Tony after the son of a prominent resident, Anton Hein, in 1897. After the loggers left and the trains stopped coming as often, the area fell into a bit of a ghostly

Present view of Paul Lindegren dairy farm, rural Tony, Rusk County. *Scott Wittman Visual, 2021.*

state, rescued by dairy farmers lucky enough to find land offering enough fertility to sustain a healthy herd.

"The population of Tony at one time was six hundred people. Now there's...what?" He looks to Lily.

"113."

"113. From 600. Think of that. There were cheese factories, a theater, opera house, saloons, dance halls. In 1975, in this township, there were forty-three dairy farms. A lot of them small dairy farms, around twenty or so cows, like mine. Now, there are five.

"Those forty-three farms—everyone raised a family, had a garden. None of them had a wife or husband working off the farm. They were all a self-sufficient business. And they thrived. The city of Ladysmith thrived. The implement dealers thrived. We had several implement stores. Everybody had a hay baler, tractors, hay mower, a plow, a disc. They provided the equipment and service for hundreds of them. Now, they're gone, too. All the services we need, all the parts, everything is now over an hour drive to get a forty-dollar part."

The remains of that time were what I was witnessing. Not just in Tony, but in Weyerhaeuser, Kennan, Jump River, Catawba, Butternut and countless

Lindegren Dairy Farm, 1923. Rural Tony, Rusk County. *Courtesy of Paul Lindegren and Lily Lindegren Nichols Private Collection.*

other towns left dormant by the fall of the family dairy farm, a full-circle deja-vu from the abandonment of the lumber camps.

By the late 1960s, any expectation or enthusiasm that dairy could sustain up here for the long haul was gone. Most had already left before then, leaving a spiderwebbed extended family throughout the northern highlands in their wake, not knowing how or where to look for other options. Those who stayed clinging to a lifestyle, or an idea, or a natural connection to the soil were stranded holding the water.

"Bottom line is anything under one hundred cows they don't want you no more," Paul said.

"Who's 'they'?" I asked, curious of his perspective, though knowing the answers.

Paul continued, "The dairies don't want you. The people that haul the milk don't want you, because they have to run too far to get a load of milk. The banks and their loaning policies, they don't want you.

"I was looking to sell my cows last fall. They're beautiful cows. Decent cows. I don't want to put them on a truck for slaughter. Auction sales will not sell them in groups, only individually, and then they'll scrutinize every one and tell you why she's only worth this little bit. I'm hoping to find someone who milks sixty to seventy cows, wants to expand by twenty. Well, here's twenty nice cows."

Paul did receive interest in his herd from several prospective buyers of the profile he was looking for.

"They all came back with the same answer: the bank wouldn't loan them the money.

"Banks will buy you a tractor. They'll buy you land. They'll build you a building. But anything that can disappear like a cow? No, they won't.

"Sometimes, you'll get an answer of 'yes,' but it's with 50 percent down, which is just a nice way of saying, 'No.'"

Paul relates that the exodus from the area continues yet today.

"A lot of my friends, seven farms within four miles south of here, all 60 to 120 cows, all disappeared in the last three to four years. Big, beautiful

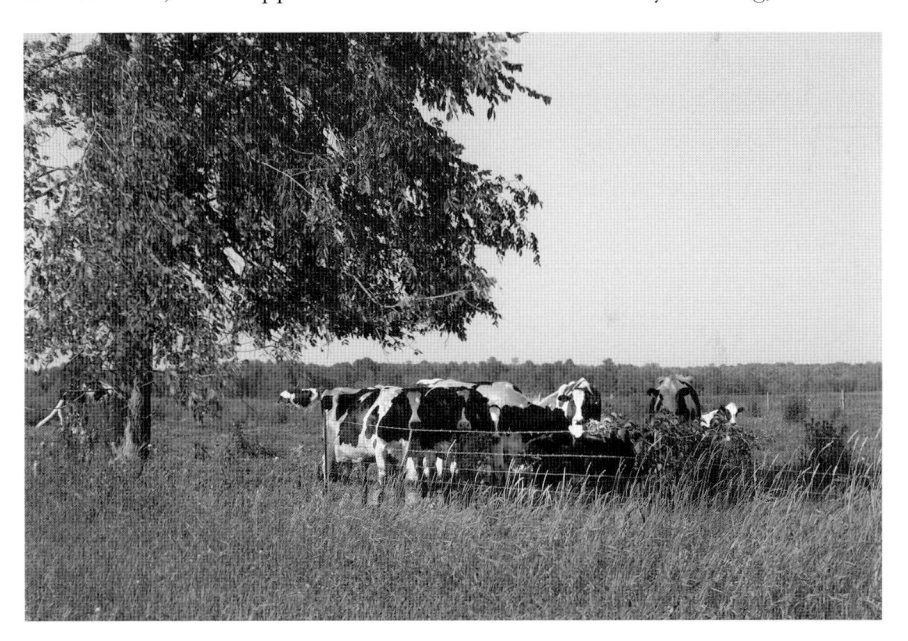

Paul Lindegren's dairy herd, rural Tony, Rusk County. *Scott Wittman Visual, 2021.*

barns sitting empty. Some of them have been turned into a place to park the combine or turned into a big machine shed. Maybe round bale storage or something. But the cows are gone.

"So, what does that hundred cows even mean? They're milking a hundred cows—[they] should be making money, right? The only difference between me and those hundred-cow farms is that they were writing bigger checks."

The effect of the push for dairy farms to go bigger is a theme I heard in virtually every conversation with every farmer I had. The need for investing in one's own business and livelihood was not without want or desire, though financial partners were often unwilling to collaborate, causing those needs to go unfulfilled and farmsteads to be unable to continue.

By 1961, the head of the National Milk Producers Association, Glenn Lake, was telling Wisconsin's dairy farmers that fewer but bigger dairy farms would be supplying America's milk products in the ensuing fifteen years, tripling a farmer's investment by 1975 from what was the current standard. Lake also stated, however, that his prediction "did not mean the end of the family-owned farm."

"The family-owned and operated dairy farm can hold its own and will continue to be the mainstay of milk production," he told attendees at the annual meeting of the American Dairy Association in March 1961.

The pressure on farmers to go bigger was accelerated in the 1960s, with modern advertising showcasing how new equipment and technology could make the job so much easier with just the right financial investment appropriate for the farmer's specific situation. If you're going to buy more cattle, you'll need to buy more land. If you buy more land, you'll need to build additional sheds and bigger barns. You may as well fill those new sheds with the most modern tractors available, or combines, or sprayers.

"You know, of course you don't really need a lot of that stuff, I guess," Pat McCormick told me. "When I started, we had a wheelbarrow and a fork. But a wheelbarrow and a fork doesn't work out so good when you get old."

Truman Graf, a UW-Madison economist, analyzed "prospects for change in the dairy industry in the next 10 years" in a study the findings of which were published in virtually every newspaper throughout the state in January 1970. His findings confirmed what most family dairy farmers already knew: that bigger dairy herds, bigger processing plants, bigger marketing organizations and bigger federal orders to be filled by bigger farms were all on the horizon. "Dairymen who had difficulty keeping up

with changes during the 60's," the study warns, "will find the 70's even more hectic."

Graf, echoing Lake from a decade prior, promoted the notion that a farmer expanding his farm is his only way forward. His vision for dairy farming leading into the decade of the 1970s was surely unsettling for farmers who had just witnessed thirty-five thousand dairy herds disappear in the 1960s, after Glenn Lake said the family-operated farm was the "mainstay of milk production."

Graf's list of predictions for 1980, made in 1970, included:

> *Half the dairy farms now in existence will be gone by 1980, with the "small" dairy farm virtually extinct. Commercial dairy farms with over $10,000 in sales will increase by 50 percent.*
>
> *Number of cows per farm will triple and the average per dairy farm will be about 75.*
>
> *Milk production per cow will increase 50 percent. Larger herds and more production per cow will quadruple milk production per man per year from 250,000 pounds at present to around 1 million by 1980.*
>
> *During the 1970's, farmers can expect a complete conversion from "can" to "bulk tank" farm milk storage and a complete conversion to Grade A quality standards. Manufacturer's grade milk will go out of existence.*
>
> *More than 50 percent of the dairy plants now buying milk from farmers will be gone, and those remaining will double the volume of milk they presently handle.*

Farmers throughout the state, who had already watched many of their neighbors leave the industry in the previous ten years, were being told by UW-Madison, the original recruiter of yeoman farmers to the state seven decades prior, that in order to compete they must double their herd, increase their land, increase milk production per cow, install a bulk tank and do all this knowing there was a good chance the factory that bought their milk might go out of business. Many dairy farmers, simply unable to improve their farms to the standards needed to compete any longer, like Bill and Carol Kranz and Sherb Mabie, ended their operations.

Alan Larson's farm had twenty-two milk cows. "We didn't have enough land for more than that. My dad worked out as a mechanic, so my mother and I took care of the cattle. When it was time for my parents to go on social security, we would have had to build a new barn and get more land. Couldn't put a barn cleaner in there cause of the way it was built;

everything was done by hand. So, I got a job at Phillips Plastics, and away went the cows.

"A lot of places now, if you have a small farm, they won't even pick up your milk. And when you do have a couple of good years, everybody says, 'Boy, get a few more cows and you'll be bringing in money.' And your production will go up, and then the price drops. Now what?"

Many more, doing what they thought was best for their family and the industry, answered the call, inviting in the Trojan horse of debt that has been picking farms off by the thousands for decades. Even some today who are simply trying to stop, like Paul Lindegren, are having trouble just getting out.

"Why is it that a farmer, every time he wants to do something, he's gotta take a beating?" he wondered.

In a 1986 interview in the *La Crosse Tribune*, Glen Knowles, an agricultural economist at the University of Wisconsin–La Crosse, conceded that the shift to bigger dairy farms would likely crush rural communities. "There certainly isn't going to be potential for growth in the small towns," he said. "It's scary. And I think there is a possibility of some of the small towns turning into ghost towns."

"They want tourism up here," Paul states. "Beef cattle and cash crops will be here, but not dairy farms. They want us gone. The state wanted to acquire half my land and half my neighbor's land to put in a thirty-five-acre lake for ducks. You see whole farms up here—big, beautiful farms—going for wildlife refuge."

As with the plight of Bessie Eggleston and the farmers of Marquette County, it seems that "wildlife refuge" is the "reforestation" of modern-day relocation efforts.

"I THINK THERE WAS a big push to get bigger. All your magazines and universities said if you don't get bigger, you'll get left behind. And I don't think that necessarily was so, but things are becoming more and more that way."

Mark Kempen farms in Catawba in southern Price County. A former schoolteacher in Phillips, he retired to dairy farm full time until health issues dictated that end in 2013. Now a full-time crop farmer growing oats, hay, corn and soybeans, Mark clearly retains his passion for dairy.

"Oh man, it was phenomenal! This whole area was all dairy." He gestures his hand at the landscape, mostly now cash crops and grassland. "When I was in high school, I used to work for Zorns [Cheese Factory] and pick up

milk cans. Every road you drove down, you picked up milk. People would have anywhere from one or two cans to a dozen or so. It was just solid farms. This area is really more conducive to dairy farming than anything else, and they were all small farms because the amount of pastureland just wasn't enough to grow much bigger.

"I still think a small dairy farm can make a living. They just have to do a really good job of it. With implement dealers and magazine ads selling and promoting bigger farms to sell more equipment. People tend to be a little bit greedy. They're always holding that carrot in front of your nose and trying to get you to reach for it, and you might be giving up a whole way of life if you reach too hard.

"Small communities really did well when there was a lot of little dairies. Every town had a grocery store, hardware store, a lumber yard, a feed mill. Some milked ten or twelve cows and had other jobs somewhere, but when I was growing up, a large farm was anything over forty cows or so. Most people made a living on ten to maybe thirty-five cows. A man and his wife and his kids could handle that. Even today, when you look at the big farms and you divide it down between the employees, it's about forty cows per person. Even with all the automation, you still need to have people to do all the work."

Mark's father and grandfather bought the land his farm now sits on right before World War II. It had been homesteaded by a family prior, though the father was gassed digging the well, similar to what happened to John Muir eighty years earlier. The wife and children made it through the Depression years but lost the farm soon after that. After changing hands a few times with nobody taking ownership of it, Mark's father and grandfather bought it from the county.

"They bought the initial eighty acres and then bought another eighty in the '50s. They took the old barns down and the house. We built all the silos. Put the barn up in '82.

"It's a good piece of land. Rocky, but high, and good land," Mark said, nodding his head as he remembered. "And we always had good cows."

I asked Mark what he would be doing if the health issues hadn't happened in 2013. What would he be up to now?

"I'd probably still be milking. Dairy was really good to me, I won't lie. I made a lot of money. I mean, we didn't get rich, but we lived pretty good off the dairy, and when we did let the cows go, we had enough money that we could retire and kind of just do what we wanted to do."

Mark saw the impending clouds ahead though.

"It used to be, if you weren't happy with who you were selling milk to, you just called another plant and they would be out there that day. After a while, it became, you better hang on to who you're with because they didn't really want to pick up milk from small farms. It was a change. You had so much milk coming from these big farms that all of a sudden, they decided it wasn't as profitable to pick up milk from these little farms anymore.

"When I was farming, I never had to pay to have my milk picked up. They wanted it that bad that they just bought it on the farm. When I was farming, I sold to Kraft, Morning Glory, Land O' Lakes. Then it became a [Dairy Farmers of America].

"Now it's an issue, getting rid of the milk. Now, if you're going to start a small dairy, you better make sure you have someone to take your milk before you start. It's just about impossible to get rid of canned milk, and it's still hard to get rid of bulk tank milk if it isn't already bought."

ABOUT SIX THOUSAND DAIRY farms remain in Wisconsin. Chapter 12 farm bankruptcies are up double digits and show no signs of slowing down. The idyllic Wisconsin dairy farm, picturesque and wholesome in its spirit, now resides more on the canvases of artists and the paper of poets than it does on the landscape on which they were born.

An unidentified woman with her cattle herd, Sheboygan County, early twentieth century. *Courtesy of the Sheboygan County Historical Research Center.*

"When I first started, all around here there were little farms everywhere," Pat McCormick remembers. "They all had ten, eleven kids. Raised 'em up. And they didn't make any money, but they made a living. Then it was, 'You gotta have a hundred cows.' Now it's 'You gotta have a thousand cows.'

"They're just all gone now. You go up on County Road I, here," he says as he sweeps his hands toward the two-lane road, at one time a main thoroughfare. "There's nobody left on it. They're all gone. It's just a hard life."

As they diminish in numbers, their skeletal remains are found along roadways all throughout the countryside. We drive by them every day. Often forgotten, they've also been diminished in character, branded as those who "couldn't keep up," disenfranchised as "imitators" or called out as jealous complainers. A prominent agricultural reporter in the state wrote that "the non-expanders" look at "any dairy farm bigger than their own as evil."

PAT IS LOOKING TO sell, though he won't sell to his children. "They're not allowed," he says, only partly kidding.

Paul Lindegren echoes that sentiment.

"My next-door neighbor, he has six kids, and he will not encourage any of them to do this. If I had children, I wouldn't encourage it either. 'Go!'" he said as he made a hypothetical pointing motion to the road. "That's what I'd tell 'em. 'Go!'

"That's what I should've done."

ON THE STEFFENS FARM, Governor Evers walked along with Lorraine, Steve and Dan as they provided a tour of their farm, the barns and the milk collection and data management processes. Media cameras followed, though the governor seemed genuinely attentive to the family, asked legitimate questions and appeared impressed with the operation. He interacted naturally with our three small children and seemed at ease on the farm. Politics were put aside at an event such as this. Helping to economically stimulate farming communities is as universally agreed upon as any topic in this state could be.

"Wisconsin is America's Dairyland, and that's something we're damn proud of," said the governor as he boasted that Wisconsin dairy farms are "our past, our present and obviously will be our future."

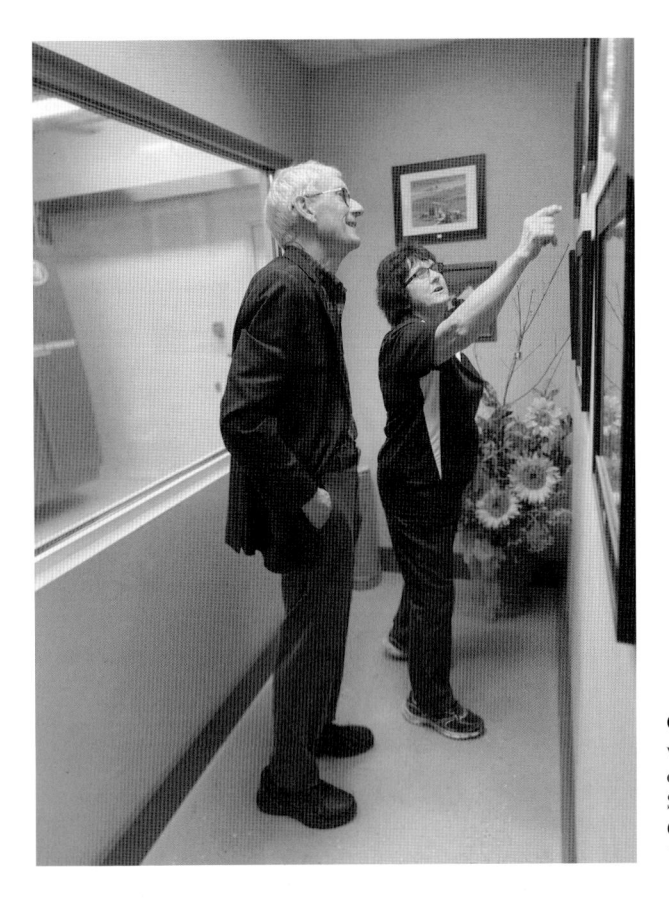

Governor Tony Evers with Lorraine Steffens on Steffens Dairy Farm, Seymour, Outagamie County. *Scott Wittman Visual, 2021.*

Many of the farmers I spoke with throughout my visits mentioned the government programs they've received over the years as being helpful, some saying they're the reason they're still afloat.

"These investments are felt beyond the farms," the governor went on. "Our farmers and our cheesemakers represent our state's heritage. For the workers in the dairy supply chain, the contractors who build and get this work and the cheap cheese enthusiasts who consume it, we need investment in America's Dairyland."

I NEVER MET MY father-in-law. The scourge of cancer took him, the patriarch of the Steffens Dairy Farm, before I met his daughter. Joe Steffens's presence, however, is still abundantly felt on the farm, as stories fill the rooms and photos decorate the home he built with Lorraine. Stories, not always about the farm, but everyday family stories. Stories about the polka band

he played in with his brothers or deer hunting with his sons, Joe Jr., Tim, Steve and Dan. Stories about fishing with my wife when she was young or his honeymoon with Lorraine in the Black Hills. Real things. The way of life he modeled is all very much alive.

I was a newcomer to the farm life when I married into the family. My experiences with dairy farms comprised mainly field trips in grade school and passing cattle along two-lane roadways and blue highways as a kid. Today, as my grade school days are long gone, so, too, are much of the cattle.

Not being raised in a farming environment myself, there is still a sense of loss, a casualty of my childhood, as the landscape of my state continues to change. It's not something that you notice on an everyday basis, although the wreckage lies everywhere. You don't notice the three or four dairy farms that sold their herds last week or maybe even the one thousand that exited the industry last year. But you do notice the eight or nine thousand lost in the last decade or the forty-plus thousand since I last went on those field trips. Long drives down country roads, which are quite common in Wisconsin, are now long drives down *empty* country roads.

Another empty space, less noticeable to most but real to me, was lying internal. Even though I never knew my father-in-law, there remained in me an injury. Being the husband to his only daughter and father of three of his grandchildren, I long to know him, but I can't. I grieve the fact that our boys, who play on the farm he created, won't get that chance either.

Joe Steffens was a dairy farmer. His wife is a dairy farmer. Two of his sons are dairy farmers. My wife was raised on his dairy farm. So a journey, I decided, would ensue. A quest of study and understanding in which I would seek him in his element, talk with him through diversified perspectives of farmers who lived as he lived, learn about his passion, his craft, trade and industry from others who built our dairy heritage, as he and his ancestors did.

In the end, the face and story of the Wisconsin dairy farmer was unrecognizable from my own initial artless perceptions. Gone were the romanticized visuals of the simple life, living quietly with their red barns and barbed-wire cow pastures. The people who lived there, in that space, were so much more.

They were revolutionaries and innovators, architects and inventors. They endured the horrors of war and the abomination of slavery. They adapted when the soil went dry, the banks went broke and corporations, lumber barons and the weather beat them down. They were of every race, color and creed, descended from countless cultures and nations the world over, and left an identity for a state that defines it still today.

Nevertheless, while dairy transitions to "megafarms" with massive herds and corporate investors, current trends lead to uncertainty of how this landscape will appear in a half century more, as the physical realm of the Dairyland they created, and what I strived to find, has been evaporating for generations.

But even as the sagging outbuildings and old cheese factories disappear, the character and resolve of those who built a legacy will not. It is engrained in our fabric now. The Shepards, the Shivers, the Egglestons, the Smazals. And Joe Steffens. Their stories are our stories. The onus is on us to make sure they don't end with them.

DURING ONE OF MY visits with Sherb Mabie, while on his now retired dairy farm, he showed me a treasure-trove of vintage farm tools, machinery and miscellaneous items he has collected over many decades—old millstones, a grain crusher, a 1907 threshing machine. He has a story for every piece, along with demonstrating how it worked.

Sherb brought me up to the haymow built by the preceding owners.

"This was built in 1952. They would've cut the logs, hauled them out here and had a portable sawmill come in here to put this up." The seventy-year-old craftsmanship was pristine. The mow was virtually empty, which showcased the natural wood throughout. "They started this farm when they took over the land in '22. There was a four-acre field here, and the rest was all cutover."

The smell was as if it was just built the day before. The comforting scent of cut lumber still permeated the inside of the mow. Hopefully, many generations from now, two other people are standing in the same spots Sherb and I were that day, admiring that building and those who built and preserved it. Sherb is the rare person you talk with who you know after that conversation is over, you have left a wiser soul than when you arrived.

After leaving Sherb's, I traveled with Bev and Dennis Brayton down a few dusty roads to Pat McCormick's farm.

"You can always tell you city drivers out here," Dennis said, as he noticed my inexperience in driving gravel dirt roads. "You're all driving slow and hugging the right side of the road. Just go down the middle and giv'er good."

Reasoning my more cautious approach as wanting to make sure a vehicle doesn't come up too fast going the other direction, as the road meandered a bit, Dennis quickly dismissed it.

"Watch for dust."

Sherburn Mabie standing in his haymow, Kennan, Price County, 2021. *Scott Wittman Visual, 2021.*

PAT WAS OUTSIDE WHEN we pulled into the driveway and up onto his farm. After a bit of introductory small talk, I explained to him that I was in Price County looking to talk and visit with family dairy farms in the area. He leaned into my open driver-side window, nodded and gave me a half smile.

"Well," he said, pausing. "You're a little late."

Maybe I am. But there's always one more story to be told.

BIBLIOGRAPHY

Beaudoin, Michael. "Oral History Interview, November 29, 1950." Wisconsin Sound Archive, WHS.

Bishop, Jim. "State Forests: From Stump Fields to Managed Forests." *Dunn County News*, December 26, 1999.

Black Settlers from Rural Wisconsin Oral History Project Interviews, 1974–1981. "Interview with Jenny Huffman Dewey." Wisconsin Historical Society, April 22, 1976.

———. "Interview with Otis and Blanche Arms." Wisconsin Historical Society, June 13, 1980.

Boscobel Dial. "The Wisconsin Cow." June 14, 1894.

Bubb, Patty. "Plymouth—Cheese Aplenty." *Sheboygan Press*, July 5, 1977.

Capitol Times. "Co-ops Solution to Many Farm Problems: Swanton." February 3, 1938.

———. "10 Children Periled as Gale Wrecks School Near Verona; Rockford Toll 7." September 15, 1928.

Cassville Index. "The Cost of Making Butter." November 15, 1900.

———. "Dairying, the Man, the Cow, and the Feed." February 24, 1898.

Cherkinian, Harry. "U.S. Eases Stance on Refuge." *Portage Daily Register*, July 14, 1979.

Cooper, Zachary. *Black Settlers in Rural Wisconsin*. Madison: State Historical Society of Wisconsin, 1977.

Cutter, William R. *New England Families, Genealogical and Memorial*. New York: Lewis Historical Publishing Company, 1913.

Davis, Jim. "Timber's Roots Go Deep." *Chippewa Herald*, August 17, 1995.

Dawes, Rufus. *Service with the Sixth Wisconsin Volunteers*. Marietta, OH: E.R. Alderman 7 Sons, 1890.

Dipple, Beth. "Plymouth's Climb to Becoming 'Cheese Capital of the World' in 1930's." *Sheboygan Press*, August 19, 2017.

Fennimore Times. "Pleasant Ridge." March 8, 1894.

Gough, Robert. *Farming the Cutover: A Social History of Northern Wisconsin, 1900–1940*. Lawrence: University of Kansas Press, 1997.

Grant County Herald. "The Making of Creamery Butter Is Lancaster's Most Important Industry." May 17, 1916.

———. "Shareholders in Butter Factory." January 11, 1894.

Green Bay Press-Gazette. "Last Survivor of Swiss Immigrants to State Is Dead." March 15, 1935.

Hanson, Monte. "Whitehall Farmer Survives, Watches Neighbors Dwindle." *La Crosse Tribune*, March 14, 1986.

Hawaiian Gazette. "Funeral of Miss Fannie Morley." September 25, 1888.

Hermolin, Joseph. "Ag Economics Fueled County's Early Dairy Industry." Langlade County Historical Society, June 2018.

Hildebrand, Jan. "Freihammer Family Settled in Town of Wilson." *Sheboygan Press*, March 6, 2005.

Holand, Hjalmar Rued. *History of Door County, Wisconsin: The County Beautiful*. Chicago: S.J. Clarke Publishing Company, 1917.

Holmes, Fred L. "Agitation to Preserve Muir's Old Home Started; Activities of Naturalist Again Recalled." *Wisconsin State Journal*, July 26, 1925.

Hoskin, Ed. "Diversity Project: Five Years Later." *La Crosse Tribune*, September 7, 2003.

Houston, Jack. "The Kickapoo in Retrospect." *La Crosse Tribune*, May 9, 1976.

Howie, Adda F. "Reminiscence." *Papers, 1904–1926*. Wisconsin Historical Society.

La Crosse Tribune. "Dawes in Mauston to View Pageant Honoring Father." August 29, 1925.

Lancaster Teller. "Patch Grove." August 11, 1892.

Larson, Lars, and Barbara A. Larson. *The Enduring Cutover: Contributions to the History of Wisconsin's Northern Region*. Whitewater: University of Wisconsin–Whitewater, 2016.

Lathorpe, H.R. "Reviews Success of Antigo Systems." *Marshfield News-Herald*, January 28, 1932.

Lincoln, Abraham. "Speech Before the WI State Agricultural Society." Milwaukee, WI, September 30, 1859.

Luchsinger, John. *The Planting of the Swiss Colony at New Glarus, Wis*. Madison: State Historical Society of Wisconsin, 1892.

Macasaet, David. *Round Barns of Vernon County*. Documentary film, 2015.

Manitowoc Herald-Times. "Fischl Dairy Started with One-Horse Rig; Now One of Largest Independent Dairies." July 25, 1961.

Miley, Marge. "Fischl Was Pioneer in Dairy Business." *Manitowoc Herald-Times*, March 27, 2005.

Muir, John. *The Story of My Boyhood and Youth*. Cambridge, MS: Riverside Press, 1913.

National Register of Historic Places. "Central Wisconsin State Fair Round Barn." Marshfield, Wood County, WI. March 21, 1997. Reference Number: 90000269.

———. "Fountain Lake Farm." Montello, Marquette County, WI. May 11, 1989. Reference Number: 90000471.

———. "Freitag Homestead." Washington, Green County, WI. November 15, 2005. Reference Number: 05001302.

———. "Shelton Farmstead." Seven Mile Creek, Juneau County, WI. August 4, 2004. Reference Number: 04000810.

Odell, Emery A. *Swiss Cheese Industry in Green County, Wisconsin*. Monroe, WI: Monroe Evening Times Company, 1936.

Oncken, John. "'96 Was a Strange Year in the Farming Business." *Capitol Times*, December 27, 1996.

Osman, Loren H. *W.D. Hoard: A Man for His Time*. Fort Atkinson, WI: W.D. Hoard & Sons Company, 1985.

Portage Daily Register. "Barn Has Lace Curtains and Other Fittings." November 10, 1915.

———. "Petri Testifies on Refuge." May 19, 1980.

Portrait and Biographical Record of Sheboygan County, Wisconsin. Chicago: Excelsior Publishing Company, 1894.

Quinney, Charlotte L. "Wisconsin Death Trip: An Excursion into the Midwestern Gothic." Thesis, Michigan State University, July 22, 2005.

Reetz, Elaine. "State to Place Marker at John Muir Park." *Portage Daily Register*, February 3, 1968.

Reuter, Lon. "What's So Special 'Bout Us?" Unpublished, Vernon County Historical Society Archives, 1978.

Richter, Albert E. *Door County: The California of the North*. Sturgeon Bay, WI: Door County State Bank, 1914.

Sheboygan Press. "Bring Back the Corner Cheese Factory." April 8, 1930.

———. "Cheese Factory Operated in Sheboygan County in 1858." August 10, 1948.

———. "Man Found Dead in County Is Believed Suicide Victim." September 4, 1929.

Shepard, Charles. "Papers 1850–1850." (Unpublished) State of Wisconsin Digital Collection. digital.library.wisc.edu/1711.dl/WI.Shepard3a.

Steinbeck, John. *Travels with Charley*. New York: Viking Press, 1962.

Stevens Point Daily Journal. "Files of Old Newspaper Hold Story of Early Times Here." August 21, 1924.

Verona, Town of. *Comprehensive Plan*. 2015.

Wisconsin Dairyman's Association. *Annual Report of the Wisconsin Dairymen's Association*. Vol. 8. Madison, WI: David Atwood, State Printer, 1880.

Wisconsin Historical Society. *Wisconsin Architecture and History Inventory*. Blumke Farmstead, Verona, Dane County, Wisconsin. Ref Number: 230718.

Zon, Rapael, and Russell Cunningham. *Logging Slash and Forest Protection*. Madison, WI: Agricultural Experiment Station, 1931.

ABOUT THE AUTHOR

Scott Wittman is a professional photographer, writer, researcher and podcaster living in the Fox River Valley of Wisconsin.

An avid road-tripping enthusiast, Scott can oftentimes be found along the backroads and two-lane highways of Wisconsin, documenting the state's unique culture and heritage, while also searching for remnants of its past physical landscape.

Scott's first book, *Lost Fox Cities*, was published by The History Press in 2019, and his work continues recognizing the contributions, both seen and unseen, of those who have come before us.

Scott and his wife, Vicky, live in Appleton with their three sons, Asa, Jett and Rhodes.

He can be reached at www.scottwittmanvisual.com.